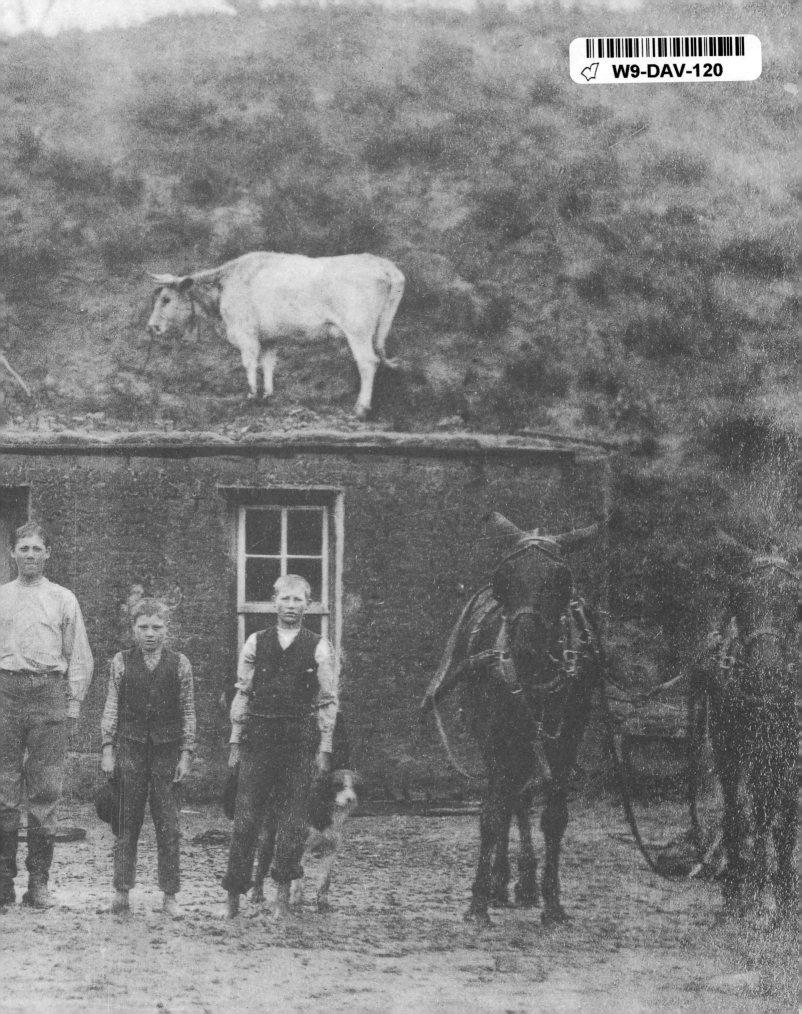

HISTORIC AMERICA

The Heartland

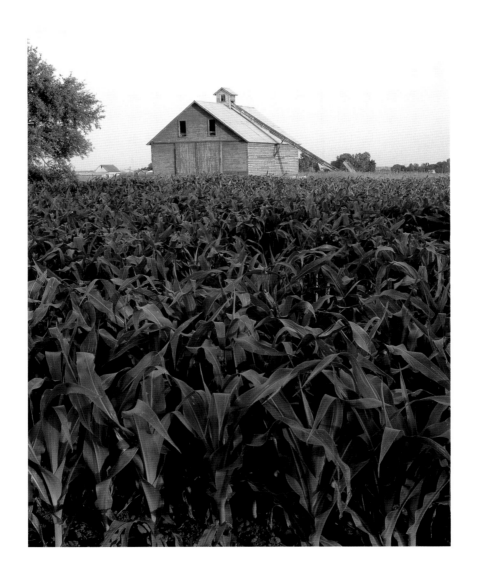

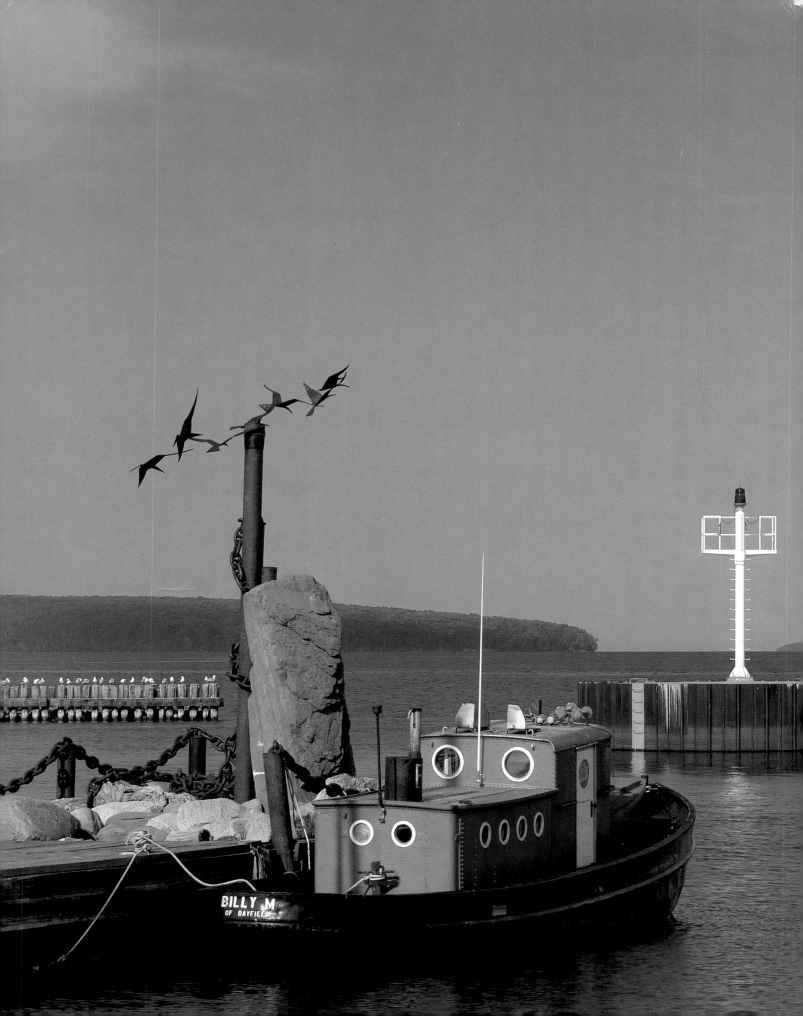

HISTORIC AMERICA

The Heartland

Brooks Robards

THUNDER BAY
P·R·E·S·S
SAN DIEGO, CALIFORNIA

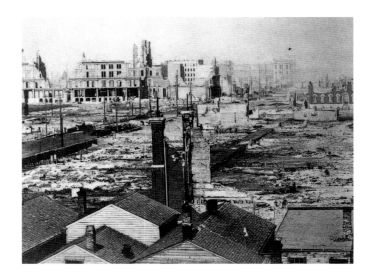

Acknowledgments and Photo Credits

The publisher would like to thank all who assisted in the production of this book, including those listed below and: Deborah Hayes, for compiling the gazetteer; Lone Nerup Sorensen, for the index. Grateful acknowledgment is made to the individuals and institutions listed below for permission to reproduce illustrations and photographs, noted by page number: © **Larry Angier:** 93; © **Mary Liz Austin:** 24–25, 97, 120–21; **Burlington Northern Railway:** 14–15; © **Ed Cooper:** 36–37, 56–57, 61, 76, 108; © **D.E. Cox Photo Library/China Stock:** 112; © **Terry Donnelly:** 1, 2, 6, 7, 8, 9, 10, 11, 12–13, 16, 18, 19, 20, 21, 22–23, 28, 32, 33, 40–41, 44, 48, 49, 52–53, 64, 65, 100–01, 104–05, 109, 113, 128; © **Carolyn Fox:** 89, 116–17; © **Rudi Holnsteiner:** 124–25; © **Wolfgang Kaehler:** 17, 27b, 29, 30–31, 73, 79, 81, 116t; **Kansas State Historical Society:** 90; © **Balthazar Korab:** 26–27, 85t, 122; **Library of Congress**, Historic American Buildings Survey/Historic American Engineering Record Collections: 96 (HABS, ILL, 16-CHIG, 60-7), 127 (HAER, MO, 96-SALU, 78-34); Prints & Photographs Division: 4, 43, 60, 66, 71, 74 (both), 77, 79b, 86, 95t, 94, 95b, 102–03, 114–15, 118 (both); **Glenn O. & Lorraine B. Myers Collection:** 39, 42, 45t, 45r, 46, 55, 68; **National Archives:** 47, 54, 59, 70, 78, 79t, 123; **Nebraska State Historical Society** (Solomon D. Butcher Collection): 15b, 75, 82, 87, 91; **Planet Art:** 45b; **Santa Fe Industries, Inc:** 99; **Saraband Image Library:** 84; **South Dakota State Historical Society:** 83, 88; **State Historical Society of Iowa:** 35, 111, 119; **State Historical Society of North Dakota:** 92; **Union Pacific Museum Collection:** 106, 107; **Yale University Map Collection** (photos © **Josef Szaszfai**): 50–51, 62, 72; © **Charles J. Ziga:** 45t, 45r, 85b.

SERIES EDITOR: John S. Bowman
EDITOR: Sara Hunt
ART DIRECTOR: Nikki L. Fesak
PRODUCTION EDITOR: Deborah Hayes

Thunder Bay Press
An imprint of the Advantage Publishers Group
5880 Oberlin Drive, San Diego, CA 92121-4794
www.thunderbaybooks.com

All notations of errors or omissions should be addressed to Thunder Bay Press, editorial department, at the above address. All other correspondence (author inquiries, permissions) concerning the content of this book should be addressed to Saraband, The Arthouse, 752–756 Argyle Street, Glasgow G3 8UJ, Scotland, hermes@saraband.net.

ISBN 1-57145-858-1

Library of Congress Cataloging-in-Publication Data available upon request.

Printed in China
1 2 3 4 5 06 05 04 03 02

Above: A view of the devastation in Chicago after the Great Fire of October 8–10, 1871.

Page 1: Corn nears maturity on this farm in LaSalle County, Illinois.

Page 2: Bayfield Harbor, on the shores of Lake Superior, Wisconsin, in the Apostle Islands area, which was first explored by the French in the 1600s.

Table of Contents

Introduction 6

1. The First Inhabitants 33

2. Explorers and Early Settlers 49

3. The "Indian Problem" 65

4. Forging Boundaries, Creating States 81

5. At Work in the Heartland 97

6. Into the Twentieth Century 113

Gazetteer 129

Index 142

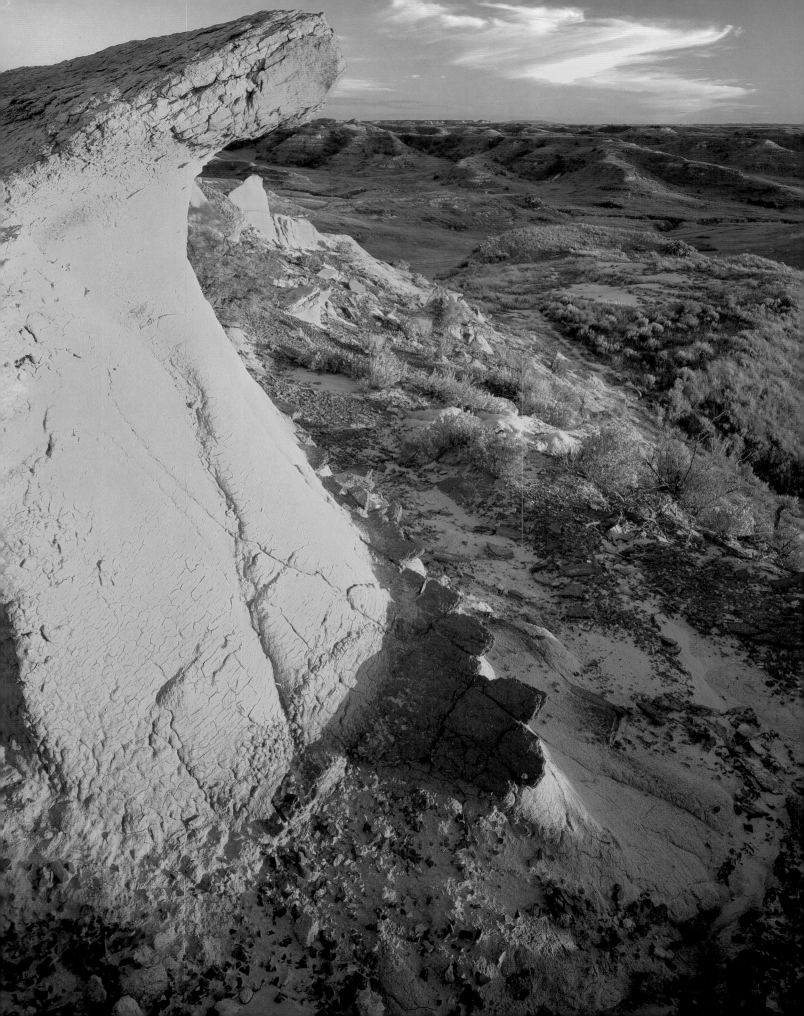

INTRODUCTION

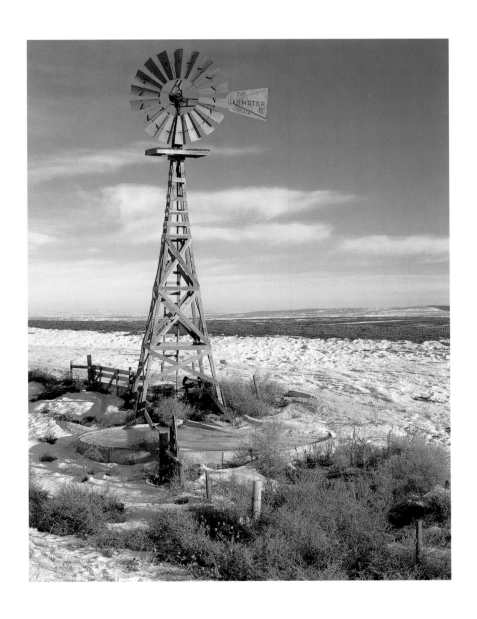

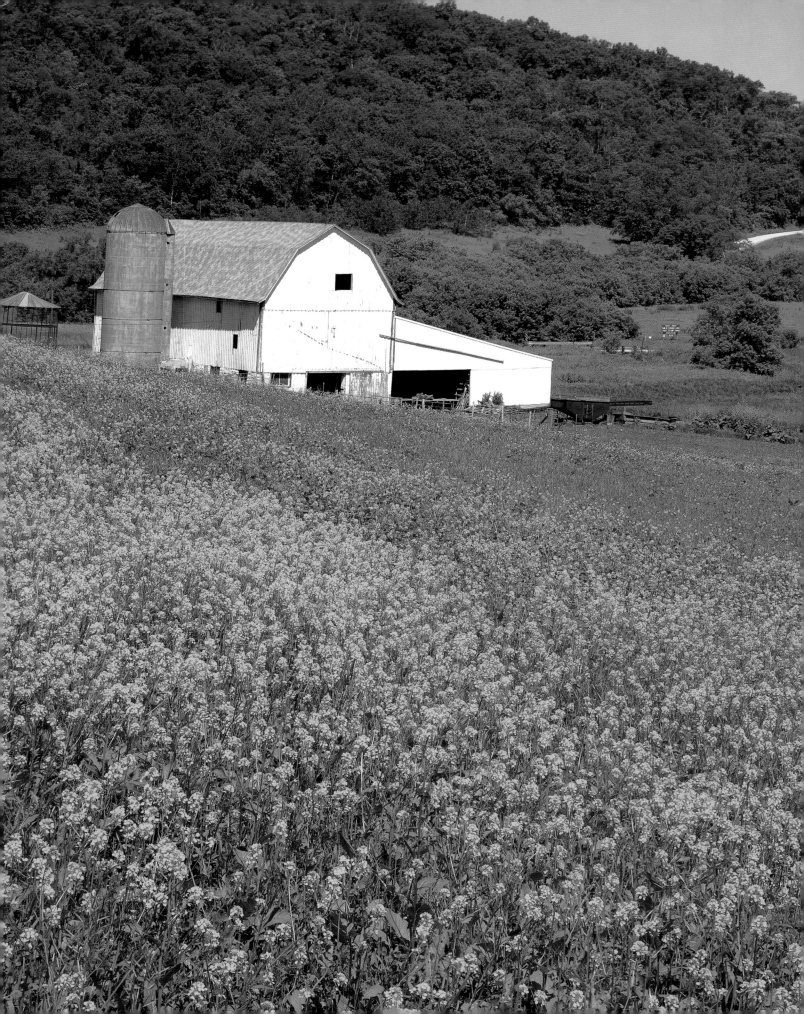

Some states cluster readily on a regional map of America, like New England or the Northwest. Others—what many call the Midwest or Central States—don't fit so easily under a single label. Even distinguishing between the Far West and the Midwest as most do is a tricky business. You might want to ask, west of what? The perspective comes from the East Coast, where the West once consisted of anything beyond the Appalachian Mountains, and the term is certainly justified by the pioneer spirit of most settlers who headed west. But West by itself is too vague.

Historians sometimes employ the umbrella term "trans-Mississippi West," which is too inclusive for our purposes. Writing about his family's migrations from Wisconsin to Minnesota and Iowa, novelist Hamlin Garland (1860–1940) used the phrase "middle border." This was how he described the shifting edge of the frontier as it moved across the nation over time. Certainly we have to account for the fact that boundaries can change. "Midwest" seems too much like a quibble that doesn't do justice to the region.

We have chosen to call this volume about the expanse of America on either side of the northern Mississippi River, fanning north to Canada and the Great Lakes, the "Heartland." For these twelve states—Ohio, Michigan, Indiana, Iowa, Illinois, Missouri, Kansas, Nebraska, Wisconsin, Minnesota, North and South Dakota—Heartland best captures the essence of their place within the larger United States without relying on geographic orientation to other regions. The Heartland states—sharing patterns of geography, settlement, and agricultural and industrial development—drive the pulse of the rest of the nation. Just as important, they capture, in some quintessential sense, those innately American qualities that ultimately join each of the regions and states to form the United States of America.

Page 6: *Sunshine lights up a jagged ridge in Theodore Roosevelt National Park, North Dakota.*

Page 7: *A windmill highlights the Nebraska plains of Keith County in winter.*

Opposite: *An Iowa County, Wisconsin, barn nestles between woodland and a field of yellow flowers.*

Below: *Soybeans, germinating in the rich black soil of Lee County, Illinois, create almost perfect geometric patterns.*

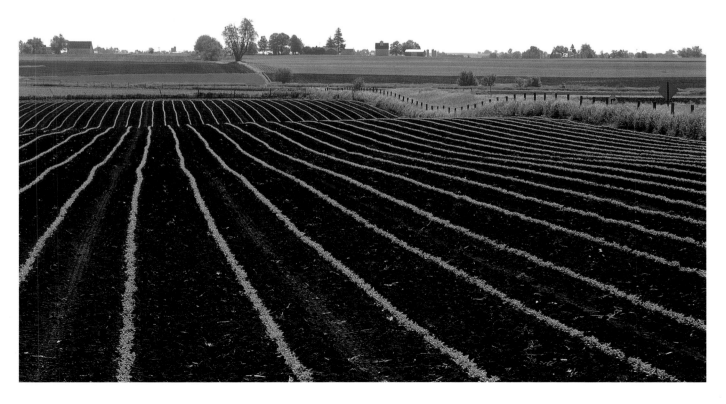

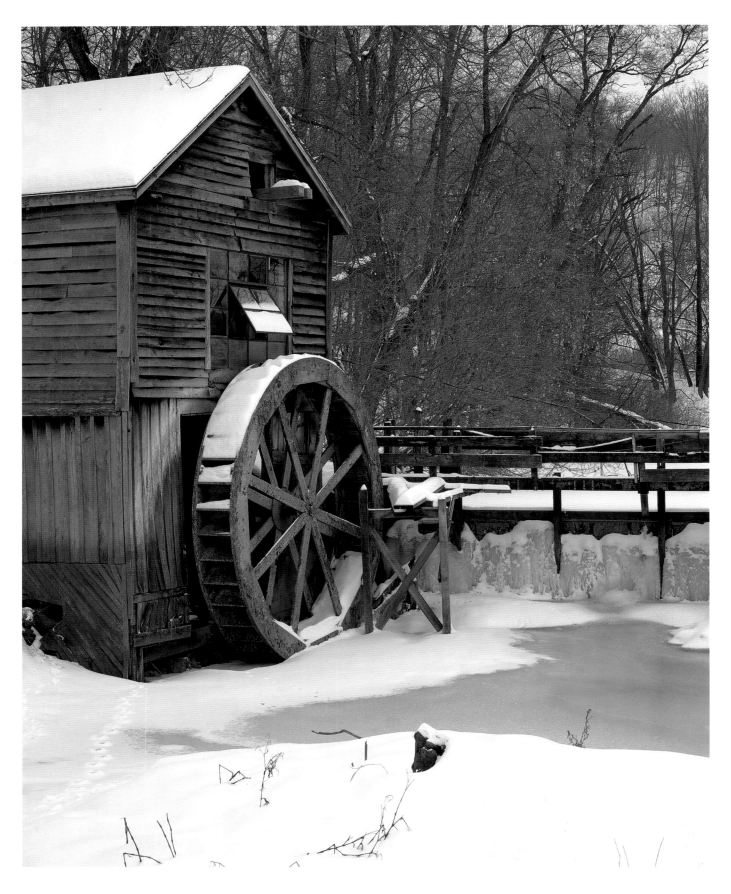

Beginning with the easternmost state, Ohio, the majority of Heartland people can trace their origins to a mix of New England, Midland (or Mid-Atlantic), and Southern influences. Frontiersman Daniel Boone personifies this pattern, since he was born in Pennsylvania, moved with his family to Missouri, then to North Carolina, before settling in Kentucky, and finally returned to Missouri. The East Coast mix like Boone's was leavened by German, Scandinavian, Slavic, and other ethnic groups as the region evolved. And, finally, the original Native American inhabitants, while most of them were killed or herded into reservations farther west, make up an important part of the Heartland's cultural character. Look no farther than the names of many towns, rivers, lakes, and monuments to appreciate the Native American influence.

No one section or city in the Heartland serves as its core or center. Some might point to the Corn Belt or to Chicago, but cultural geographers would disagree. The Heartland spreads out consistently across the center of America. If it divides itself at all, that happens along a north-south axis, with the northern populations more like those of New England or the Northeast, and southern Heartlanders more like Southerners.

Some of Americans' greatest country-men have been born or lived in the Heartland. Abraham Lincoln's life in Springfield, Illinois, before he went to Washington, D.C., comes to mind. And perhaps no American president exemplifies Heartland values better than Harry Truman of Missouri. The great inventor, Ohio-born Thomas Alvah Edison, left school in Michigan after three months when his teacher said he was "daffy," then went on to create many of the devices that define modern life. Henry Ford, the man who first made automobiles available to the masses, didn't stray far from his birthplace in

Opposite*: Snow festoons Hyde's Mill (1850) and Trout Creek in Iowa County, Wisconsin.*

Overleaf*: Mist covers the Ohio River Valley at Cave In Rock State Park, Illinois, at sunrise. It was first explored by the Frenchman M. de Lery in 1729.*

Below*: Hokenson Brothers Fishery on Sand Bay juts into Lake Superior from Apostle Islands National Lakeshore in Wisconsin. The historic fishery has a museum open to the public.*

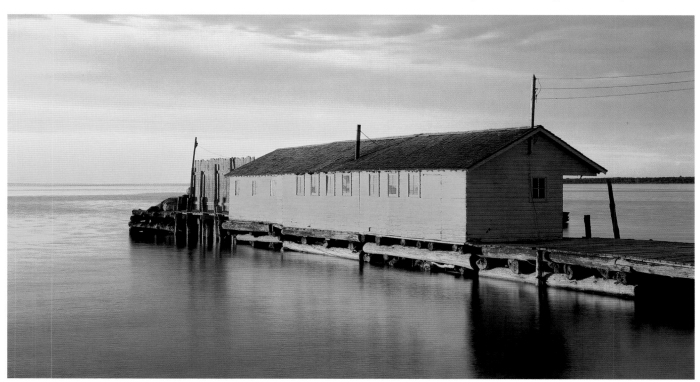

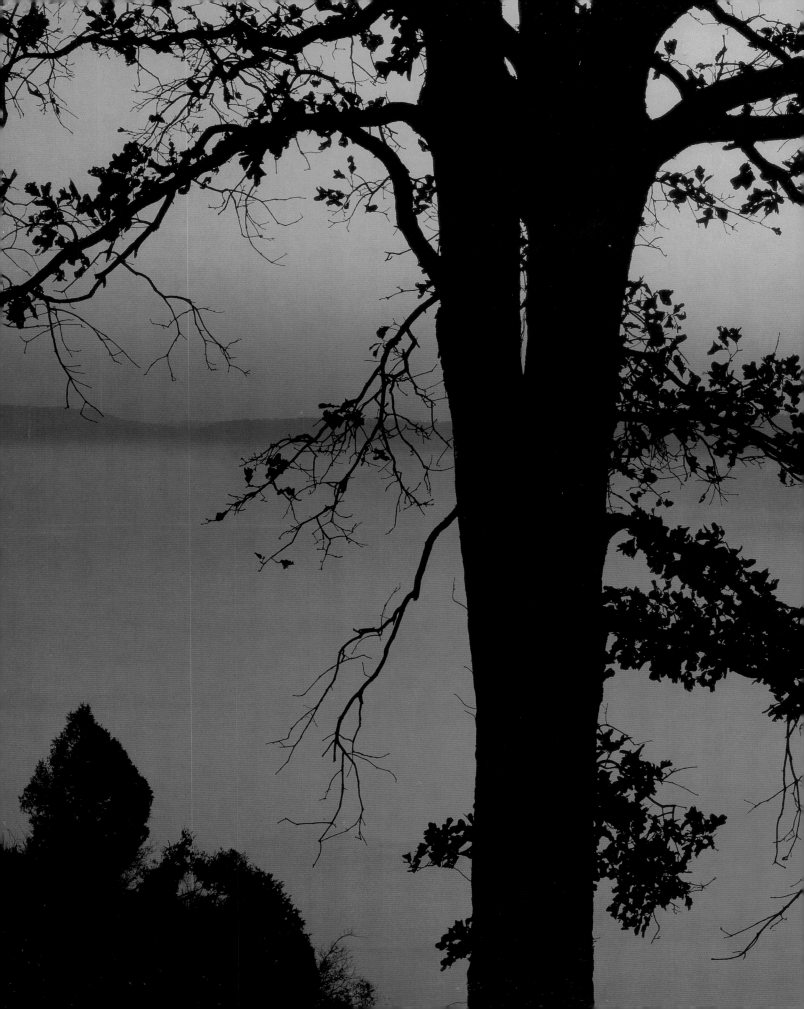

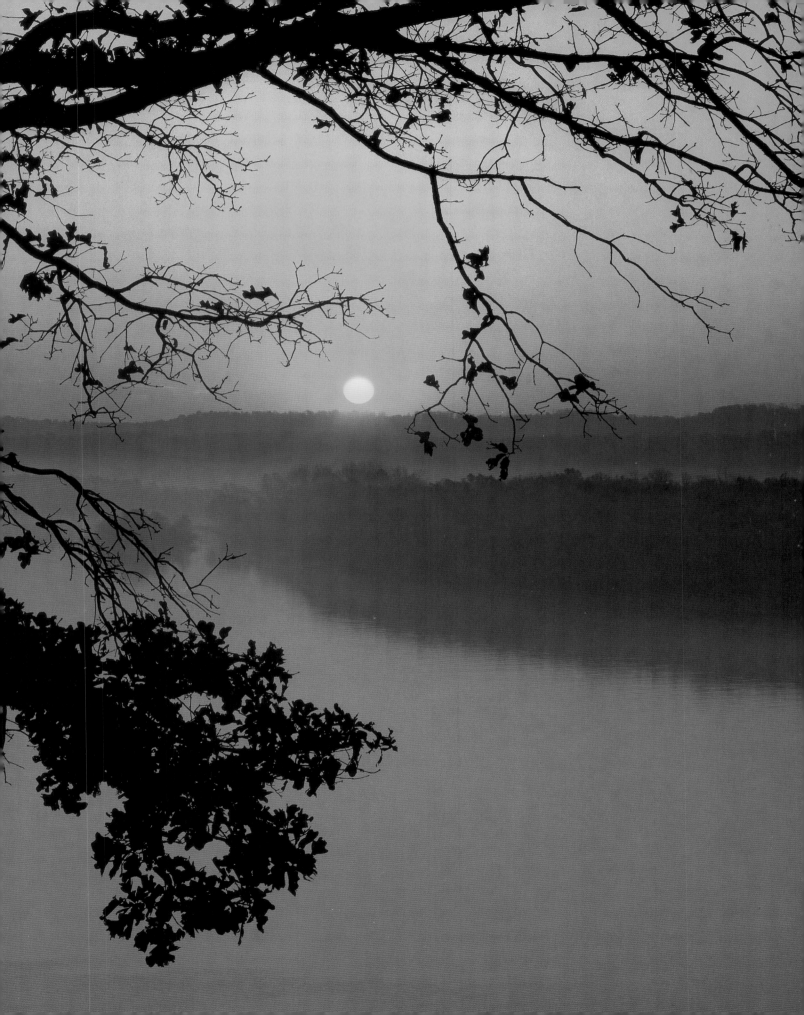

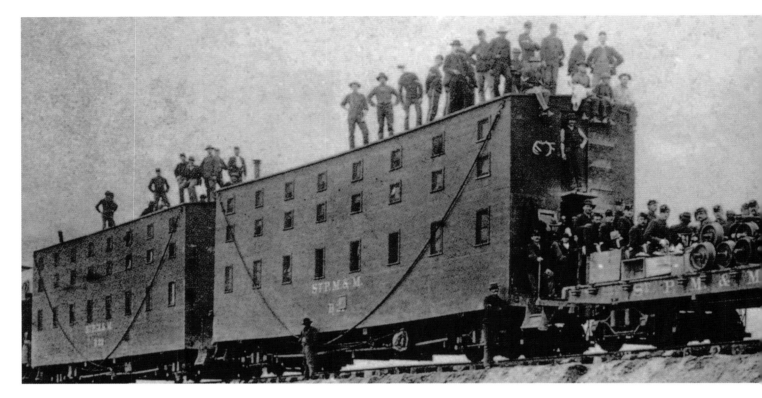

Above: Triple-deckered railroad cars served as dormitories for construction workers on the St. Paul, Minnesota-based Great Northern Railroad. In Wisconsin, a tourist excursion and dinner train still operates along the Namekegon River between Spooner and Springbrook.

Dearborn, Michigan, to do it. Some of the twentieth century's greatest American writers have been Heartlanders, including Ernest Hemingway, who came from Oak Park, Illinois; Willa Cather, who grew up in Nebraska; Langston Hughes, who was a Joplin, Missouri, native; and Nobel Prize Laureate Toni Morrison, who was born in Lorain, Ohio.

Anyone who questions the Heartland's pioneering spirit should keep in mind that most of it started as parts of the Northwest and Louisiana Territories. The story of how the Heartland came into existence through the changing boundaries of various territories is intricate and intriguing. Imagine wide reaches of essentially uncharted wilderness, sparsely inhabited by Native Americans so dramatically different from the European-stock pioneers who sought to settle it that they often evoked an unwarranted sense of terror. As Wilbur Zelinsky points out in *The Cultural Geography of the United States*, the Native Americans and the pioneers "differed so profoundly, not only in level of material achievement but in the essential style or shape of cultural pattern that genuine communication was nearly impossible." Yet it was the Indians who often taught the European-stock settlers how to survive, and who led them to the resources that made the region rich.

Unlike in the South and Southwest, Spanish influences in the Heartland were less significant than French ones. The difference is an important one because the French explorers who ventured south into the Heartland from Canada were less interested in settling the area than trading there. Although the English replaced the French after the French and Indian War, the American Revolution started fewer than fifteen years later, quickly ending foreign domination. The flood of immigrants who flavor many parts of the Heartland today started soon after.

North America has the largest variety and number of natural resources of any continent. Its richest section of all is occupied by the United States, and the Heartland lies at the center of those riches. Physical geographers describe the region as the Interior Plains. Although it is no "Great American Desert" as some nineteenth-century explorers claimed, the Heartland climate tends to be semi-arid. Western Kansas receives 20 inches of rain annually, while eastern Nebraska averages 28 inches. Closer to the Mississippi River, western Missouri has 36 inches. Heartland states east of the Mississippi enjoy somewhat more rainfall.

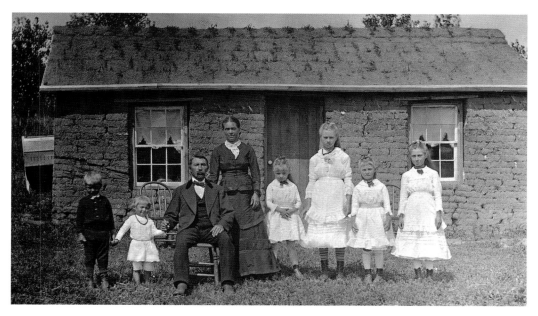

Left: The John Hohman family of Woods Park in Custer County, Nebraska, poses in front of their sod house. The county was ceded to the U.S. by the Pawnee Nation in 1857 and later named after General George Armstrong Custer.

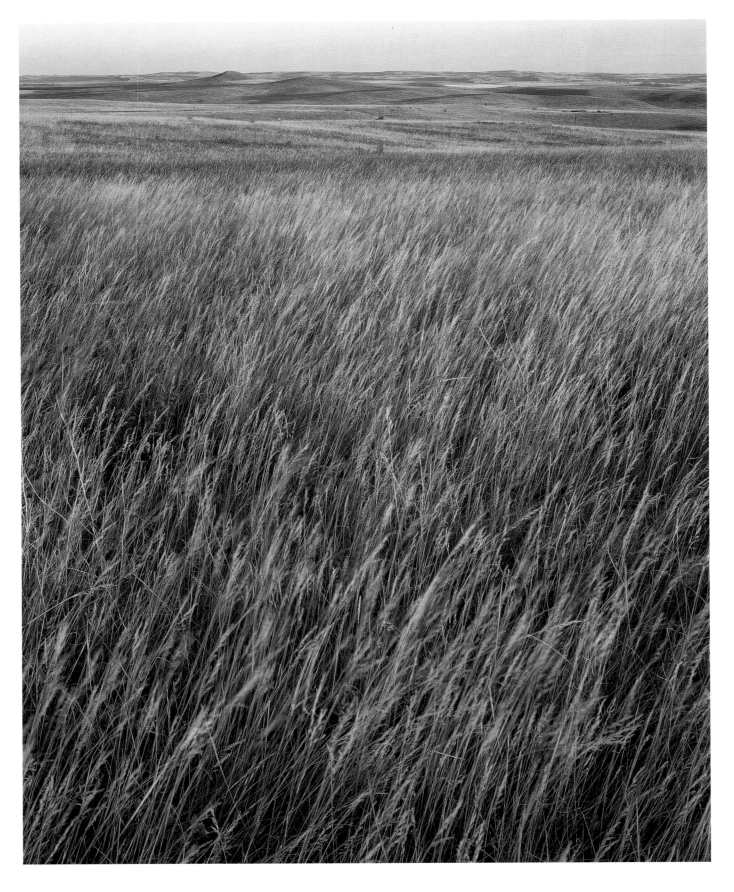

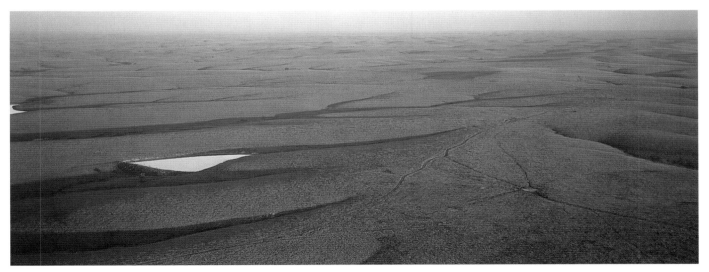

Heartland soils tend to be sandy, increasingly so the farther west you go. As the name Interior Plains implies, the Heartland consists predominantly of open, level grasslands, although South Dakota's Black Hills rise in the north, and to the east, Minnesota, Wisconsin, Illinois, Indiana, Michigan, and Ohio, which border the Great Lakes, are more heavily wooded. Northwestern sections of the Heartland that are devoid of trees grow a range of grasses, depending on rainfall. Southwestern Minnesota, for instance, has enough soil moisture for tall-grass prairies of porcupine grass, big bluestem, and yellow Indian grass. Illinois poet Carl Sandburg paid tribute to his home state's tall grass in a poem:

The prairie sings to me in the
forenoon and I know in the night
I rest easy in the prairie arms,
on the prairie heart.

With less moisture, Kansas, Nebraska, and central South Dakota have mixed-grass prairies of blue grama, hairy grama, and little bluestem. Parts of Kansas and Missouri feature what geologists call "dissected till plains," once

covered by glaciers. Nineteenth-century historian Francis Parkman waxed lyrical about the prairieland near Fort Leavenworth, Kansas:

On the left, stretched the prairie,
rising into swells and undulations,
thickly sprinkled with groves, or
gracefully expanding into wide
grassy basins, of miles in extent,
while its curvatures, swelling against
the horizon, were often surmounted
by lines of sunny woods; a scene to
which the freshness of the season
and the peculiar mellowness of the
atmosphere gave additional softness.

With an ecological history more like the Rockies farther west, South Dakota's Black Hills are forested with ash, birch, elm, hackberry, bur oak, white spruce, paper birch, and ponderosa pine. In sections of the Heartland like North and South Dakota's badlands that are underlaid with shale, sandstone, mudstone, and limestone, water, wind, and frost have carved the land into haunting vistas. North Dakota's flat lands are often broken up by prairie potholes, as its circular lakes and ponds are called.

Above: *An expanse of tall-grass prairie in Flint Hills, Kansas, is broken up by a "prairie pothole." Tall-grass prairies are natural laboratories for scientists studying climatic changes and may provide a natural warning system for global warming.*

Opposite: *The fields of Little Missouri National Grasslands in Theodore Roosevelt National Park, North Dakota, stretch out toward the horizon. The USDA Forest Service administers twenty grassland areas, totaling four million acres. Located primarily in the Heartland states, these grasslands were once home to giant herds of buffalo and elk.*

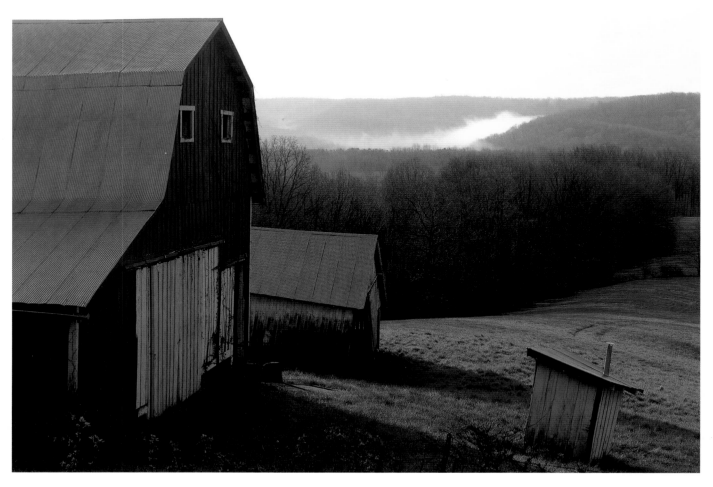

Above*: Spring fog hugs the hills near a Brown County, Indiana, farm.*

Opposite*: Hardwoods bordering the Carp River in Ontonagon, Michigan, show off their fall colors. The view is from Escarpment Trail in Porcupine Mountains Wilderness State Park. The Park contains Michigan's largest undeveloped wilderness area.*

In 1846, Parkman described his travels in Nebraska's Platte River Valley with criticism that turns into a compliment: "It had not one picturesque or beautiful feature; nor had it any of the features of grandeur, other than its vast extent, its solitude, and its wildness." Although a state like Ohio might not seem to consist of prairie land, geologists have found evidence that prairies extended that far east, and patches of prairie still exist there.

No wonder that water is so important to the dry Heartland. The Mississippi River is the "Father of Waters," as Native Americans called it, for all America, not just the Heartland. Beginning at Lake Itasca in Minnesota and running 2,350 miles south, its watershed reaches into thirty-one states. Meandering through Minnesota's many lakes, creating rapids and waterfalls along the way, it spreads out and flattens south of Minneapolis. Thousands of years ago in this region, it was the major channel for a melting continental ice sheet.

Where Minnesota meets Wisconsin and Iowa, the Mississippi enters what geologists called the "driftless area," which did not have glaciers. Instead, the sedimentary rock laid down in this portion of Minnesota, Wisconsin, Iowa, and Illinois produced an abundance of caves, sinkholes, and other spectacular scenery. As it reaches the southernmost edge of the Heartland, the Mississippi begins to spread out, reaching widths of a mile at the Missouri border.

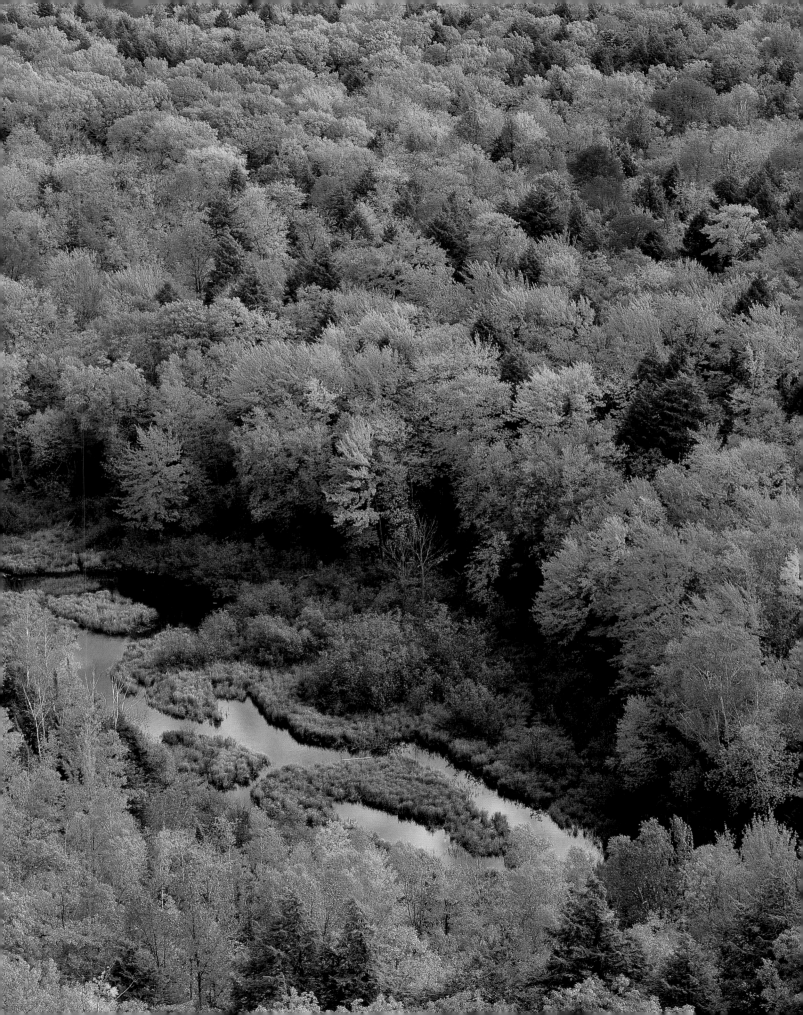

Above: These weathered buildings at Cornucopia Harbor in Bayfield County, Wisconsin, sit on the south shore of Lake Superior. Bayfield County was named for a British naval lieutenant who made the first survey of this Great Lakes region.

Opposite: Split Rock Lighthouse overlooks Lake Superior from a rocky promontory.

Overleaf: Evening sun in the Black Hills, South Dakota, an area inhabited by the Sioux before the Louisiana Purchase.

The five Great Lakes rival the mighty Mississippi as the Heartland's most significant body of water. Half of our Heartland states border them. A virtual peninsula, Michigan is surrounded by four of the five Great Lakes, and, as a result of the moisture, is heavily forested. Loggers cut down most of its first-growth trees in the nineteenth century, but second-growth pine and hardwood cover 20 million acres of the state today. Flattened by glaciers, Wisconsin acquired 9,000 lakes and 20,000 miles of rivers when the ice melted, producing marshes and wide expanses of pine forest. Only Minnesota has more lakes—nearly 12,000. The geographic center of the entire continent, it borders Lake Superior from Duluth to the Canadian border, a woodland known as the Lake Superior Highlands.

Indiana's physiography follows a similar pattern of flattening through glaciation in most sections, but the Wabash and Ohio Rivers add hills, ravines, and woodlands. South of Wisconsin, Illinois

has a shoreline along Lake Michigan. Chicago, the nation's second-largest city for much of the twentieth century, overlooks Lake Michigan from the mouth of the Chicago River. The city's name means "wild-garlic place" in Algonquin. Nearby Gary, Indiana, serves as that state's perch on Lake Michigan, while much of Ohio's northern border lies along Lake Erie. Proximity to the Great Lakes gives these six states greater geographic variety than those Heartland states farther west.

Thousands of years ago, such exotic animals as giant bison and wild horses, beaver, and camels, inhabited the Heartland region. By the time the first European explorers arrived in the sixteenth century, these prehistoric creatures were gone, and no one knows why they disappeared. Early explorers did find hordes of buffalo, or bison as they are more properly called, which fed and clothed the Native Americans for centuries and served as a valuable commercial product for settlers, until their near extinction in the nineteenth century.

Spanish explorer Francisco Vasquez de Coronado saw pronghorns, or antelope, in Kansas as early as 1535, and their numbers were as great as those of the buffalo. The American elk, or wapiti as they were called by the Shawnee, once roamed the Heartland but now are confined to prairie badlands and river regions in the Dakotas. Bighorn sheep, as well as moose, inhabit the western sections of North and South Dakota, and a variety of deer make their home in Heartland forests, including whitetail and mule deer. Once the bane of Heartland settlers with livestock, wolves have been wiped out except in areas like Minnesota's wilderness. Its smaller relative the coyote is more numerous.

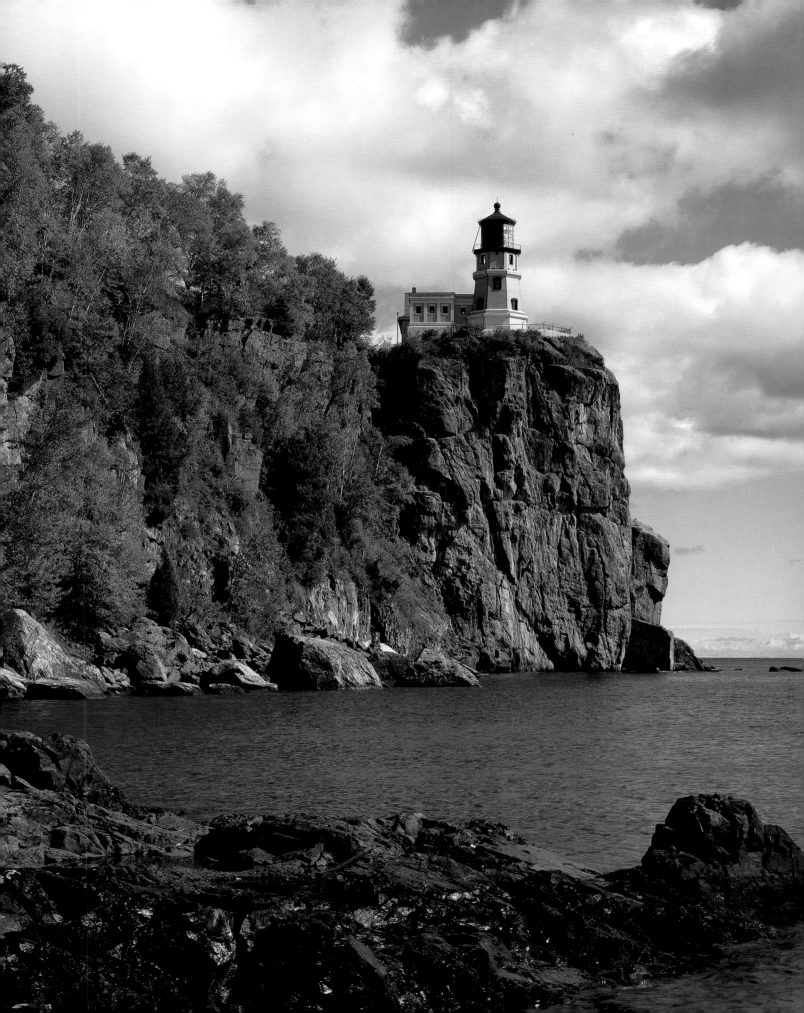

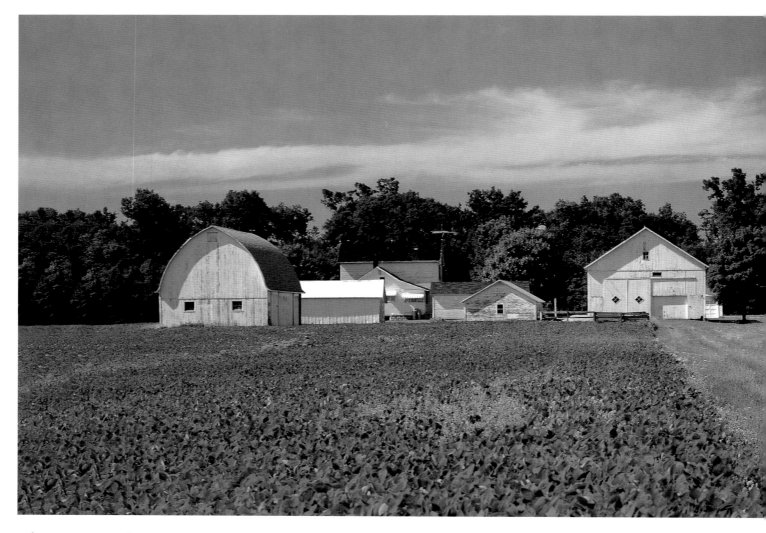

Above: Barns and outbuildings frame the fields of a rural Ohio farm near Toledo, which has featured an outdoor farmer's market since 1832.

Previous pages: *Sleeping Bear Dunes National Lakeshore, Michigan. The area's name comes from an Indian legend about a mother bear waiting for her cubs to swim across the lake.*

The elusive mountain lion has been sighted in every one of the Heartland's states with the exception of Indiana. Although hunted to near extinction by settlers, the big cats still inhabit remote forests in the Heartland, feeding on its deer, elk, and smaller prey. Before the arrival of white settlers, the grizzly bear ranged as far as the Mississippi River, but it has been replaced in the Heartland by the less aggressive and smaller black bear.

If many species of the Heartland's wildlife were decimated by settlers, some types actually increased with settlement. These included the prairie chicken and grouse, as well as other seed-eating birds like quail and doves, which coexisted well with grazing livestock. By the middle of the nineteenth century, conservation groups began a campaign to educate the public. National parks were closed to hunting, and states began issuing hunting licenses in an attempt to curb wholesale killing of wildlife. America's 1916 Migratory Bird Treaty with Canada protected much of the bird population that travels annually through the Heartland.

When the federal government took over control of predators, it destroyed the Plains wolf population in 1918–20, then went after the coyote, jackrabbit, and prairie dog. Called "barking squirrels" by Lewis and Clark when they encountered them in South Dakota in 1804, prairie

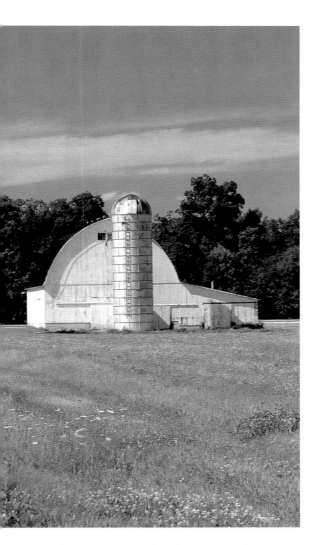

some cases, new species were introduced, like varieties of the partridge. The dustbowl years of the 1930s in the Heartland led to a greater appreciation of water and soil conservation, and with it, wildlife habitat preservation. The 1934 federal Duck Stamp Act generated money for waterfowl protection. That same year, the Taylor Grazing Act ended the practice of homesteading in the Heartland and elsewhere in America. This federal law ultimately led to creation of the Bureau of Land Management, whose mission is wildlife conservation. Establishment of the Fish and Wildlife Service in 1940 meant a more concentrated federal focus on the Heartland's nonhuman life.

Hunting has been a longstanding tradition in the Heartland, and sports hunters have helped finance wildlife conservation through licensing and other forms of hunting control. Contamination of wildlife environments through pesticides and heavy metals, however, continued to be an unresolved issue by mid-century in the Heartland.

Below: *Wild turkeys look for food at Konza Prairie Research Natural Area in Kansas. Owned by the Nature Conservancy and managed by Kansas State University, the preserve provides researchers the opportunity to study tall-grass prairie environments.*

dogs were actually a boon to cattle ranchers in the Heartland because they fed on invasive shrub seedlings and tumbleweed sprouts. Like the jackrabbit, prairie dogs also provided food for the Heartland's coyotes, bobcats, and other predators. When these "range weeds" began to increase, though, they were almost annihilated. Now prairie dogs are valued residents in some Heartland states.

The tall-grass prairie portions of the Heartland lost much of the indigenous wildlife through hunting and farming. Changes such as the replacement of the drafthorse by the tractor meant fewer fields were needed for feed grain. This change allowed wildlife to return. In

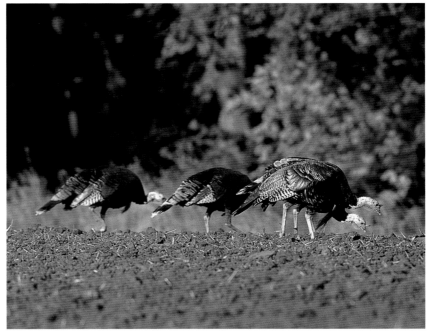

Below: Viewed from its rooftops, Fountain City in Trempealeau County, Wisconsin, is quiet at sunset. The Fugina House on South Main Street, built in 1916 by Martin Fugina, a prominent local citizen, is listed on the National Register of Historic Places.

Only to the uninitiated could the Heartland seem boring or unexceptional because of its flatness. Heartland states abound with natural wonders. Wyandotte Caves in Indiana contain the world's largest stalagmite, rising 35 feet from the cave's floor. Miners speculate that the lignite fields of Amidon, North Dakota, have been burning since the days of the Indians. Michigan's Kitch-iti-kipi, or Big Spring, near Manistique, was called the Mirror of Heaven by Native Americans and is the state's largest spring. Multicolored sandstone and minerals created the images on Pictured Rocks National Lakeshore along Lake Superior.

The Chippewa legend behind the name of Sleeping Bear Dunes National Lakeshore near Empire, Michigan, tells how they were named for a mother bear who swam across Lake Michigan from Wisconsin to escape a forest fire. She fell asleep waiting for her cubs, who did not survive the journey. Tahquamenon Falls near Newberry, Michigan, is the largest waterfall east of the Mississippi, dropping 50 feet and spanning 200 feet. The Cave of the Mounds near Horeb, Wisconsin, was discovered by accident in 1939, when limestone workers broke through into the cavern, which is loaded with stalactites and stalagmites.

Native American legend claims a giant serpent that formed the Wisconsin River arrived at Wisconsin Dells and stuck his head into a crevice in the sandstone ridge there to create its narrow passageway. Magnificent, 120-foot High Falls on the Minnesota-Canadian border forced the early explorers to take the nine-mile trail known as the Grand Portage in order to continue their journeys. In Castalia, Ohio, divers have never reached the bottom of the Blue Hole. This giant spring bubbles up from the limestone depths, producing 7,519 gallons of water per minute. The Northwest Angle in Minnesota was created accidentally by mapmakers who thought the source of the Mississippi River was there. When it turned up farther south, this tiny jut of land, surrounded by Manitoba, Canada, and the Lake of the Woods, was isolated from the rest of Minnesota and now has the distinction of being the northernmost point of the lower forty-eight states.

While the Heartland encompasses too large an area to rely exclusively on generalizations about its history, certain patterns do emerge. Many of the region's states served as gateways to pioneers traveling farther west. As Eugene H. Rosebloom and Francis P. Weisenberger point out in their history of Ohio, the state is a political rather than a geographical unit. Three of the states it borders—Kentucky, Pennsylvania, and West Virginia (part of Virginia until the Civil War)—were already well established before Ohio had a chance to define its boundaries. The same pattern is visible in the very regular borders of many of the other Heartland states that evolved through territorial status before achieving statehood.

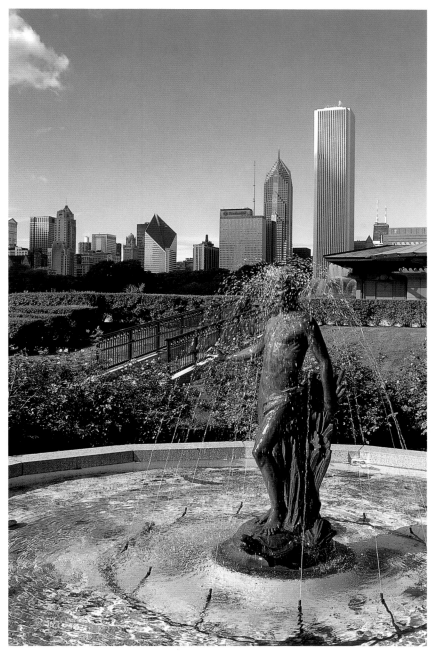

Closest of the Heartland states to the densely populated Eastern Seaboard, Ohio experienced successive waves of migration. Of those who settled first in Ohio, many moved on in time to Iowa and Kansas, then farther west. The lack of a geographic barrier like the Rocky Mountains made Heartland states such as Ohio, Kansas, Iowa, Nebraska, and Missouri eminently accessible to the

Above: Chicago's modern skyscrapers rim the horizon behind this Grant Park fountain statue. The park is one of many planned by Chicago architect and city planner Daniel Burnham in 1909.

earliest population centers on the East Coast. Accessibility led to faster economic and cultural development.

The Heartland states developed at a time in the nation's history when rivers provided the major means of transportation, and the region's dry climate makes rivers that much more important to its citizens. The significance of the Great Lakes and the Mississippi River to the Heartland has already been mentioned. Many other Heartland rivers were equally important to the region's settlement and growth. Wending its way toward the Mississippi as the southern border of Ohio, the Ohio River became a major conduit first for settlers, then goods. Known as the "Beautiful" by the Iroquois and "La Belle Rivière" by the French explorers who followed, it reached its heyday during the golden age of steamboat travel.

At 2,464 miles, the Missouri River is the longest waterway in North America. It borders or cuts through five different Heartland states before emptying into the Mississippi as its major tributary. Traveling through dry country, the "Big Muddy" carries more sediment than any other Mississippi tributary. It also carried Meriwether Lewis and William Clark, whose explorations helped not

Below: Detroit's tall buildings line up along the St. Clair River at sunrise. The St. Clair is an international waterway that separates Detroit from Ontario, Canada.

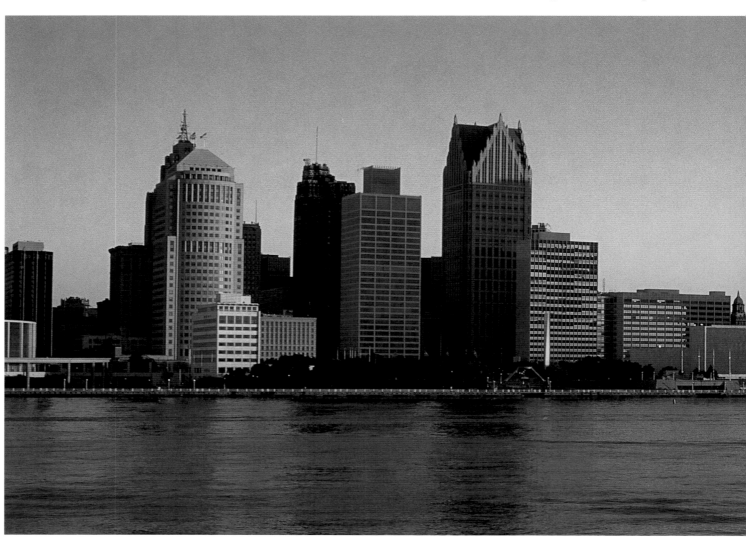

only to open up the entire region but make it the bridge between the United States' East and West. No longer entirely navigable because of dams, the Missouri now provides irrigation and recreation to many Heartland states. The Platte River, whose north and south forks join in Nebraska, has been described as "a thousand miles long and six inches deep." In fact, it varies from a mere trickle to a torrent, depending on rainfall.

Here you will learn about the Native American culture that was the Heartland's earliest. You will follow the explorations of the early Spanish, French, British, and colonial pathfinders. You will

be saddened by the violent warring between native inhabitants and settlers that decimated the native population. You will read with pride the history of the Heartland's role in the American Revolution, then discover how the great, unsettled Heartland frontier developed from a series of territories into states during the nineteenth century. You will see how farmers, industrial workers, miners, and entrepreneurs built the Heartland into a thriving economy. You will follow the paths of growth the Heartland has taken through the first half of the twentieth century. Here in the Heartland you will find the heart of America.

Overleaf: *Corn ripens on the stalk in Bureau County, Illinois. Despite its spelling, the county was named for a French Creole trader, Pierre de Beuro, who built a trading post on the Illinois River in the eighteenth century.*

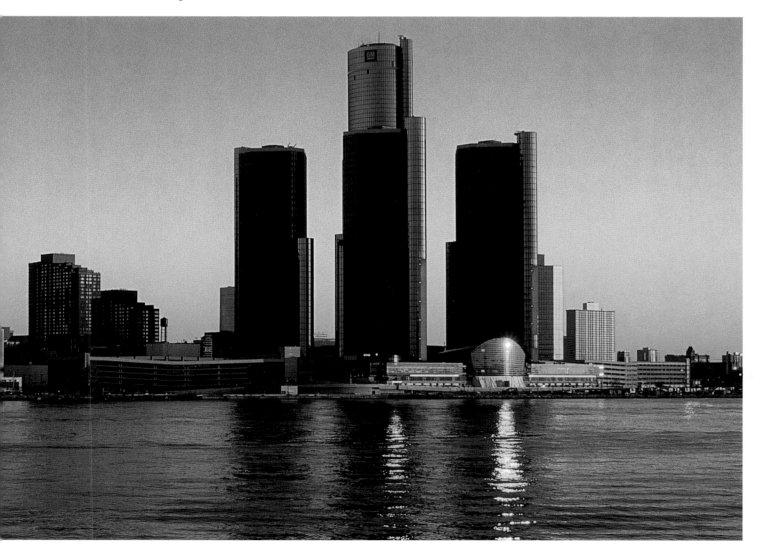

THE
FIRST INHABITANTS

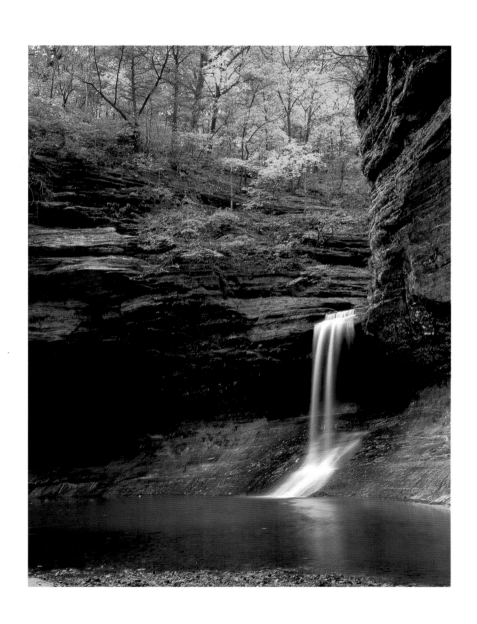

Previous page: This waterfall is one of many that cascade down through the rocky canyons of Matthiessen State Park in north-eastern Illinois. Humans have inhabited the area since at least 8000 BC, including Indians of the Woodland, Hopewell, and Mississippian cultures. Marquette and Jolliet came through this area in 1673.

There can be no denying that the choice of the name "Heartland" is intended to convey something of the feeling that modern residents of and visitors to the United States have for this vast region—an image of warmth and hospitality. But there was nothing warm or hospitable about the region in 15,000 BC. At that time, a thick glacier, up to two miles deep, covered much of the northern part of the region—from South Dakota in the west, over across Iowa, Minnesota, and Wisconsin and Michigan, into Illinois and northern Indiana, and into western Ohio. The other states—Missouri, Kansas, Nebraska—were not covered by the glacier, but their climate and total natural environment were those of a subarctic zone.

This period, the last of the four major glaciation stages of the Pleistocene Ice Age, is known as the Wisconsin Stage because it was in this state that it was first studied in great detail. To this day Wisconsin's terrain has many of the most spectacular witnesses to this glaciation (although, in fact, a sizeable area in southwestern Wisconsin was bypassed by the glacier), but all these states have some remains for those knowledgeable enough to recognize them: drumlins ("streamlined" hills); moraines (mounds and ridges of rocky debris); and striated (scratched) rocks. The impact on the southern tier was also severe but in less visible ways: the rich loess soil of Kansas, for instance, was formed by the dust of rocks that were ground up by the retreating glaciers to the north.

The Wisconsin glacier was fast receding by about 12,000 BC, and shortly after this—at least by 10,000 BC—the first human beings are believed to have begun moving into this region. Possibly they had been in the southern tier several thousand years earlier. Whether they all came from the west and southwest or some came down from the north is not known for sure. These first people would have found a land quite different from what we know today, although some of the major geographic features would have been in place. The Great Lakes, with different shorelines than today, had been left behind by the retreating glacier. The great rivers—from the Mississippi to the Missouri, from the Platte and Arkansas to the Ohio—here and there would have followed other riverbeds, but they would be close to where they are today. The vast plains and mountains would also be much as they appear today. Not much else about the Heartland, however, would be recognizable to us. For several thousand years after the retreat of the glacier, the region's climate would have still been cold and damp, the land and its vegetation less hospitable—much like the tundra of the subarctic.

Little is known about these first humans in the Heartland except that they were the descendants of the first humans to move into North America across the land bridge (called Beringia) between Siberia and Alaska. Known today as Paleo-Indians ("old Indians"), they engaged largely in hunting down the large game—mammoths, mastodons, giant western bison, muskoxen, and caribou. (The chalk beds in Gove and Trego counties of Kansas contain rich fossil remains of these prehistoric animals, while one of the prize exhibits held by the Geology Museum of the University of Wisconsin at Madison is a mastodon skeleton found at Richland Center, Wisconsin.) These Paleo-Indians used flint spearheads and arrowheads

described as fluted-points, in reference to the groove, or "flute," chipped into these stones. Such weapons are assigned to two different phases, the Clovis culture and the Folsom culture, both named after the first sites in New Mexico where these tools were originally found. These phases were succeeded by the so-called Plano culture, Indians who made unfluted projectile points. It is assumed that all these Paleo-Indians hunted down mammoths and mastodons one at a time, but they learned to kill the bison by driving herds over a cliff into a boggy wetland or trapping them in a small canyon, where the Indians would proceed to kill them with their spears or darts. Remains of these Paleo-Indians have been found all across the Heartland, but two special sites are those at Big Eddy Falls on the Wolf River in Wisconsin and another at Gainey, Michigan.

Naturally, given the sheer geographical extent and environmental variety of

Below: *This painting on a buffalo hide is attributed to Wacochachi, a member of the Sauk and Fox tribes that originally inhabited eastern Michigan and Wisconsin. Hide paintings recorded both tribal and individual's histories.*

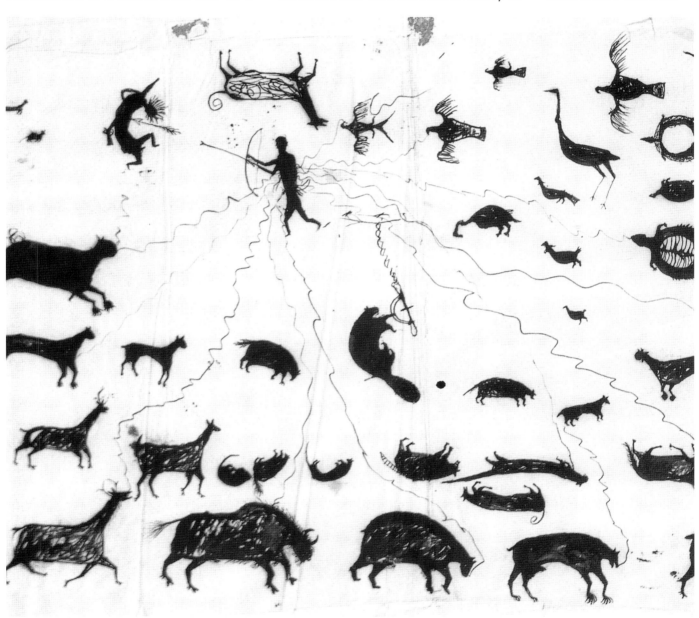

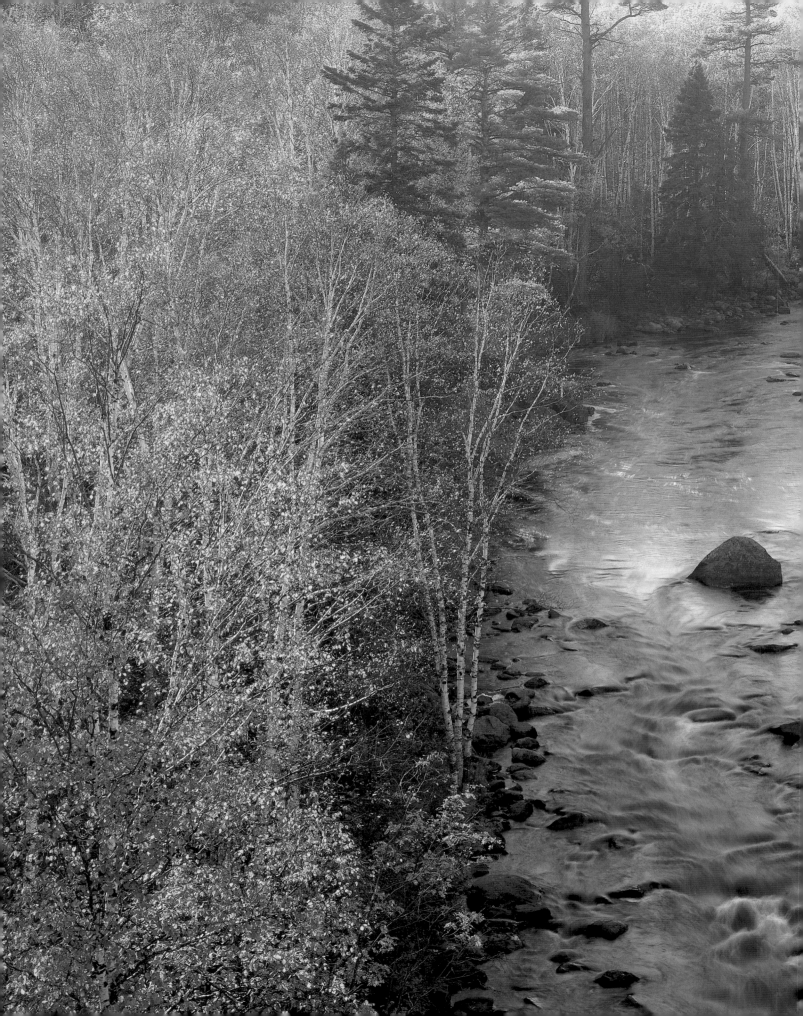

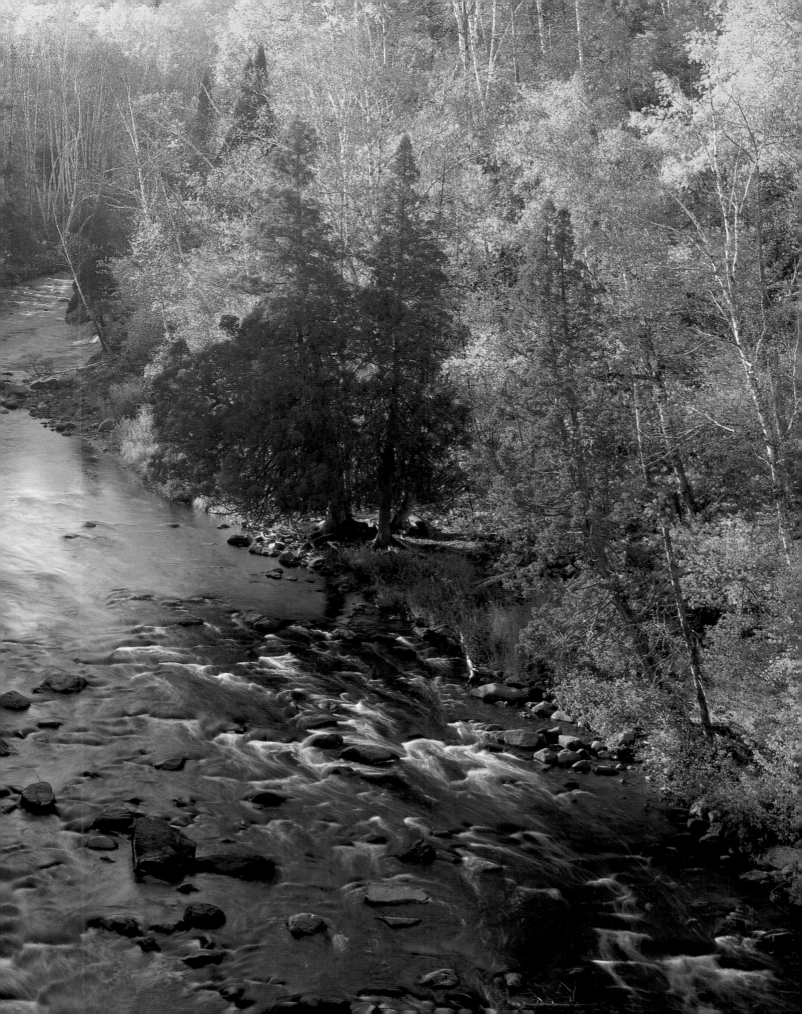

Previous pages: *The Baptism River flows though the Superior National Forest in northeastern Minnesota before entering Lake Superior. The region is known to have been inhabited by Paleo-Indians at least by 8000 BC. By the late 1700s, the Ojibwa had moved into this area.*

the Heartland, not all its early inhabitants proceeded on one simultaneous course. But in general, this Paleo-Indian lifestyle lasted until about 7500 BC, when there was a warming of the climate across much of North America with a resultant change of vegetation and wildlife. In general, more diverse and familiar modern species moved into the Heartland region. New deciduous trees began to grow and form forests that provided cover for a variety of animals: white-tailed deer, mule deer, pronghorns, coyotes, bears, opossum, raccoon, badgers, and rabbits. Lakes, rivers, and streams supported not only many fish and mussels but also beavers, ducks, and geese. The great plains that began to flourish were taken over by the various grasses—bluestem, buffalo grass—and small game such as prairie dogs, pheasants, quail, and grouse.

The culture of the Indians that developed in response to this new ecology is designated Archaic. Where the Paleo-Indians seem to have led a fairly transient existence, moving after game throughout much of the year, these Archaic Period Indians began to establish a more settled existence. This was at least in part dictated by their increasing dependence on a vegetable diet, which meant that they settled down to gather natural vegetation such as seeds, herbs, berries, and nuts. Eventually they began to tend plants like marsh elder and goosefoot, an early form of agriculture. Mussels and fish from the many rivers and lakes also played a major part in their diet, as did wild game of many species—deer in particular, but also other small mammals. Where bison were still plentiful, the Archaic Indians continued to hunt them.

The Archaic Indians had a more specialized toolkit than their predecessors. They had grinding utensils to prepare some of their food. They made sharp-edged stone knives and scrapers for cutting away animal skins and preparing meat. They used atlatls, or spearthrowers, to help them throw their spears farther and with greater force. They made stone adzes, or sharp cutting tools used for stripping, planing, or gouging wood and, some archaeologists suggest, for making dugout canoes. They had bone awls and bone needles, suggesting they worked leather and made baskets. And by 5000 BC, some of these Archaic Indians were even making more permanent shelters from trees, although most Archaic Indians probably moved about during the seasons to take advantage of food sources.

The Archaic Indians had also moved well beyond a lifestyle geared only to survival. Some would take care to bury their dead in what can only be called cemeteries. The care with which the bodies were prepared strongly suggests both a ritual burial and some sense of an afterlife. Red ocher was sometimes dusted over bodies, a practice that would be observed by many indigenous people throughout North America well into historical times. Even their domesticated dogs were sometimes buried with care. And at the Koster site in Illinois, hematite beads testify not only to a sense of aesthetic adornment but also to some practice in trade, since the closest source for such hematite would be in northern Michigan. Trading networks began to emerge throughout the region, as evidenced by the fact that copper, galena (a lead ore), marine shells, and exotic stone artifacts from the period have been found in widespread sites.

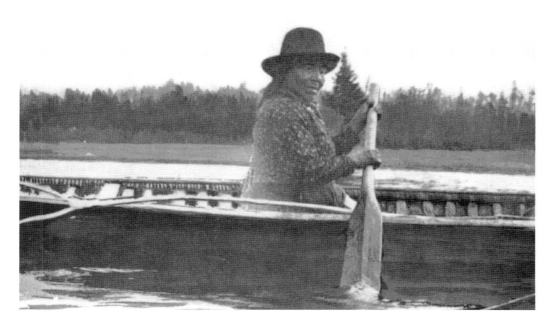

Left: The Native Americans of the Great Lakes region began harvesting wild rice thousands of years ago. This Indian, photographed early in the twentieth century, was continuing the tradition, one that is practiced to this day.

The Koster site, located some 70 miles north of St. Louis, was inhabited almost continuously from at least 7500 BC to AD 1200 and has provided some of the most important evidence of the way Archaic Indians lived. Other important Archaic sites include Modoc Rockshelter and Carrier Mills in Illinois, and Graham Cave and the Rodgers Shelter in Missouri.

Needless to say, due to the different climates and environments that stretched from the chilly lake country in the north to the hot grasslands of the south, the lifestyles of the Heartland's Archaic Indians varied considerably. But sometime about 1500–1000 BC, certain developments began to emerge across much of the Heartland, signaling the period known as the Woodland, or Eastern Woodlands, Culture. One of the most significant of the new elements was the making of clay pottery. Pottery not only allowed for the carrying and storing of liquids and solids of all kinds but also for cooking food over an open fire. Another change was the shift to the use of the bow and arrow, which gave hunters greater advantage against their prey.

Probably the most important development was that the Woodland people of the Heartland began to practice agriculture, producing crops on a relatively large scale. They began with sunflowers, squash, and pumpkins, then added beans and tobacco, and by about AD 1000 they grew maize; several of these crops may have been developed independently by the Heartland Indians, but tobacco and maize were definitely introduced there from Middle America. This is not to say that these people abandoned their hunting and food-gathering—where bison were plentiful, for instance, they still relied on them. But the practice of agriculture impacted their lives in ways that went far beyond diet. The regularity and storage of crops led to increased populations, which in turn led to more occupational distinctions, economic classes, and social ranks. The labor required to prepare and work the fields also led to a stronger sense of territoriality, which eventually encouraged warfare among villages apparently competing for land and resources.

It was during this Woodland phase that a particular practice began to

Overleaf: Horseshoe Lake, located in Horseshoe State Park in Illinois along the Mississippi River, has yielded many archaeological finds. Some go back to the Archaic Period that commenced about 7500 BC, but a mound in the park is associated with the Mississippian culture that thrived in Cahokia, across the river in Missouri, from about AD 1000 to 1500.

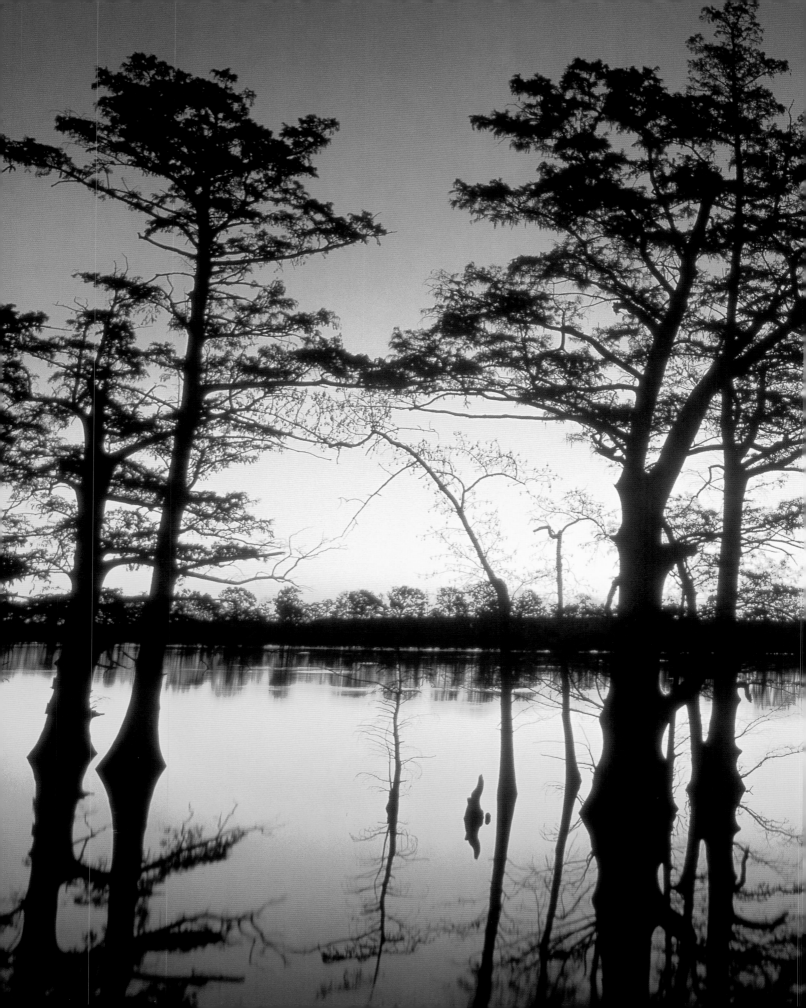

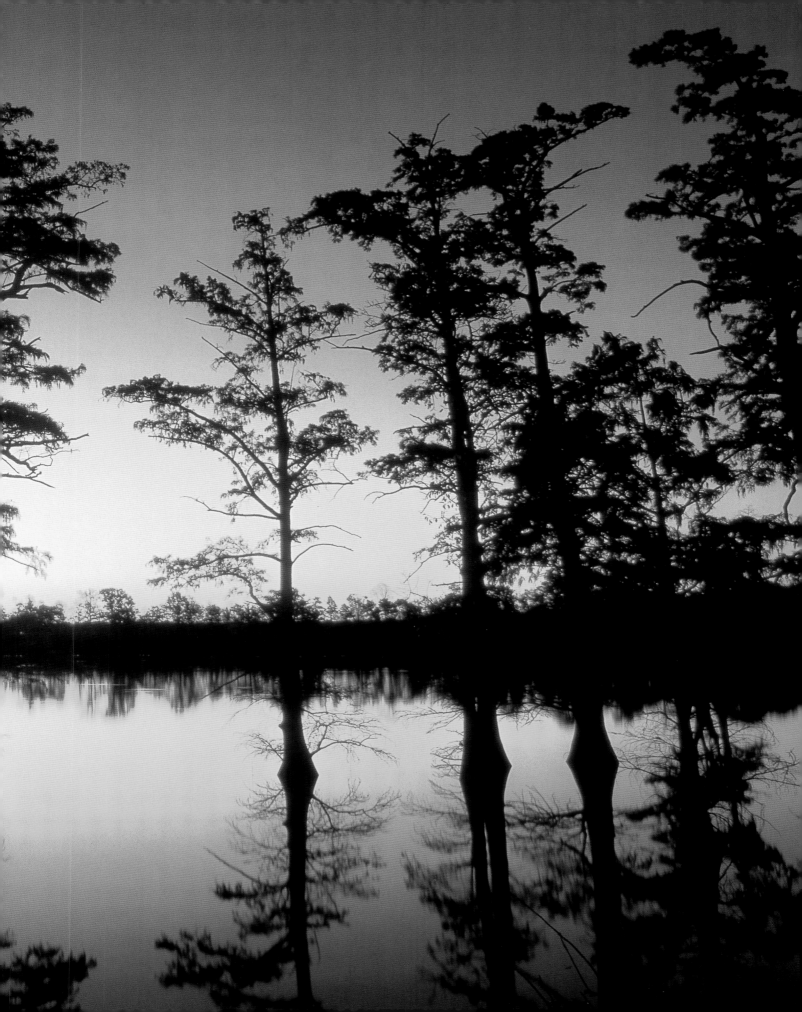

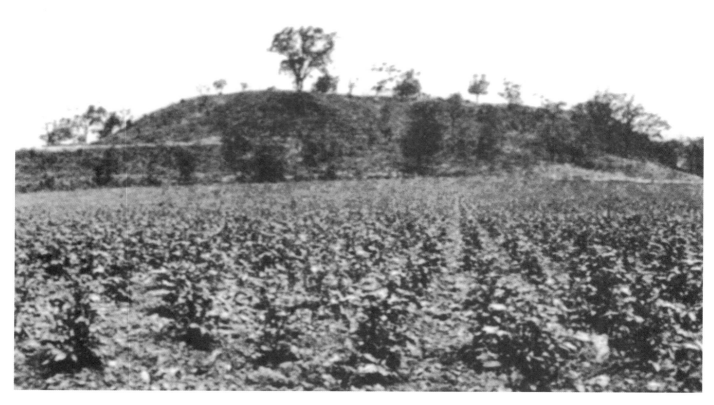

Above: Monks Mound is the largest of the Mississippian Culture's mounds and part of the great urban complex at Cahokia, east of St. Louis, Missouri. One hundred feet high and covering fourteen acres, it served some ceremonial purpose; both its form and function may have been influenced by Mexican Indians.

spread throughout much of the Heartland: the construction of large mounds. The exact origins of this practice, and the relationships among the various peoples who built them, are questions that cannot be answered for certain. It is believed, however, that these mound-building peoples of North America may well have been influenced by the great ceremonial mounds of Mayan civilization. In any case, the mounds of the Heartland can be characterized as serving three functions: some were for burials; some, known as effigy mounds, were in the shape of animals and served some ritual or religious function; and some were effectively bases for temples or lodges. Although they continued to hunt and gather food, the mound-builders also practiced agriculture. They raised tobacco, which they smoked in finely carved stone pipes.

They also engaged in trade with distant peoples, for in their mounds are found mica from New England, marine shells from the Gulf of Mexico, obsidian from the Rocky Mountains, and copper from the Lake Superior region.

The first of these mound-building peoples are known as the Adena Culture (c. 500 BC–AD 100), named after an estate near Chillicothe, Ohio, where the first of their mounds was identified. Inside the mounds socially important individuals were buried in elaborately prepared log tombs (the mass of people were cremated). In addition to burial mounds, the Adena people built some mounds in the shape of animals, such as those near McGregor, Indiana; they also built earthwork circles, such as that at the Dominion site, in Columbus, Ohio. The Adena people may also have built the Great Serpent Mound in

Hillsboro, Ohio; in the shape of a serpent swallowing an oval object that is believed to represent the sun, at nearly one-quarter of a mile long, the Great Serpent Mound is the largest animal-shaped earthwork in North America. The Adena Culture, although centered in southern Ohio, was found in Indiana as well as in Kentucky, West Virginia, and western Pennsylvania. Their way of life was characteristic of an Eastern Woodlands people, but their culture emphasized such elements as fine carved siltstone pipes that were used for smoking tobacco in ceremonies.

About 100 BC, a new phase emerged: the so-called Hopewell Culture, again named after a site in Ohio; very likely it evolved from the Adena culture. The Hopewell Indians were concentrated in the valleys of the Ohio, Illinois, and central Mississippi rivers, but eventually seem to have formed at least trading relations with tribes far from that region. Their mounds were large and conical or dome-shaped and were used primarily for burials. Besides such mounds, the Hopewell Indians often built earth walls that enclosed large rectangular, oval, octagonal, or other geo-

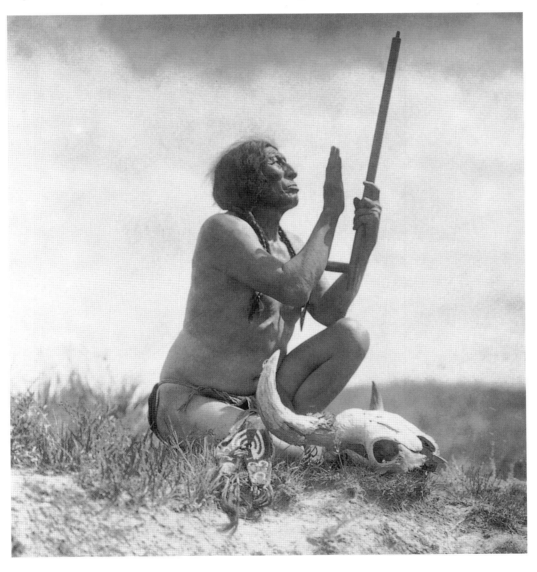

Left: This photograph of the Sioux Slow Bull engaged in a religious ritual was taken by Edward Curtis about 1900, by which time the Sioux had moved over into the Great Plains. But before other tribes pushed them out, the Sioux lived in the upper Mississippi region, and such rituals had not changed over the centuries.

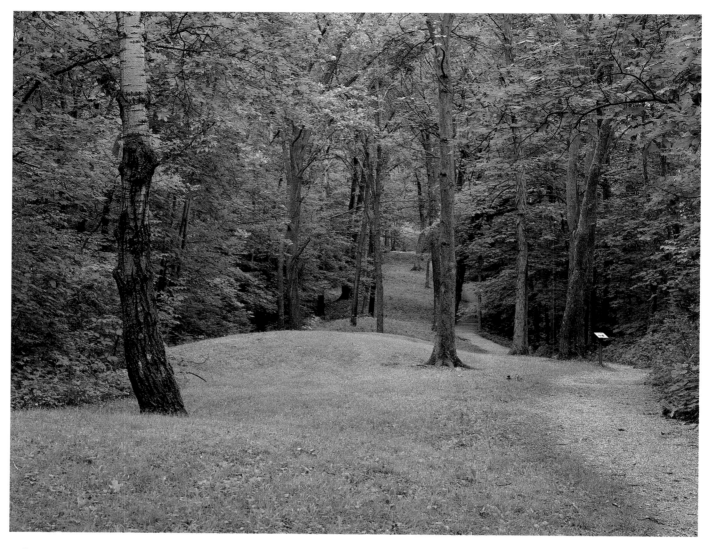

Above: *At Effigy Mounds National Monument, near Marquette, Iowa, is a complex of earthen mounds shaped like animals. These are considered an offshoot of the Hopewell and Mississippian cultures' mounds, thus dating anytime from about 100 BC to AD 1500.*

metrically shaped areas; these earthworks marked off ceremonial centers and social gathering places. It is also claimed by some archaeologists that some of these mounds and earthworks were designed to form solar and lunar sightlines for calendrical observations. Their largest known ceremonial center, the Newark Earthworks (in Newark, Ohio) is a vast complex with numerous mounds and earthworks; it is located close to Flint Ridge where the Hopewell Indians obtained their favored rainbow-colored flint. Because they buried so many fine objects with their dead— objects made of clay, wood, stone, mica,

copper, animal claws and teeth—the Hopewell people are regarded as among the most skilled and artistic craftsmen of pre-Columbian North America.

About the year AD 700, a new mound-building culture appeared, known as the Mississippian Culture because its practitioners lived mainly along that river and its branches. In the south it extended from Arkansas to Florida, and in the Heartland it extended into Illinois, Wisconsin, and Minnesota. The Mississippian people were agriculturists, growing squash, beans, and corn, and were skilled hunters with the bow and arrow, but they are best distinguished by the large earthen mounds with

flattened tops on which they built wooden temples and the meetinghouses and residences of their great chiefs and priests. They decorated their temples with carvings and paintings. Some of these Mississippian people constructed large circles of cedar poles that were used for astronomical observations. They were skilled craftspeople, especially noted for their fine pottery. Falcons, jaguars, and other animals were used as symbols in their decorations, suggesting that these Indians had close relations with Indians in Mexico. A variant of the Hopewell and Mississippian cultures' mounds are known as the Effigy Mounds, earthworks in the shape of animals. Examples of these are found at Effigy Mounds National Monument near Marquette, Iowa, and at Wyalusing State Park in Wisconsin.

But the most impressive of all the mounds in the Heartland is the Mississippian-culture Monks Mound at Cahokia Mounds, Illinois, just east of St. Louis. The largest prehistoric earthwork in North America, Monks Mound covers 14 acres and rises to a height of 100 feet. Its name dates from the 1700s, when it was claimed that French priests built a chapel on the site; in any case, the French called the site Cahokia after the Indians who inhabited the area when the French arrived in the late 1600s. Cahokia resembled a city more than any other site in pre-Columbian North America; it covered some six square miles and had a population of 20,000 living in rows of houses. Its influence spread far beyond its immediate neighborhood until, it appears, this influence came to be resented by others in this region, many of whom did not adopt the Mississippian culture. Some did but developed another variant known as the Oneota culture, distinguished by its ceramic jars, triangular arrowheads, and various stone scrapers. One of their centers was at Red Wing, Minnesota, along the Mississippi; later they moved downriver to LaCrosse, Wisconsin. Eventually they moved west, and when the French first encountered them, they called them the "Ioway," thus giving that name to the territory.

The Mississippian Culture was only one of several cultures flourishing throughout the Heartland when Europeans first began to penetrate there. From about AD 1000 most of these people were speaking varieties of the Algonquian, Iroquoian, and Siouan languages, and it is assumed

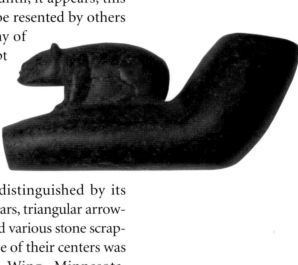

Left and above: These pipes, carved to represent animals and a human being, were made by the Adena Culture Indians who flourished in the Heartland about 500 BC to AD 100. Attached to wooden pipe stems, they were used for smoking tobacco in ceremonies that had both spiritual and communal significance.

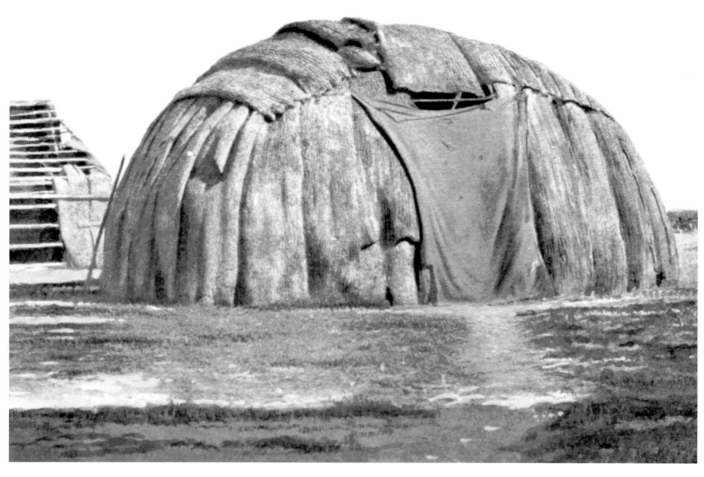

Above: This wigwam—made of the bark of ash trees over a pole frame, with a blanket over the door—was typical of the dwellings of the Ojibwa. Originally concentrated in the southern Canadian region along Lake Superior, by the late 1700s they were moving down into the upper Mississippi Valley.

their relationships extend far back in time. The first Europeans in the region recorded tribe names, but these were frequently based on misunderstandings and mispronunciations. Sometimes, too, Europeans would adopt the derogatory name applied by a tribe's enemies—for there was hostility among the region's peoples. This sometimes led to one tribe's being forced to move out of a territory. Many of the historical tribes had been migrating around the Heartland for some time, so it is hard to pin down exactly which tribes were "native" to a specific place at any

given time. However, from the early 1600s, Europeans began to name places for local tribes; some of these names eventually became state names.

By the seventeenth century the locations of many tribes were documented. The Ponca and Assiniboine were in what is now Ohio; the Illinois (which included the bands known as Cahokia, Kaskaskia, Michigamea, Moingwena, Peoria, and Tamaroa) lived in Indiana along with the Omaha and Osage; the Miami lived in Illinois; the Ottawa, Potawatomi, Sauk, and Mascouten were living in Michigan; the Fox, Kickapoo,

Menominee, Winnebago, and some of the Dakota and Lakota Sioux lived in Wisconsin; the Arapaho, Cheyenne, Ioway, Ojibwa and some of the Lakota and Kanota Sioux lived in Minnesota; Ioway and Oto lived in Iowa; the Missouria and Oto lived in Missouri, the Kansa and Wichita lived in Kansas; the Pawnee lived in Nebraska; the Arikara lived in South Dakota; and the Arapaho, Hidatsa, Mandan, and Ojibwa lived in North Dakota.

During the first century of contact, many of these people were on the move. As their tribal names suggest, some would later become associated with quite different regions. Some lived as seminomadic seasonal hunters, but others had established villages. When the Europeans met them, they were subsisting on a mixture of agriculture and hunting and fishing. Many of these peoples had their own specialized arts and crafts—making handsome leather clothing, using feathers for decoration and ceremonies, and constructing superb birchbark canoes. All had religious beliefs and rituals and conducted secular ceremonies and celebrations. It was a relatively good life, but it was all about to change.

Overleaf: Pictured Rocks National Lakeshore, Michigan. Archaic and Woodland Indians first hunted and fished here, as did the Ojibwa later.

Below: Henry Schoolcraft discovering (1832) the source of the Mississippi River, in northern Minnesota, guided by Native Americans.

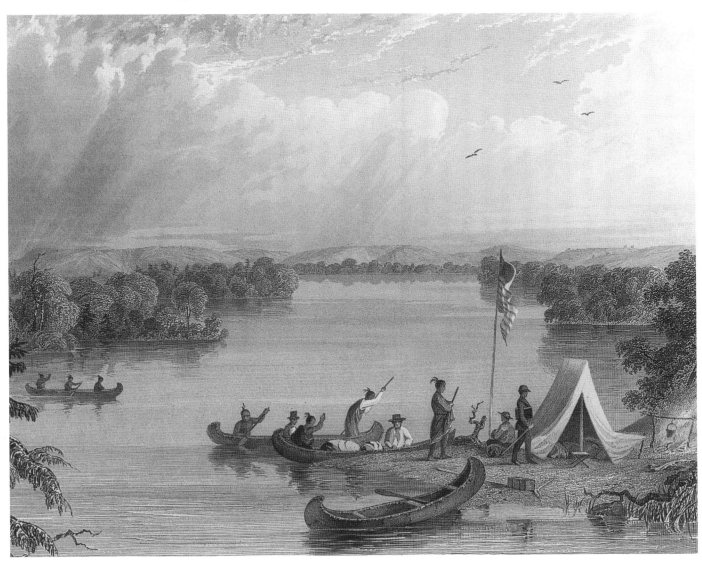

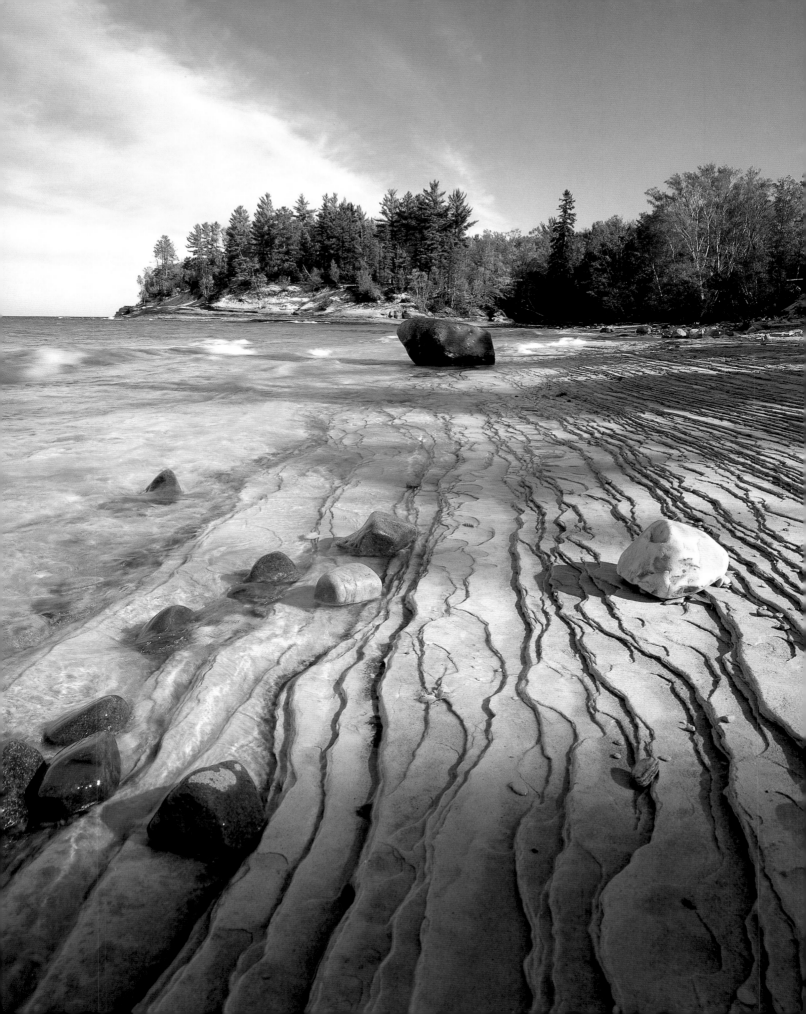

EXPLORERS
AND
EARLY SETTLERS

Unlike the original thirteen states, those in what we are calling "the Heartland" began their existence as parts of larger territories, some claimed by the original thirteen when they were still British colonies, some by powers other than Great Britain. Most of the Northwest Territory, for example, a name originally given to the disputed region east of the Mississippi River and north of the Ohio River, ultimately became Wisconsin, Illinois, Michigan, Indiana, and Ohio. What would become Minnesota, North and South Dakota, Missouri, Nebraska, and Kansas changed hands several times before becoming part of the United States.

Spain, of course, led the way in discoveries of all the Americas, although less so in the Heartland. The explorer Francisco Vasquez de Coronado traveled as far as Kansas during his ventures into the Southwest and the Great Plains in 1540–2. The Spanish claimed the entire region west of the Mississippi that later became known as the Louisiana Purchase, but they made no attempt to settle beyond the Southwest.

French explorers ranged across northern sections of the Heartland as part of their excursions through New France, the name for Canada in those early years. Samuel de Champlain charted Michigan's Lake Huron during the period 1603–15, when he traveled through the eastern Great Lakes. It was twenty-year-old Etienne Brulé, however, sent by the great explorer to live with the Huron, who led him to Lake Huron in 1612. Brulé was probably the first European to see all the Great Lakes except Lake Michigan, although he is credited with exploring Michigan's Upper Peninsula about 1620.

In 1634 Jean Nicolet, another Champlain delegate, crossed Lake Huron to the Mackinac Strait between upper and lower Michigan, and went as far as Green Bay, Wisconsin. A statue there commemorates his visit—again, probably the first by a European. During their 1654–60 travels, Pierre Radisson and Médard Chouart, Sieur des Groseilliers, reached the western shores of Lake Superior—now Minnesota—while exploring the upper Mississippi River and parts of Wisconsin. Travelling with them was the Jesuit René Menard, who established missions at Keweenaw Bay, Michigan, and Ashland, Wisconsin.

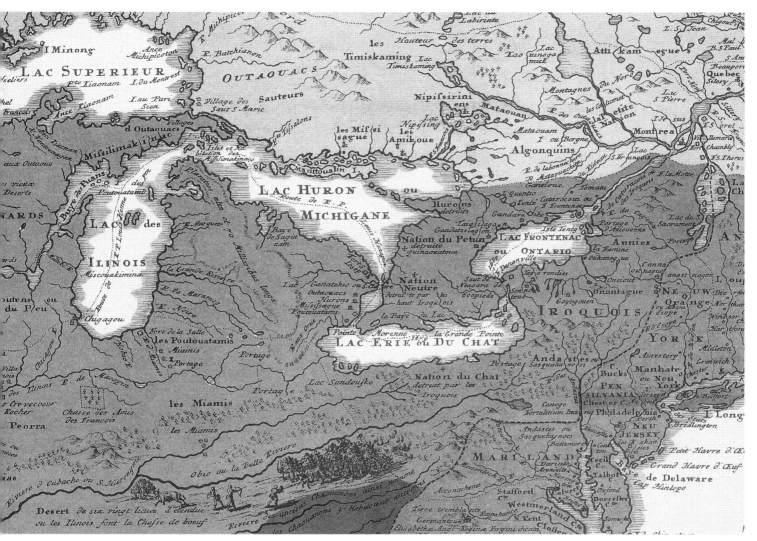

Another Jesuit, Jean Claude Allouez, voyaged to Lake Superior in 1665 and founded several Wisconsin missions, including Chequamegon Bay and De Pere. His explorations contributed to an important Jesuit map of Lake Superior. Jesuit Jacques Marquette, serving as a missionary to the Ottawa, founded Michigan's first permanent settlement at Sault Sainte Marie in 1668. By the end of the seventeenth century, the French had explored and mapped much of Michigan.

One of the greatest of the French explorers, Robert Cavalier, better known as Sieur de La Salle, contributed greatly to the opening up of Michigan and other sections of the Heartland. In 1669, he began a voyage on the upper Ohio River. He visited Lake Ontario and the other Great Lakes, becoming the first European to enter Ohio in 1670. He traveled in the Griffon, a sailing ship built by one of his lieutenants, Henri de Tonti. It was the first such boat to enter the Great Lakes.

France based its claims to the region on La Salle's visit, leading to later disputes with the British, who made similar claims. La Salle reached the head of Lake Michigan in 1679. From there, he crossed Illinois to Missouri on the Illinois River before voyaging down the Mississippi River to the Gulf of Mexico.

Overleaf: Nelson's Point at Peninsula State Park, which is located on Lake Michigan outside Green Bay, Wisconsin, once inhabited by the Potawatomi. The French explorer Jean Nicolet was the first European known to land in this area (1634); he was followed later by French missionaries and fur traders.

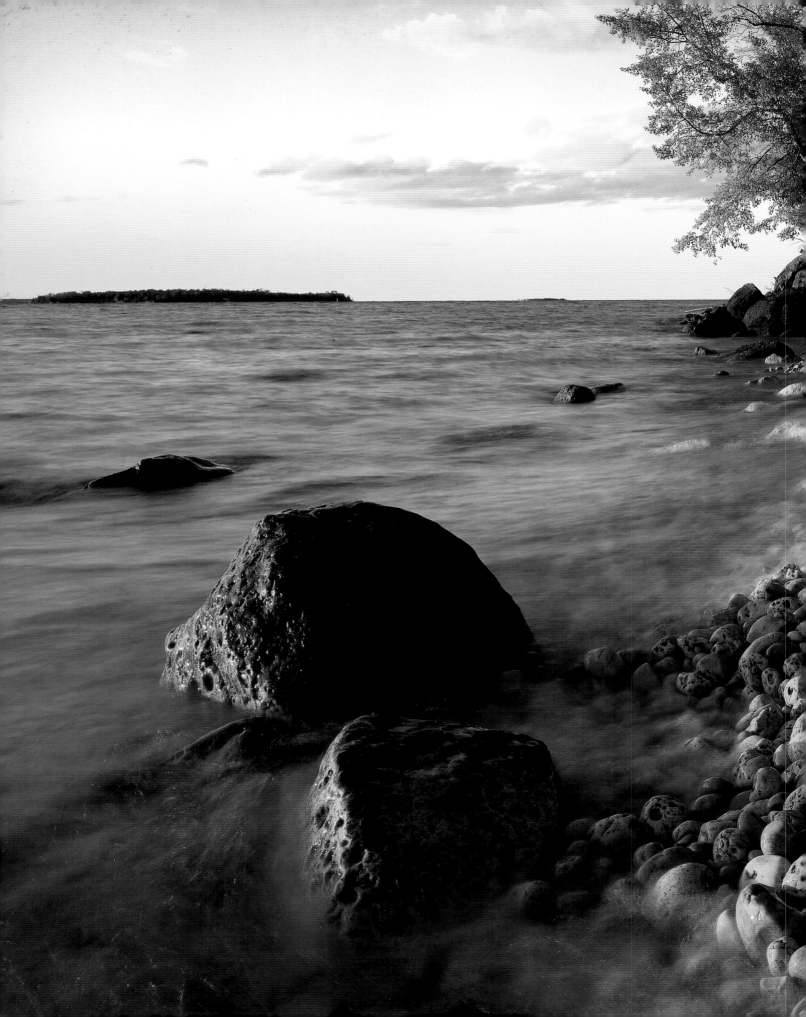

During his 1679–80 excursions, he became the first European to arrive in Indiana, and claimed for France the territory west of the Mississippi that included Kansas and Nebraska, as well as parts of North and South Dakota.

Other French explorers of the upper Mississippi included Louis Jolliet, who went down the Wisconsin River with Father Marquette as far as the Arkansas River in 1673, returning to the Great Lakes through the Illinois-Chicago portage. The two were most likely the first Europeans to set foot in Illinois and Iowa, and they marked the junction of the Mississippi and Missouri Rivers at St. Louis. Shortly before his death in 1675, Father Marquette established a mission near Utica, Illinois. Daniel Greysolon, Sieur DuLhut, after whom

Duluth was named, entered Minnesota in 1679 and claimed the entire upper Mississippi Valley for France.

Meanwhile, La Salle commissioned his chaplain, Recollect Franciscan Louis Hennepin, and his lieutenant Michel Aco to travel the upper Mississippi from the Illinois River to the Minnesota in 1682. After travelling through Iowa, they were captured by Sioux in Minnesota. In their company, Hennepin visited and named the Falls of St. Anthony at what is now Minneapolis.

For the French, after discovery came not settlement, but fur trading. La Salle himself was one of the many licensed fur traders, known as coureurs de bois ("vagabonds of the forest") in New France, who blanketed the region. They usually bought their pelts from Indians,

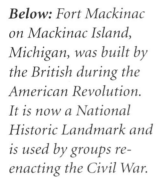

Below: Fort Mackinac on Mackinac Island, Michigan, was built by the British during the American Revolution. It is now a National Historic Landmark and is used by groups re-enacting the Civil War.

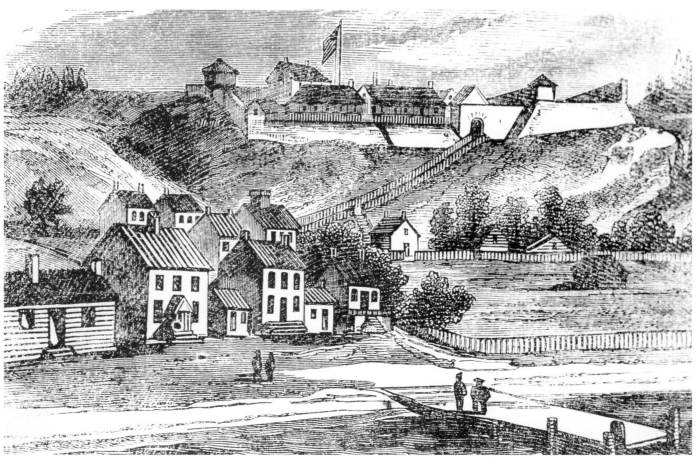

and beaver was the fur of choice because of its durability and popularity in hats and coats. France's King Henry IV commissioned the first fur traders in 1600, and by 1750 they traversed the entire Mississippi Valley. Because the French were not inclined to settle the regions they explored, their relations with the native peoples there tended to be better than those of the English. In Indiana, French trappers did build trading posts, such as Ouiatanon in 1717, near what is now Lafayette, and another in 1731 on the Wabash River at Vincennes, which became the most important one.

In those Heartland states west of the Mississippi, French traders looked for lead, gold, and salt, as well as furs. In 1690 Nicholas Perrot, who started French fur trading, taught people of the Miami tribe in Iowa, near East Dubuque, to mine lead. The French were mining lead in the eastern Ozarks as early as 1715.

Religious proselytizing motivated French settlement in some instances. Cahokia, the oldest town in Illinois, began as a mission in 1699, expanded into a trading post, and eventually became the center of French influence in the upper Mississippi Valley. The founding of Kaskaskia, like Cahokia named by missionaries after a local Indian tribe, followed in 1703. The first Missouri mission, St. Francis Xavier near St. Louis, lasted only from 1700 to 1703 before being abandoned.

At the end of the seventeenth century, relations between France and England, the two major colonial powers active in the Heartland, were less than cordial. Construction of Heartland forts by these adversaries was often motivated by jockeying for strategic military advantage. That was the argument used in 1701 by

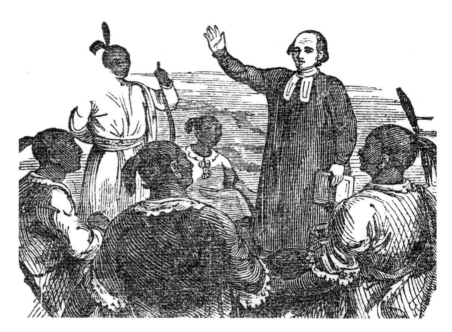

French nobleman Antoine de la Mothe Cadillac to win a land grant and trading rights in Michigan. He named the stronghold he constructed at what is now Detroit, Fort Pontchartrain. By the next year, the French and English were embroiled in the second French and Indian War, known as "Queen Anne's War." With its conclusion in 1713, the Treaty of Utrecht gave England control over the Hudson Bay territories that included the northeastern corner of what is now North Dakota.

But the French kept Detroit and Michigan and continued to explore and colonize the Heartland. Etienne Veniard Bourgmont was acting commander at Detroit when a native uprising led him to flee in 1706. By 1714, he had traveled up the Missouri River to the Platte River in Nebraska. By 1720, the Spanish, who dominated the southern territories, grew concerned enough about a French presence in Nebraska to send an expedition north from Santa Fe, New Mexico, to demonstrate their own influence.

Above: *An early print of a French priest, dressed in black cassock and tippet-style collar, depicts him preaching to local Indians at a site probably in the Great Lakes region.*

Overleaf: *The Northwest Company Depot at Grand Portage National Monument on the shore of Lake Superior in Minnesota features a trading post, stockade, and Great Hall, replicas from the eighteenth-century fur-trading days. Discovered by Native Americans, Grand Portage became the gateway to the West for European trappers and traders.*

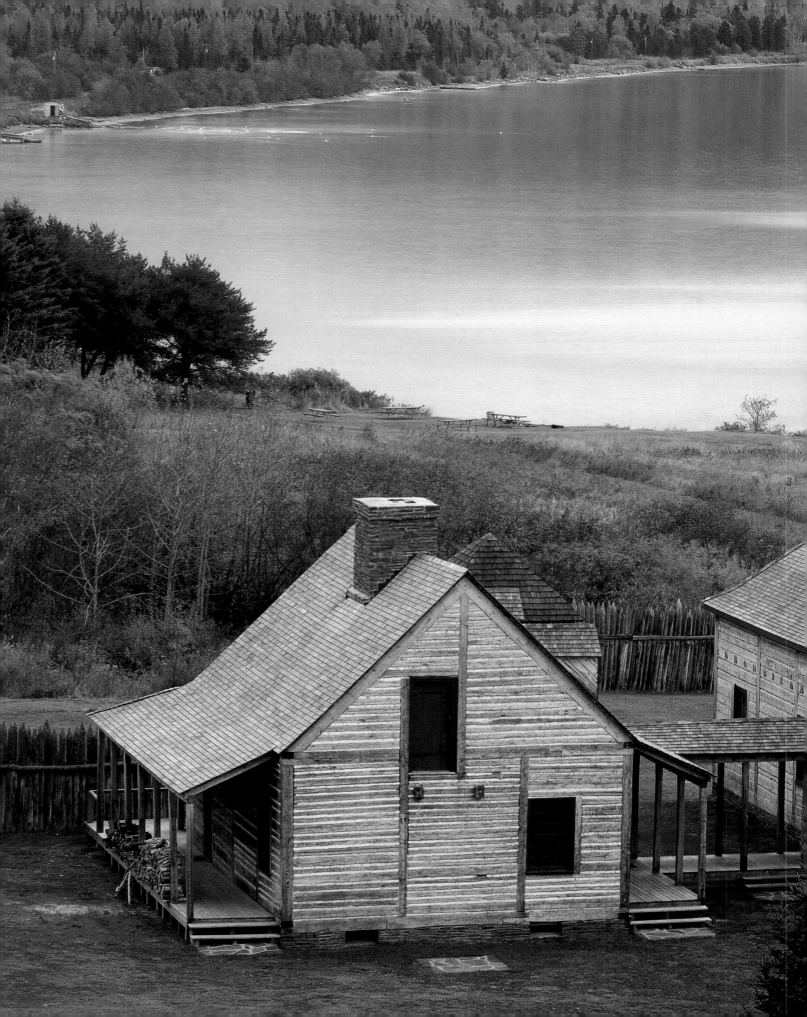

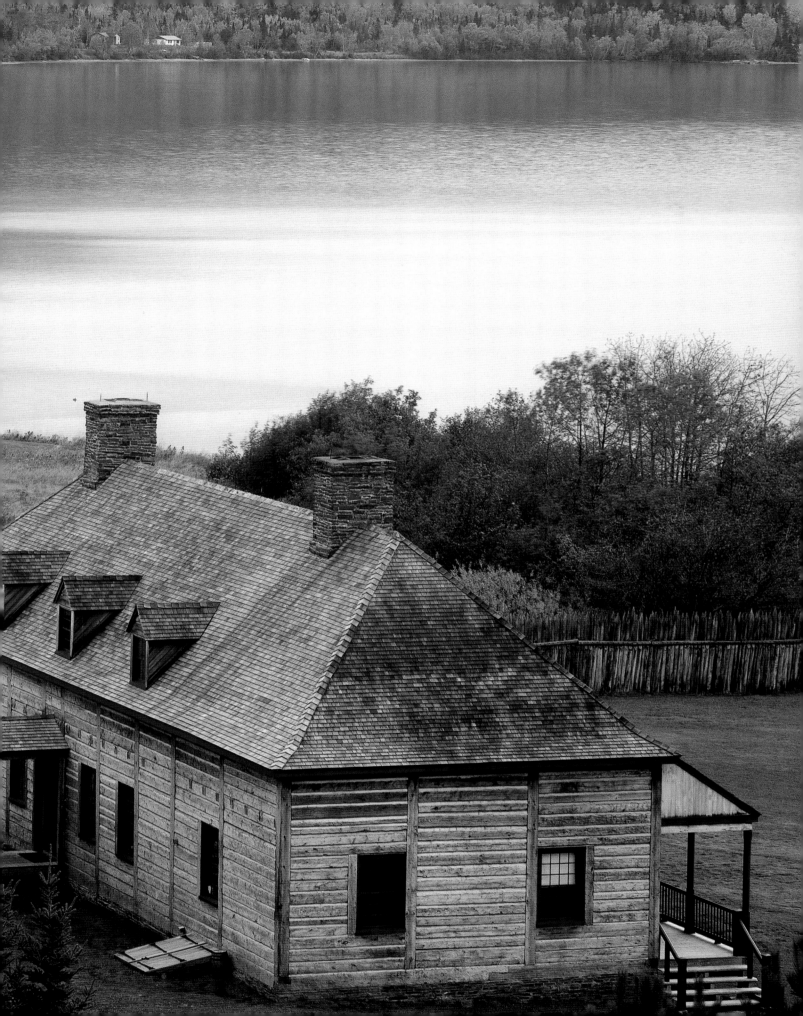

Meanwhile in Illinois, confusion over whether the region now occupied by this state was part of Quebec Territory or Louisiana Territory was resolved when the French established the Illinois colony in 1717. A Scotsman, John Law, who had allied himself with the Duke of Orleans, brought settlers to the new colony. The French established four new villages along the Mississippi south of the Missouri River: at Fort de Chartres, in 1721; St. Philippe, in 1722; Ste. Genevieve, ca.1735 (regarded then as part of Illinois but in fact the first European settlement on the other side of the Mississippi in Missouri); and Prairie de Rocher, also ca.1735.

Discovery of an overland passage to the Pacific, still called the Western Sea in the early eighteenth century, was uppermost in the minds of French explorers. Pierre Verendrye, who had served in France's colonial army, established a series of forts, including St. Pierre on the Rainy River between Minnesota and Ontario in 1731, and St. Charles on Lake of the Woods, a little farther west, in 1733. By 1738 Verendrye had reached a Mandan village near Bismarck, North Dakota.

Verendrye's sons Louis Joseph and Francois continued in their father's footsteps—an older brother had already been killed by Sioux—during 1742–3. They traveled west through South Dakota, and a lead tablet they buried at Fort Pierre when returning to the Missouri River was uncovered in 1913. The plate, which was considered a formal announcement of ownership, can be viewed in the South Dakota Cultural Heritage Center in Fort Pierre.

As early as 1749, Pierre Joseph de Céloron de Blainville also buried lead plates in the Ohio Valley to assert France's rights there. The British, however, had their own plans for Ohio. Forming the Ohio Company in 1748 to extend their Virginia claims westward, they sent Christopher Gist to explore the Ohio Valley in 1750. The friction between France and Britain over Ohio contributed to the final French and Indian War.

In a move intended to keep the British out of the region west of the Mississippi Valley, known as Upper Louisiana, the French signed a secret treaty with Spain in 1762. As a result, the Heartland states of North Dakota, South Dakota, Nebraska, Kansas, Minnesota, Iowa, and Missouri remained under Spanish jurisdiction until 1800. French traders and trappers continued, however, to be active in this part of the Heartland.

The year 1756 marked a turning point in the rivalry over control of the North American colonies. With their colonists far outnumbering the French, the British finally decided to shift their superior military resources, in particular their navy, to the North American colonies. In 1753, Virginia's governor sent the young George Washington, a member of the Virginia militia and the Ohio Company, to investigate French activity in the Ohio River Valley. He discovered that the French intended to defend their holdings there, so the British began marshaling their forces. Hostilities started the next year and continued until 1763—becoming known in America as the French and Indian War. In the Treaty of Paris signed that year, all the Heartland states east of the Mississippi River—Wisconsin, Illinois, Michigan, Indiana, and Ohio—went to Britain. Native Americans were not happy with the increased British presence; Ottawa Chief Pontiac's war against the British is detailed in the following chapter.

Left: French cartographer Victor Collot surveyed and mapped the Mississippi and Ohio River valleys in 1796. His engraving is entitled "French Habitation in the Country of the Illinois," and his account of his travels, Journey in North America, *is considered one of the best books on eighteenth-century explorations of the American frontier.*

Once the contest between the French and British over North America was resolved, the Heartland saw a decade free from strife, and settlement continued. Not long after the French and Indian War ended, a New Orleans fur trader named Pierre de Laclede Liguest won a trade monopoly for the Missouri region of the Heartland. Traveling with René Auguste Chouteau, son of his paramour Marie Thérèse Chouteau, Laclede landed first at Ste. Genevieve, then Kaskaskia, but soon ended up establishing his own settlement on the west bank in Missouri, thereby founding St. Louis.

In Ohio, an evangelical Christian missionary born in Moravia (now part of the Czech Republic), David Zeisberger, founded a Moravian mission called Schoenbrunn in 1772. At the onset of the American Revolution four years later, Zeisberger was imprisoned and the settlement razed, but he established others in Ohio later on.

By 1774, American colonists increasingly began to resent British control and policies. When they acquired Canada in 1763, the British put in place only a temporary governing structure. The Quebec Act of 1774 provided a permanent framework and could be seen as an enlightened document in its treatment of French colonists, granting freedom of religion and other benefits, but it deeply angered the American colonists. They considered it one of the "Intolerable Acts," a nullification of their rights to lands north of the Ohio River and a retaliation for the Boston Tea Party. Under the Quebec Act, Wisconsin and Michigan became part of Quebec Province, but not for long. The American Revolution was about to erupt.

King George III declared that the American colonies were in "open and avowed rebellion" on August 23, 1775. The colonies' first formal retaliation came, of course, with the Declaration of Independence, drafted initially by Thomas Jefferson, and signed on July 4, 1776, by the Continental Congress. Hostilities reached the Heartland in 1777. In June and July, British Lieutenant Governor Henry Hamilton organized war parties of British soldiers and Native Americans to head south from Fort Detroit into the Ohio Valley and occupy Indiana, then part of Illinois Territory,

which at the time included Ohio, Indiana, and Illinois. Hamilton became known as the "hair buyer" as a result of civilian scalpings by his Indian combatants.

The region was hotly disputed. Americans in New York and Pennsylvania were reluctant to let Virginians take control of the area, let alone the British. Nevertheless, on December 4, American Colonel George Rogers Clark left Virginia and headed for Illinois Territory. In 1778 he captured both Kaskaskia and Cahokia in Illinois, sending Leonard Helms on to Vincennes, which agreed to ally itself with the American cause. The alliance proved shortlived, though, and Hamilton soon recaptured Fort Sackville, the main fort at Vincennes. Not to be outdone, Clark surprised Hamilton, who had sent his Indian cohorts home, and rewon Fort Sackville two months later. Hamilton was packed off to Virginia as a prisoner, and Illinois Territory became part of Virginia. Clark continued his campaign, defeating Shawnee allies of the British in Ohio, as seen in the next chapter.

Even Spain, entering the war in 1779, played a brief role in the Heartland's revolutionary skirmishes. In 1781, a group of French fighters and Native Americans won authorization from the Spanish governor at St. Louis to attack Fort St. Joseph, near Niles, Michigan, strategically located near the southwestern shores of Lake Michigan. They marched north from St. Louis and won the fort for one day, raising the Spanish flag. The "Spanish Raid" became justification for Spain's unsuccessful effort to claim lands east of the Mississippi at the end of the Revolution.

When the American Revolution ended on September 3, 1783, with the signing of the Treaty of Paris, that part of the Heartland known as the Northwest Territory joined the new United States. Because it was considered frontier land, much of it was claimed by members of the original thirteen states. With the potential for rebellion on the new government's hands if it did not handle the issue successfully, the Northwest Territory's disposition became one of the major problems the new nation had to resolve.

Virginia claimed all of the lands north and west of the Ohio River and east of the Mississippi. The Northwest Territory included the Illinois Territory (present-day Indiana, Illinois, and Ohio), Michigan, Wisconsin, and the eastern section of Minnesota. Virginia was not, however, able to maintain order there. Anarchy was the order of the day until the arrival of Governor Arthur St. Clair in 1790.

Virginia's claims on the Northwest Territory were complicated by competing ones from Connecticut and Massachusetts. States like Maryland,

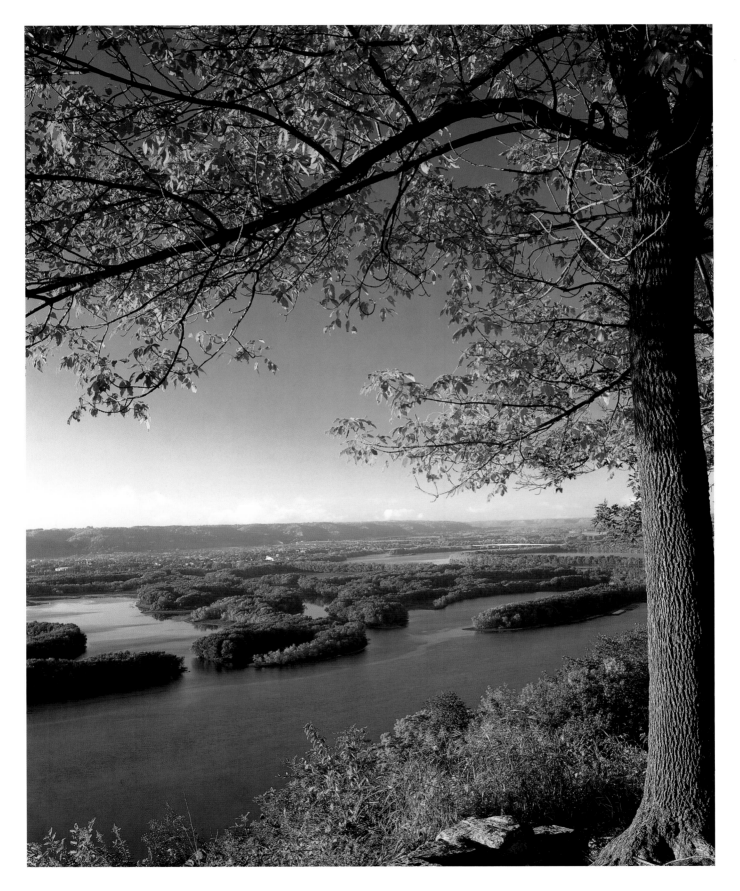

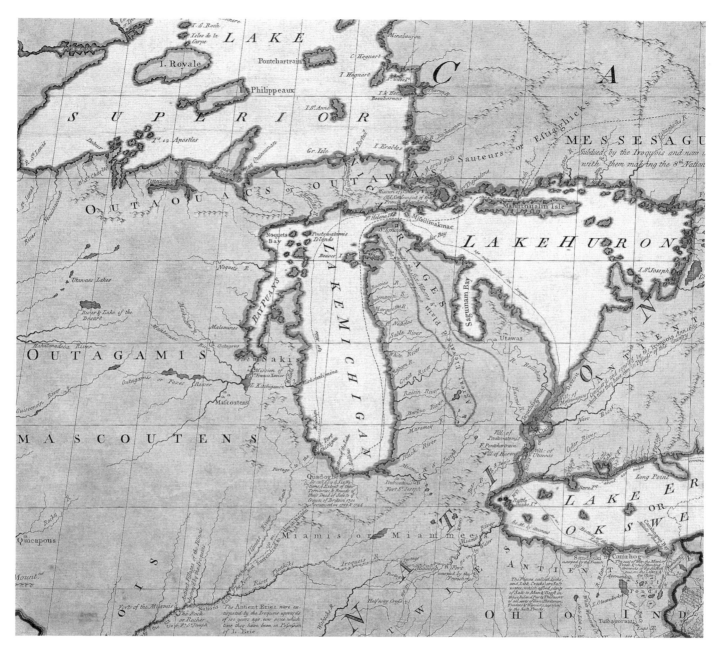

Above: *The Great Lakes region in a 1755 map by John Mitchell, which reveals clues of the competing claims over the region at the time.*

which had no such claims, argued against permitting Virginia and others to keep their frontier lands. The dispute was resolved through a series of land ordinances enacted starting in 1784, in which all the new states agreed to yield to the U.S. government any claims they held on additional lands. Virginia gave up its rights to the eastern part of the Heartland in 1784; Massachusetts, in 1785; and Connecticut, in 1786.

The matter of governance and territorial and state status was a complex one, and it was not finally resolved until 1787, with passage of the Northwest Ordinance. Re-enacted in 1789 under the new nation's Constitution, it provided for an administrative structure with a governor and, once a census listed 5,000 free male residents, a legislature. Residents of the Northwest Territory were guaranteed civil rights, and eventual accession to state-

hood. At least three and a maximum of five states could be created in the Territory. These new states would be equal in status to the original thirteen, and Congress could add one or two more states if necessary. Historians have called the Northwest Ordinance one of the new nation's greatest accomplishments under the Articles of Confederation.

With these important matters finally resolved, development continued. Illinois, settled predominantly by the Roman Catholic French, received its first Protestant minister in 1787. The Ohio Company of Associates, consisting mostly of New England veterans, was formed in 1786 as a land-buying operation. It began negotiating with the federal government to purchase land the next year. In 1788, two of the Associates, Rufus Putnam and Manasseh Cutler, founded Marietta, Ohio's first planned, permanent settlement. Many other veterans of the Revolution settled along the Ohio River. Anthony Wayne, who like Putnam had served as a general in the Revolution, built Fort Recovery on the Wabash River near Ohio's border with Indiana. The Greenville Treaty, discussed in chapter 3, brought large numbers of settlers into Ohio.

Despite the Treaty of Paris that had ended the Revolutionary War, the British refused to give up Fort Mackinac on Mackinac Island, to which they had withdrawn from Fort Michilimackinac during the American Revolution. They finally left after the Jay Treaty was signed in 1795. Detroit, still inhabited primarily by French settlers, also remained under British control after the Treaty of Paris, despite its official surrender. It stayed a British holding until 1796, when American forces took over.

The rest of the Heartland—including present-day states North Dakota, South Dakota, Nebraska, Kansas, western Minnesota, Iowa, and Missouri—remained in Spanish hands in the years following the Revolution. This vast territory—known as Louisiana despite the fact that France had ceded it to Spain in 1763—was populated mainly by Native Americans. European settlement in the lower Missouri River Valley, however, dates from 1700, and the oldest town in Missouri, Ste. Genevieve, was founded in 1735. In 1799, when Daniel Boone, who had lost many of his land holdings in Kentucky in legal battles, moved to St. Charles County, Missouri, the Spanish gave him land there in the Femme Osage Valley and appointed him district magistrate.

French explorers Pierre and Paul Mallet probably were, in 1739, the first white men to traverse Nebraska, which otherwise remained Native American country. Except for the occasional fur trader passing through, the same was true for Kansas and North Dakota. French-Canadian fur trader Pierre Dorion, whose wife was a Yankton Sioux, was probably the first European to settle in South Dakota, as early as 1773. Minnesota was part of the U.S. after 1783, though in practice it was controlled by England's North West Company with its many fur-trading posts in the region rather than by the fledgling U.S. government. Iowa received its first white settler, Julien Dubuque, in 1788. Dubuque came to mine lead with the Fox, receiving the first land grant in the state-to-be from the Governor of Louisiana. He lived there until his death in 1810, and Dubuque, Iowa, located on bluffs overlooking the Mississippi River, is named for him.

The new century began with the vast Louisiana Territory changing hands after Napoleon Bonaparte pressured Spain into ceding the Louisiana Territory back to France in the secret 1800 Treaty of San Ildefonso. That same year, Congress passed the Division Act, cutting the Northwest Territory in half on the grounds that it was too unwieldy to govern. Ohio, half of Michigan, and a section of southeast Indiana remained part of the Northwest Territory, with Chillicothe, Ohio, serving as its eastern capital, and the rest became Indiana Territory. In 1802, a convention in Chillicothe organized a state government for the eastern part of Indiana Territory, and Ohio became the seventeenth state on March 1, 1803. It was that same year, 1803, that Napoleon, who was under pressure from all sides and in fear of an Anglo-American alliance, sold the Louisiana Territory to the United States. With this one historic acquisition, the United States doubled in size and its Heartland tripled.

Right: The powder magazine building at the French Fort de Chartres, the oldest extant building in Illinois. Built of limestone in 1753–6 on the site of an earlier palisaded fort, this was one of the key defenses in the French and Indian War; it was surrendered to the British in 1765. French involvement in the Heartland would end altogether as the next century dawned.

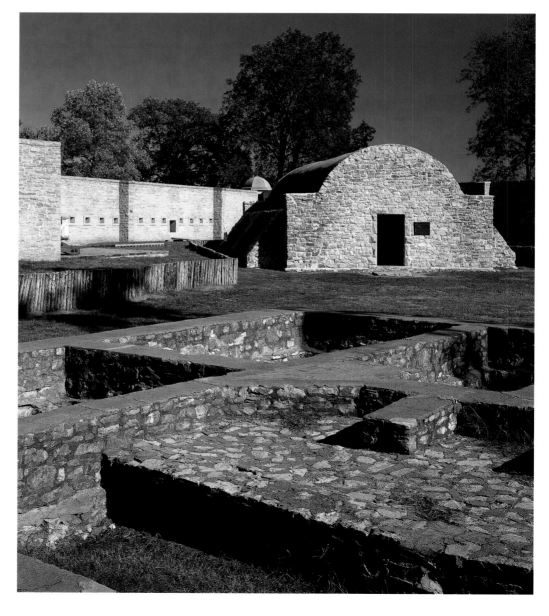

THE
"INDIAN PROBLEM"

Previous page:
Chequamegon National Forest in Wisconsin acquired its name from the Ojibwa who once lived there: they called it "place of the shallow waters" and fished there for smallmouth bass, walleye, northern pike, and trout.

Right: *A depiction of a council of Plains Indians. The feathered peace pipe in the foreground, known as a calumet, was smoked during ritual gatherings.*

Like most of the new United States, settlers of the Heartland believed Native Americans should be contained, if not removed entirely from the regions they wished to settle. The clash between Native American and European cultures in this region began well before the Declaration of Independence.

In Wisconsin, the French engaged in a series of wars against the Fox, starting in 1712. With a reputation for savagery, the Fox, or Meshkwahkihaki, who moved into the Green Bay area from Michigan during the early seventeenth century, harassed French explorers and traders. French forces severely reduced their numbers by 1730, but the Fox joined with allies among the Sauk, and conflicts continued until 1740.

The French and Indian War of 1754–63 was not fought primarily in the Heartland, but its ramifications were significant. It was part of a larger, European conflict, and France's Colonel Celeron de Bienville's voyage south from Lake Erie in 1749 was a strategic move to pre-empt English control of Ohio, Indiana, and Illinois.

The most important outcome of the French and Indian War for the Heartland was that England became the dominant presence. While both French and Native American cultural influences remained, the Heartland became anglicized. Although much of the Heartland became part of Spain's Louisiana Territory from 1763 to 1800 and was in fact run by them until the Louisiana

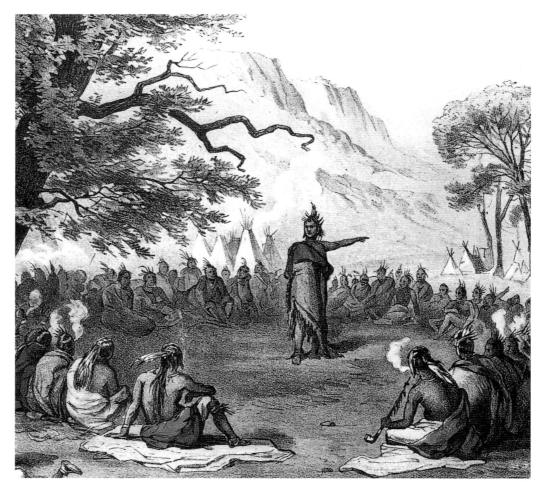

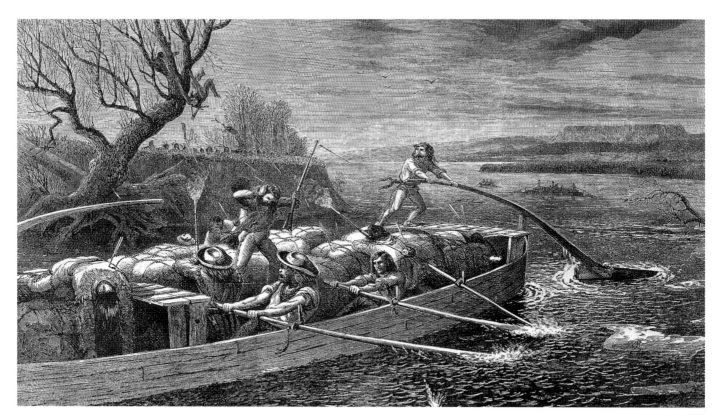

Purchase of 1803, the Spanish cannot be said to have exerted a strong cultural influence over the region.

Despite Colonel de Bienville's efforts, the Ohio, Illinois, and Indiana region came under British control. British administration offered a rude awakening to Native American tribes, who were used to more laissez-faire French policies and had no desire to give up land to British settlers. In 1762–3, the Delaware tribesman Neolin, called the Prophet, began rousing Ohio River Valley tribes to reject white control. Ottawa Chief Pontiac focused Neolin's message on the British. Pontiac persuaded a tribal council held at Ecorse near Detroit to attack British forts.

Hostilities threatened to begin May 7, 1763, when a group of Native Americans arrived at Fort Detroit, but conflict was averted by the heavily armed British troops, who received Pontiac and 300 of his men inside the fort. Within weeks, however, ten more British forts ranged along the southern borders of the Great Lakes were under attack. The British had no more than 1,000 troops garrisoned in these forts, while Pontiac commanded as many as 3,000 fighters. The region was heavily wooded, an advantage for Pontiac's forces, but the British troops could call on thousands of English settlers and forces from the eastern colonies.

The first bloodshed in Pontiac's War occurred on May 9, with a new attempt to enter Fort Detroit. This time the British would receive only fifty of the attackers, who withdrew to Isle au Cochon ("Hog Island," now Belle Isle). There they killed two settler families, three part-time soldiers and twenty-four head of cattle. Several days later, Pontiac's forces again approached Fort Detroit but turned back when the British fired. The incident began a five-month siege.

Above: *French fur traders under attack by Arikara warriors on the upper Missouri River, as shown in this engraving of an eighteenth-century scene. The Arikara migrated to North Dakota along the Missouri from the lower Red River Valley in Louisiana.*

Right: Chief Pontiac, a leader of the Ottawa people of eastern Michigan, Ontario, and Ohio, meets with British officers. Pontiac's Rebellion was fought from 1763 to 1765 after Lord Jeffrey Amherst imposed harsh new trading policies in the region.

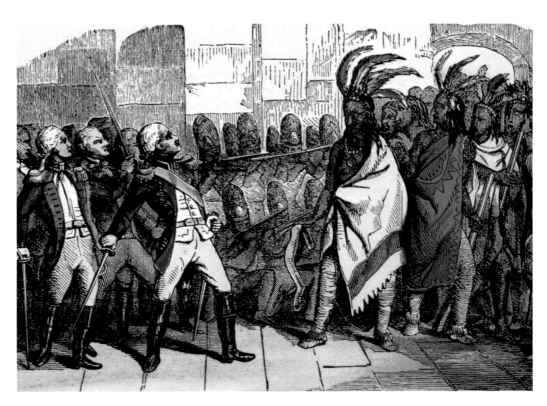

During the next weeks, Pontiac's forces attacked and/or captured seven more forts between Lake Michigan and western Pennsylvania, killing dozens of British soldiers. At Fort Michilimackinac in Michigan, Britain's northernmost installation, Indian fighters used a ploy to gain entrance. Playing baggataway, the Indian precursor to lacrosse, they kicked a ball inside the fort, followed it, and once inside attacked, killing seventeen and capturing fifteen.

Still under siege, Fort Detroit received supplies and reinforcements in August, but by October Major Henry Gladwin was ready to surrender. He held on, and many attackers left for home or hunting. Chief Pontiac ended the siege, although a few fighters remained behind and continued harassment until Colonel John Bradstreet arrived the next year. A series of minor engagements and negotiations followed, until Pontiac agreed to a peace treaty with Sir William

Johnson on July 23, 1766. Pontiac's War taught the British to conduct affairs with the region's native peoples on a more respectful, French-style basis. As a result, they won allegiance from many tribes during the American Revolution.

Southern Ohio saw many new settlers in the early 1770s, but the Shawnee still considered it their territory. Despite occasional unauthorized raids on their people, the Shawnee did not retaliate until 1773. After a group of Shawnee chiefs suing for peace were imprisoned over the winter of 1773 by Virginia Governor John Murray, Lord Dunmore, and were then attacked by his agent Dr. John Connolly, the Shawnee struck back. Connolly called on the settlers to defend themselves, and Lord Dunmore's War of 1774 began.

George Rogers Clark, who captured British forts in the Heartland during the American Revolution (see Chapter 2), joined the British effort to quash the revolt. British-colonial forces engaged the

Shawnee at Point Pleasant, West Virginia, and when the Shawnee, led by Cornstalk, abandoned the field, the British declared victory. Lord Dunmore readied an attack on a Shawnee settlement across the Ohio River in Chillicothe, but the Indians called for peace. In an eloquent speech, Mingo Chief John Logan, whose family had been attacked by irregulars, accused the British of murder. The Shawnee, however, were forced to relinquish claim to land south of the Ohio River, opening up the entire Ohio River Valley to new settlement.

A year later, the American Revolution was underway, turning the Heartland's settlers and the British into enemies. For the region's native people, it meant choosing sides all over again. Initially, the Americans pursued peace with them and in 1775 negotiated a treaty that provided for Indian neutrality. Before long, it was clear the native people could not remain neutral. The Americans and British began competing for Native American allegiance. The Indians tended to support the British, who had more to offer in the way of material rewards, and because the settlers, now enlisted in the American cause, hungered after their lands. Nor was the American cause aided when Shawnee Chief Cornstalk and his son were murdered at Point Pleasant while on a peaceful mission.

George Rogers Clark, a hero for capturing British installations at Kaskaskia, Cahokia, and Vincennes, defeated British-allied Shawnee at Springfield in the 1780 Battle of Piqua. Although he attempted to march on Fort Detroit the next year, a group of reinforcements was decimated by Indians, and he had to abandon the plan. Many of Ohio's Delaware, who had been converted to Christianity and pacifism by David Zeisberger and his Moravian missionaries, were massacred by American militia, who refused to believe in their neutrality. In retaliation, Captain William Caldwell was burned at the stake by the Delaware in the Battle of Olentangy.

After a devastating defeat at Indian hands in Kentucky, Clark rode with over 1,000 cavalrymen up the Miami Valley in 1782 and burned Shawnee towns along the way. It was the last skirmish of the American Revolution in the Heartland. Despite Clark's victories, most of Ohio and Detroit remained under control of British and Native American forces. Diplomacy, not warfare, ultimately won the Heartland for America.

The new United States could not stem the unruly tide of settlers flooding north of the Ohio River. In a 1784 letter to Jacob Read, George Washington wrote: "This gives great discontent to the Indians, and will unless measures are taken in time to prevent it, produce a war inevitably with the western tribes." It didn't help that the British remained at Forts Detroit and Michilimackinac.

By then, Clark had become an Indian commissioner and helped persuade the Shawnee, reluctantly, to confine themselves to the lands between the Great Miami and Wabash Rivers in western Ohio and Indiana. Increasingly, the Native Americans came to believe treaties with the U.S. were not binding unless agreed to by all tribes. Indian raiding parties again grew active in the Ohio River Valley. After the new Congress delayed, Clark took the initiative and led a sortie in the Wabash region in 1786, putting a temporary end to the raids.

By 1787, Congress designated this region the Northwest Territory, and it would experience what is regarded as its

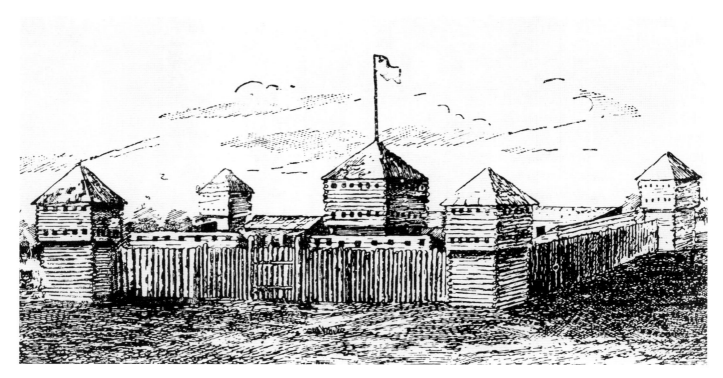

Above: British Fort Sackville at Vincennes, Indiana, was lost and recaptured during the American Revolution. General George Rogers Clark recaptured it from the British in 1779, and it was renamed Fort Patrick Henry. Indiana celebrates George Rogers Clark Day annually on February 25, the date of the British surrender.

first war in the fall of 1790. President George Washington and his secretary of war Henry Knox authorized an attack on Ohio River Valley Indians, and sent Major John Hamtramck up the Wabash River from Fort Knox (by now a town— Vincennes, Indiana) with a raiding party. Lacking adequate food provisions, they returned to Fort Knox. At the same time, Brigadier General Josiah Harmar left Fort Washington near Cincinnati and traveled up the Ohio River to the Maumee River. There, near what is now Fort Wayne, Indiana, he and his men destroyed ten tons of corn and five Miami villages. After several sections of his forces were ambushed, Harmar and his troops returned to Fort Washington.

Because of casualties suffered by Harmar's men, Congress almost doubled the size of the armed forces. Washington put Arthur St. Clair, the Northwest Territory's first governor, in charge of a military force that was to build a fort in Indian territory, violat-

ing the U.S. treaty with the Indians. In 1791, St. Clair and his men traveled north along the Miami River, building forts as they went and spreading themselves too thin. Surprising them before dawn near the Indiana border, Miami Chief Little Turtle attacked. Nearly two-thirds of St. Clair's forces were killed or wounded, the worst loss in all the army's conflicts with Native Americans.

The next year Congress established a recruitment policy that expanded the U.S. Army to more than 5,000 strong. Major General Anthony Wayne became its commander. President Washington continued trying to negotiate with the Native Americans, but to no avail. In the fall of 1793, Wayne departed over the same route St. Clair had taken. Arriving at the spot where his predecessor suffered defeat, he ordered his men to build Fort Recovery. First they buried the remains of those killed two years earlier.

Wayne tried negotiation with the Indians unsuccessfully and headed

north. Little Turtle attacked a packhorse supply train, then tried to take over Fort Recovery, but the Americans held on. After this failure, Little Turtle began urging peace and was replaced by the Shawnee Black Wolf and Blue Jacket leading the Ottawa, Chippewa, and Potawatomi. Meanwhile, Wayne devised an ingenious way of sapping their power. By massing repeatedly along the Maumee River, he made his opponents, who fasted before battle, think he was going to attack over and over again. Wayne then turned the tables on his adversaries by trapping them in a tangle of tornado-dropped trees. At what became known as the Battle of Fallen Timbers, near what is now Toledo, Wayne defeated the Native American forces, who had been led to believe the British would aid them.

The next year Wayne summoned leaders from twelve tribes to Fort Greenville near the Ohio-Indiana border. The resulting Treaty of Fort Greenville stipulated a prisoner exchange and required the Native Americans to cede Ohio—from the Ohio River to the Great Lakes—to the U.S. In exchange, they received cash and goods. Indian conflict thereby ended in the Northwest Territory for more than fifteen years, and the floodgates for white settlement opened.

One of the greatest warriors, the Shawnee Tecumseh, born near Springfield, Ohio, began his military career in the conflicts against settlers trying to move into the Ohio River Valley. Tecumseh and his younger brother Tenskwatawa, known as the Shawnee Prophet, began urging others to unite and reject white culture. In 1808, Tecumseh established Prophetstown on the Tippecanoe River in Indiana. It was

celebrated among Native Americans as far away as Minnesota and Florida.

When William Henry Harrison, who became Governor of Indiana Territory in 1800, negotiated transfer of three million more acres of native-held land to the U.S. under the Treaty of Fort Wayne, Tecumseh rejected the agreement. By spring of 1810, the British were sending aid to Prophetstown. Harrison tried to negotiate with Tecumseh, but after the leader edged him off a bench to demonstrate his sense of betrayal, Harrison began calling him the new Indian "menace." While Tecumseh was away seeking support from southern tribes, Harrison attacked Prophetstown in the 1811 Battle of Tippecanoe. The Indians finally withdrew, and the army burned the village.

The British, eager to prevent their former colonies from expanding into the Northwest Territory, supplied the region's Native Americans with guns. This testy issue, along with a number of others, led to U.S. involvement in the

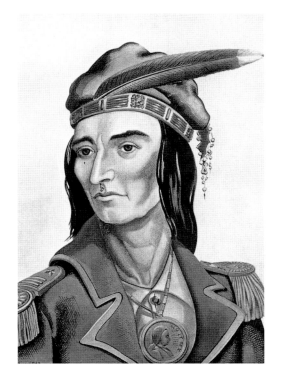

Left: *Shawnee leader and warrior Tecumseh, born in 1768 near Springfield, Ohio, first won recognition fighting against Kentuckians attempting to settle in the Heartland, west of the Ohio River.*

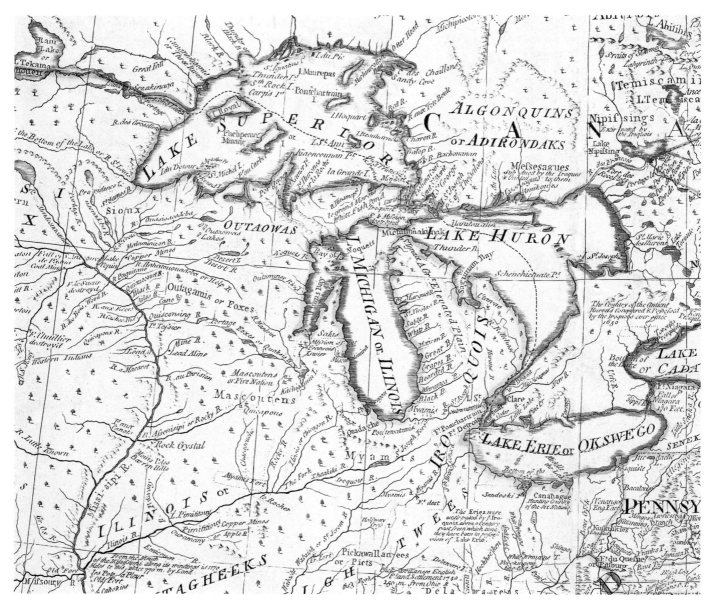

Above: The green boundary on the map represents U.S. land and the red, British, after the 1783 Peace of Paris agreement. Indian-American conflict continued south and west of Lakes Erie and Michigan through the rest of the century.

War of 1812. Tecumseh aligned his Shawnee forces with British General Sir Isaac Brock near Fort Detroit, which was now in American hands. After a series of skirmishes there and near British-Canadian Fort Malden, American General William Hull surrendered to Brock, giving Tecumseh free rein to make raids in the area. Hull was court-marshaled for his actions, which had also led to the massacre of civilians and soldiers told by him to evacuate Fort Dearborn, near what is now Chicago.

"Remember the Raisin" was the cry inspired by defeat of Brigadier General William James Winchester in January 1813 at the Battle of Raisin River in Michigan. Some months later, General William Henry Harrison's men recaptured Fort Detroit. The decisive battle for the Northwest Territory was fought October 5, 1813. Americans prevailed against British and Indian soldiers led by General Henry Procter in the Battle of the Thames River. Although his body was never recovered, Tecumseh was presumed dead.

With British support, Native raids continued against settlements in Missouri Territory—formed at the start of the War of 1812 out of Upper Louisiana—until U.S. Indian commissioners arranged a treaty in 1815 at Portage des Sioux on the Mississippi River.

Located as it was in the sparsely populated Missouri Territory, South Dakota did not see Americans until the famous William Lewis and Meriwether Clark expedition in 1804–6, discussed in Chapter 4. In 1823, a group of Arika attacked a fur trading party led by Missouri Territory's Lieutenant Governor William Henry Ashley. In retaliation, Colonel Henry Leavenworth raided Indian villages with a party of fur traders, U.S. infantrymen, and Sioux. A treaty with the Indians was signed in 1825.

The next major Indian-American conflict in the Heartland occurred in 1832. A group of Sauk and Fox, or Mesquakie, who lived in what is now southwestern Wisconsin and northwestern Illinois, refused to adhere to treaties yielding their traditional lands. When U.S. settlers tried to move into Sauk leader Black Hawk's village, he prepared to retaliate. General Edmund

Below: South Bass Island is one of a series of islands on Lake Erie in Ohio occupied by the Ottawa and Huron before the War of 1812. The island has served as a popular resort since the early nineteenth century, and visitors there can still see the remains of the Victory Hotel, destroyed by fire in 1919.

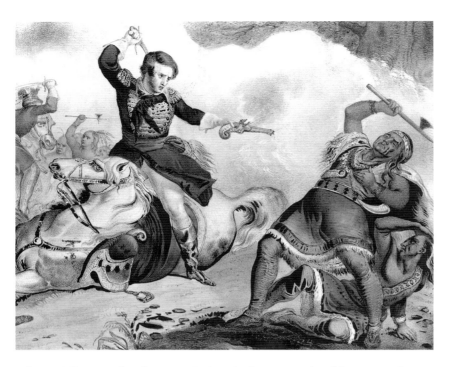

Above*: The Death of Tecumseh at the Battle of the Thames, October 18, 1813, is depicted in this Nathaniel Currier lithograph. Before his death, Tecumseh served as a brigadier general in the British army during the War of 1812.*

Right*: Sauk warrior Black Hawk, known as Ma-ka-tai-me-she-kia-kiak, fought with the British in the War of 1812. In 1832 he led the Sauk and Fox in a three-month war that ended with his imprisonment for a year.*

Gaines's forces arrived by steamboat, and Black Hawk moved across the Mississippi River into Iowa. When he returned, hostilities continued until his war party was decimated at Bad Axe River in Wisconsin. In the resulting peace treaty, the tribes had to cede a 50-mile swath of land along the Iowa River, while in return, the U.S. promised a cash and goods settlement. Serving in the Illinois militia, Abraham Lincoln did not take part in any fighting.

In 1854, Congress created two new territories through the Kansas-Nebraska Act. Settlers eager for land pressured Congress to encroach further on Indian territory, and it was just a matter of time before the Plains Indians would respond with hostilities.

In 1857 at Spirit Lake in the Iowa region, a Wapekutah Sioux party swooped down on white settlements, but the massacre was considered an isolated incident. More violent was the 1862 Sioux Uprising in Minnesota. Santee Sioux Chief Taoyateduta, or

Little Crow, acceded to a key land treaty in 1851 and then a second division of reservation land. The 1862 murder of five settlers by tribesmen disintegrated into war, despite Little Crow's initial resistance to engage in conflict.

No longer able to subsist through hunting, the Santee relied on federal subsidies. Indian Agent Thomas Galbraith refused to release supplies to the starving Sioux. Little Crow led an attack on the Lower Sioux Indian agency, killing the trader who had told them to "eat grass or their own dung." They stuffed his mouth with grass. The war enveloped southern Minnesota. Little Crow's forces attacked Fort Ridgely, New Ulm, and Birch Coulee, capturing 200 settlers, including women and children.

A battle at Wood Lake brought the Santee to their knees. Colonel Henry Hastings Sibley, who had organized Minnesota's volunteers and army regulars, established a military court. More than 300 Sioux were tried, and thirty-eight were hanged in the nation's largest mass execution. Little Crow escaped to

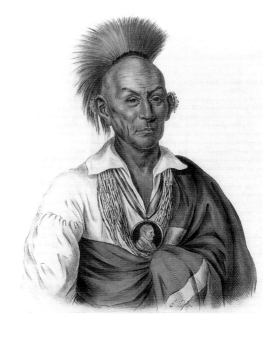

Canada but was shot when he returned temporarily to Minnesota. Many of the Santee Sioux involved in the uprising moved west to the Great Plains. By 1865 the Indian-white conflict was escalating in the northern Plains.

Congress established Dakota Territory in 1861, and by the Civil War's end in 1865, settlers encroached increasingly on the Teton Sioux, who lived in northern Plains country. Most of the fighting in Oglala Sioux warrior Red Cloud's War (1866–7) occurred outside the Heartland, but once Red Cloud was defeated, he and his cohorts were sent to Pine Ridge Reservation in South Dakota. Kansas was the scene of the next major conflict in 1867, Hancock's War. After General Winfield Scott Hancock destroyed an Indian encampment near Fort Larned as a show of force, the angered Cheyenne and Sioux

began a series of raids against mail stations, stagecoaches, wagon trains, and railroad workers. Even with help from Colonel George Armstrong Custer, Hancock could not subdue the raiders.

Two final conflicts between Indians and settlers of the Heartland occurred in 1876–7 and 1890–1. The first, the Black Hills War, came about when prospectors and railroad workers moved into the Black Hills, sacred to Teton Sioux and believed to be home to Sioux gods. Although they were violating their own treaties, the U.S. sent troops into the Black Hills in 1874 to scout sites for a new fort, and found gold. Prospectors moved in almost immediately, and at a meeting in White River, South Dakota, the U.S. government tried to persuade the Sioux and other Indians to permit mining in the Black Hills. They refused, and, inevitably, conflict followed.

Below: *Prospectors at work in the Black Hills, ca. 1876, after a military expedition there found gold. The region belonged to the Sioux until the Black Hills Act of 1877.*

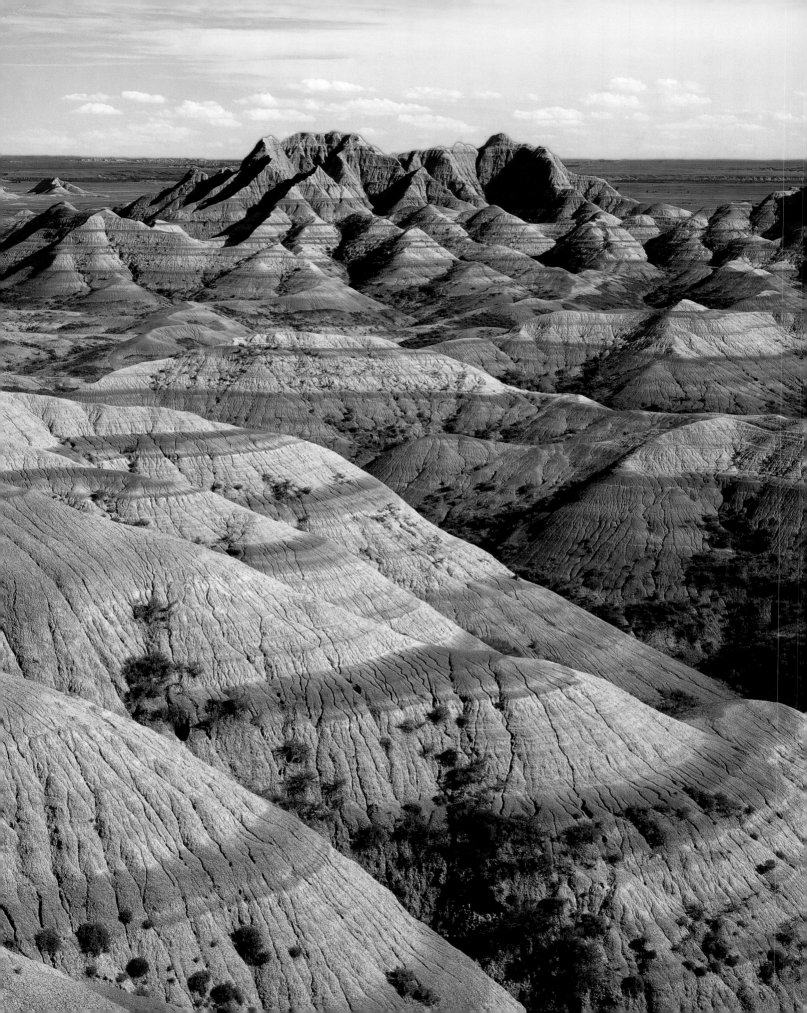

All Sioux to were ordered to report to a reservation by January 31, 1876, or consider themselves at war with the U.S. General Alfred H. Terry commanded the U.S. forces out of Fort Abraham Lincoln in Dakota Territory. At the Battle of Rosebud Creek on June 17, 1876, U.S. troops under General George Crook claimed victory. The most notorious battle of the era, Little Bighorn, was fought in Montana but with a detachment of South Dakota troops. Terry's forces in the field were led by the celebrated General George Armstrong Custer, who had considerable experience fighting Indian Wars. One of Terry's detachments, led by Major Marcus A. Reno, was sent to look for Indians in the Powder River area of Montana. Finding them in larger numbers than expected, he beat a retreat, losing at least one-third of his battalion. On June 25, as Reno waited upriver, Custer and his Seventh Cavalry battalion were destroyed by Cheyenne and Sioux. Word reached the Eastern seaboard on July 4—devastating news for the nation's centennial.

Approaching starvation, many of the fighters surrendered in the spring of 1877. The remaining Cheyenne gave themselves up to Colonel Nelson Miles at Fort Robinson in Nebraska. The legendary warrior Crazy Horse arrived at Fort Robinson with over 1,000 Sioux and Cheyenne fighters. He and 300 of his warriors sang a peace song, marking the end of the Black Hills War. Over the following fifteen years, U.S. troops, 10,000 strong, hunted down 30,000 Indians, mostly Sioux, on the northern Plains.

More and more land was withdrawn from reservations. Crazy Horse was arrested and killed in a fight with his guards. Chief Sitting Bull, who had fled to Canada, vowing, "So long as there remains a gopher to eat, I will not go back," surrendered his gun in 1881 at Fort Buford, North Dakota. The Cheyenne were relocated to a reservation in Oklahoma's Indian Territory. When 300 of them tried to escape, some 10,000 U.S. troops chased them for 1,500 miles. One group surrendered, and another was captured when they reached Nebraska. Life on a reservation for the Plains peoples was like prison, and when droughts damaged settlers' crops in the late 1880s, the U.S. government reduced the size of the Dakota reservations even further.

The nation's final Indian conflict, the Ghost Dance Campaign, occurred in 1890. In the grim and hopeless environment of the reservations, a Paiute prophet named Wovoka seemed to offer help. Word of his mystical Ghost Dance spread among the Sioux, who shaped its message into an anti-white theme. When the Ghost Dance was performed on reservations at Pine Ridge and Rosebud in South Dakota, Indian agents called in military protection. Sitting Bull

Left: *Crazy Horse, or Tashunca-uitco, was an Oglala Sioux military leader. He resisted confinement to a reservation after the Black Hills gold rush and later was taken into captivity and killed by an American soldier.*

Opposite: *South Dakota's Badlands National Park, which is partially enclosed by the Sioux Pine Ridge Reservation, has been called "a work of art still in progress." Erosion formed the gullies, spires, and sandcastles 500,000 years ago.*

Below: An image of Sioux warriors in ceremonial regalia, by Edward S. Curtis. Curtis began a photographic documentation of Native Americans in 1895. The largest project of its kind, it was published as the twenty-volume work The North American Indian.

at Standing Rock Reservation urged Short Bull and Kicking Bear, Sioux leaders of the Ghost Dance faction, to leave the Sioux reservations with their followers, but he was still treated as a subversive. He was detained and killed in the commotion attending his arrest.

A second leader, Big Foot, was en route to Pine Ridge Reservation with a cortege mostly of women and children when he was stopped by members of the Seventh Cavalry and told to go to the cavalry base at Wounded Knee Creek. Ill with pneumonia, Big Foot was

killed in an Army ambulance wagon during the melée that occurred when the Indians were told to turn in their guns; before the shooting stopped, at least 200 Sioux were dead at Wounded Knee. By January 15, 1891, Kicking Bear, the last insurgent, turned in his weapon. After this conflict, Native Americans remained confined to reservations, and white settlers acquired large tracts of their land. Two years later American historian Frederick Jackson Turner would declare that the American frontier had come to an end.

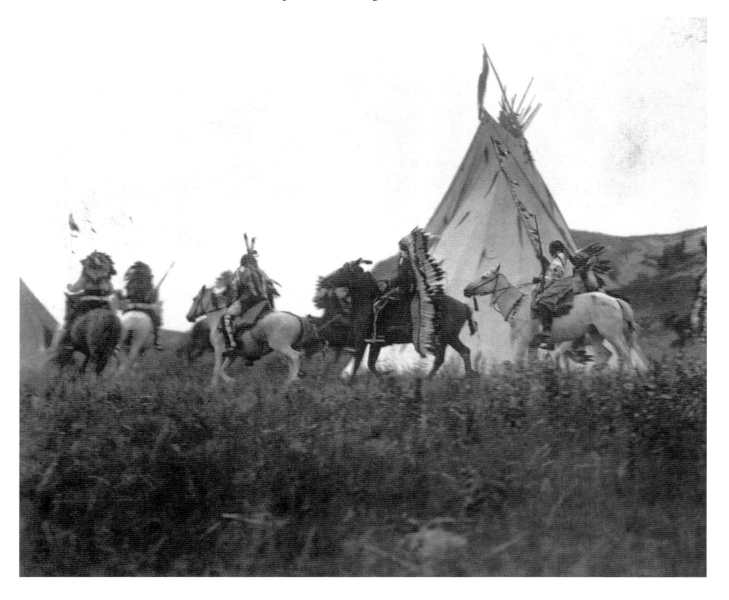

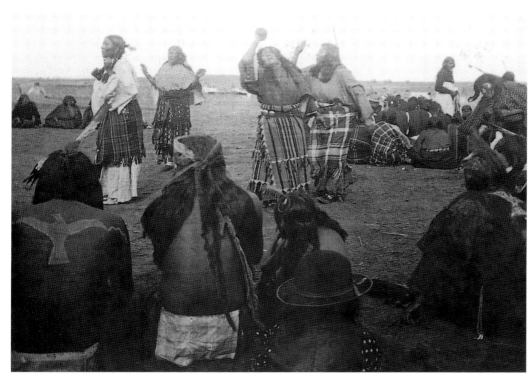

Left: Women perform the Ghost Dance.

Overleaf: The bison, or buffalo, provided food, clothing, and tools for Native American peoples for centuries, but the Heartland's herds were almost wiped out by 1900.

Below: The Wounded Knee Massacre of December 29, 1890, began when Colonel James Forsyth attempted to disarm a party of Miniconjou Sioux.

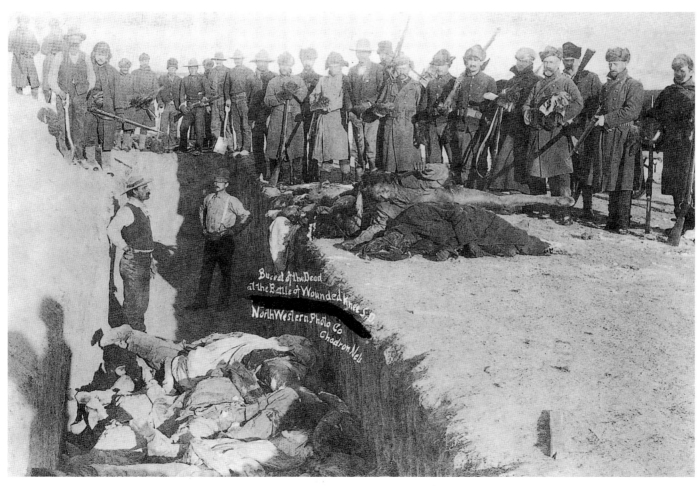

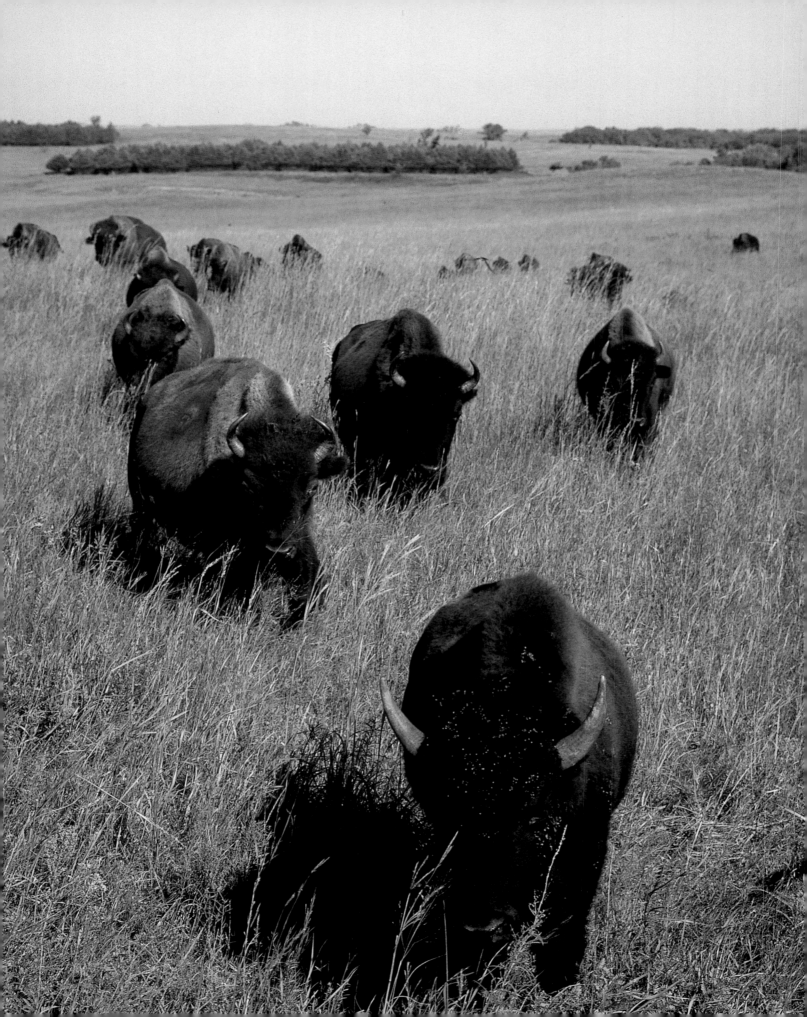

FORGING BOUNDARIES, CREATING STATES

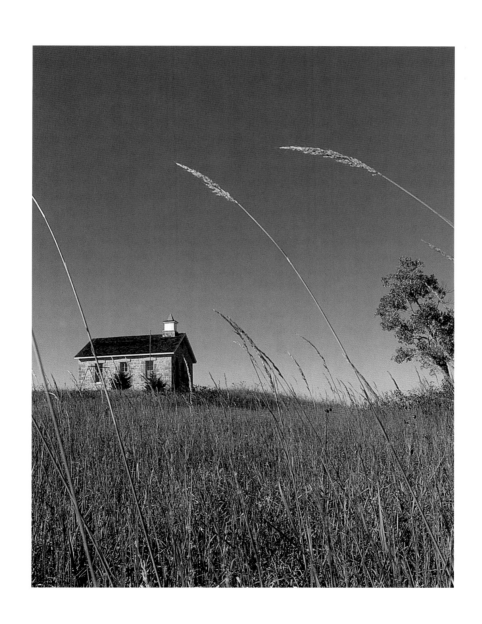

Previous page: An abandoned schoolhouse near Strong City, Kansas, in the Flint Hills, is one of the attractions at Tallgrass Prairie National Preserve, the only part of the national park system dedicated to preserving a tallgrass prairie environment.

Below: A Nebraska farming family stands in front of their sod house in Custer County, a section of the state acquired by the federal government in 1857 from the Pawnee Nation.

The conflicts between America's settlers and its Native American population that raged in the Heartland during most of the nineteenth century can best be understood as a clash of two very different cultures. The nineteenth century also marked a time of tremendous population growth for the region. The great appeal of the Heartland lay in its wide open spaces, ripe for farming during an age still predominantly agrarian.

With the Louisiana Purchase of 1803, the young nation doubled its land area. Heartland additions included Kansas, Missouri, Nebraska, South Dakota, North Dakota, Minnesota, and Iowa. As part of the Northwest Territory, the northernmost sections of North Dakota and Minnesota already were U.S. territory, along with Wisconsin, Illinois, Michigan, Indiana, and Ohio. In 1790 the non-native

population of the Northwest Territory was only 3,000. By 1800, Ohio alone had 45,000 settlers. In 1803 it became the first Heartland state to enter the Union.

That same year, President Thomas Jefferson asked Congress to fund an exploration of the Missouri River, the longest on the continent, in hopes of finding a passage to the Pacific by water. Expedition leaders Captain Meriwether Lewis and William Clark left St. Louis on May 14, 1804, and traveled northwest along the Missouri and into South Dakota, stopping at Elk Point. Moving on, they camped at the mouth of the Bad River, where they raised the American flag for the first time. In North Dakota, they wintered at a Mandan-Hidatsa village and built Fort Mandan. They would retrace this route on their way back in 1806. A white stone obelisk in Sioux City,

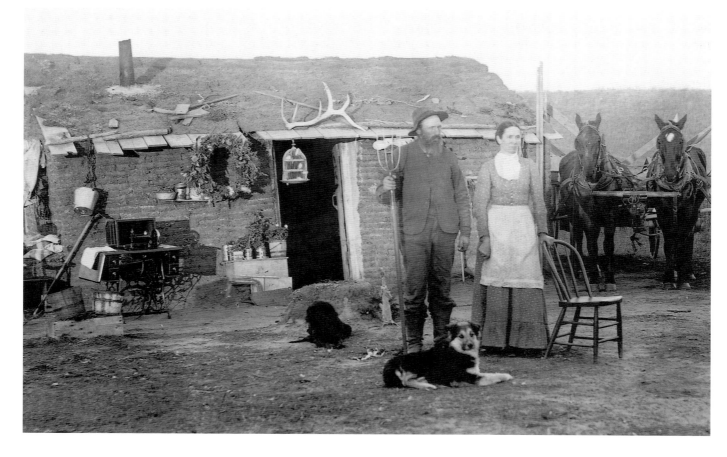

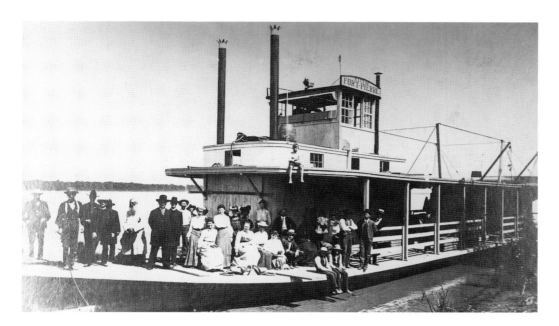

Left: Passengers pose for a portrait on the Fort Pierre, *a steamboat named for South Dakota's oldest continuously settled community. Travel by steamboat became common in the Heartland early in the nineteenth century.*

Iowa, memorializes Sergeant Charles Floyd, the only member who did not survive the expedition.

The regional boundaries of the Heartland as we know it today gradually began to take shape. Michigan became part of Indiana Territory in 1800 and 1802, then was made a territory in its own right in 1805. Illinois settlers, never happy with their inclusion in Indiana Territory, won territorial status in 1809. Indiana achieved statehood in 1816, and Illinois followed in 1818.

Further exploration added to the shaping of the region. Zebulon Pike set out from St. Louis in 1805 to explore the headwaters of the Mississippi. Leaving most of his men to winter at Little Falls, Minnesota, he continued up the main branch of the Mississippi but never reached its source, Lake Itasca, on another branch. He explored parts of Iowa and Nebraska as well as Minnesota. Because of drought, Major Stephen Long called the section of Kansas and Nebraska he traveled through in 1820 a "Great American Desert," although the label was not to prove accurate.

Fur trader Manuel Lisa helped open up the Missouri River basin from 1807 to 1820. He started the Missouri Fur Company and based his operations at Fort Lisa near Omaha, Nebraska. Fort Madison, Iowa's first military installation in 1808, doubled as a trading center and was built to compete with British traders. Before long, Kansas was crisscrossed with travel routes. Pack animals carried goods to the southwest along the Santa Fe Trail, opened by William Becknell in 1821. The Oregon Trail was blazed across the northeast quadrant of the state-to-be in 1812 by fur trader Robert Stuart. In 1817 Joseph LaFramboise started a fur trading post at Fort Pierre on the mouth of the Bad River, creating the oldest continuous non-native settlement in South Dakota.

Until the first steamboat, the New Orleans, traveled down the Mississippi River in 1811, boating on the nation's waterways depended greatly on manpower. Steam propulsion speeded up river travel for all the Heartland states along the Mississippi. In 1831, the sidewheeler Yellow Stone, built to navigate

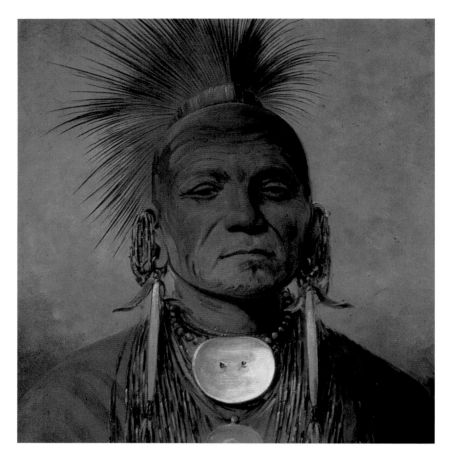

Above: *Artist George Catlin, a Pennsylvania native, traveled west in the 1830s and spent eight years in Indian Territory, painting a record of Native American lifeways along the Upper Missouri River.*

Opposite, below: *The primary mode of transportation for the Amish, a religious sect that originated in Switzerland, is still the horse and buggy. The largest Amish population in the world is found in Ohio.*

the shallow waters of the Missouri River for the American Fur Company, traveled on its first voyage from St. Louis to Fort Tecumseh, Missouri. One passenger was painter George Catlin, who dedicated himself to depicting the vanishing Native American peoples. One of the nation's best-known writers, Samuel Langhorne Clemens, spent nearly five years piloting a Mississippi steamboat. Growing up in Hannibal, Missouri, where he played with the Robards brothers, Clemens took the pen name of Mark Twain, a riverboat term for safe water, and wrote such classics as *Life on the Mississippi* and *The Adventures of Huckleberry Finn.*

Farther west in the Heartland, North Dakota gained its first permanent settlers in 1812, when Thomas Douglas, Earl of Selkirk, brought a group of Scottish

and Irish settlers from Canada and built Fort Daer on the Red River. It was the same year North Dakota, South Dakota, and Iowa became part of Missouri Territory. The slavery issue kept these territorial components from an easy partnership. What was to become the state of Missouri wanted slavery, while the other parts did not. The Missouri Compromise of 1820–21 resolved the conflict by permitting slavery only in Missouri, which became a state in 1821.

The Heartland remained on the peripheries of America's first nineteenth-century conflict with the British, the War of 1812, except for engagements at Fort Detroit and on Lake Erie north of Ohio. After General William Hull surrendered Fort Detroit to the British, American forces led by General William Henry Harrison recaptured it in 1813, but Fort Mackinac was not returned by the British until the war ended. Captain Oliver Perry led his ships against British forces on Lake Erie in the fall of 1813, proclaiming with their defeat, "We have met the enemy and they are ours."

Settlement continued. Lake Erie saw its first steamship, Walk-in-the-Water, launched in 1818, and the Age of the Canal began. Illinois, Indiana, and Ohio, in particular, burgeoned during the Canal Era. The Erie Canal, built in 1825, opened upper New York State to Lake Erie and Ohio. It was followed by the Ohio and Erie Canal (1832), connecting the Ohio River at Portsmouth to Lake Erie at Cleveland and spanning the state from south to north. Other canals soon linked Heartland locales.

Trading was not the only motive for settlement in the Heartland during the early nineteenth century. Led by Joseph Michael Bimeler, a group of

German immigrants escaping religious persecution founded Zoar, Ohio, in 1817 and helped build the Erie Canal. New Harmony, Illinois, became the eponymous site in 1825 of a utopian community lasting three years. Swedish followers of Eric Janson founded a utopian community in Bishop Hill, Illinois, which lasted until after his death in 1850, when celibacy was introduced. In 1855, members of the Community of True Inspiration founded a cluster of five Iowa villages called the Amana Society, one of the nation's most successful religious communities.

Left: *Lutheran Separatists known as Rappites originally established Harmony (1814), a utopian community, along the Wabash River in Illinois. In 1825 they sold the town to Robert Owen, a Scottish industrialist, who renamed it New Harmony and began his own utopian community.*

Right: *After their prophet Joseph Smith was murdered in Nauvoo, Illinois, the Mormons left the city, which they had made one of the largest in the state. It was the nation's largest group migration.*

Mormons migrated into Ohio, Illinois, and Missouri, founding Nauvoo ("Beautiful Place"), Illinois, in 1839 under the leadership of Joseph Smith. When he and his brother were killed by a hostile mob, the rest moved west on what became known as the Mormon Trail. Most Mormons settled in Utah. Meanwhile, inspired by the books and talks given by Oregon missionaries and reports from military expeditions, a series of pioneers crossed the Heartland by way of the Oregon Trail on their way west. The first group left Independence, Missouri, in 1841, traveling along the Platte River through Nebraska.

John Jacob Astor, the richest American of his time, built his fortune on fur trading predominantly in the Heartland. He established a base on Mackinac Island in 1817 and persuaded Congress to eliminate government fur trading in 1821. Privatization allowed his American Fur Company to create a de-facto monopoly, and Astor expanded with a series of centers in the Plains and Rockies before he retired to New York in 1834 to concentrate on his real estate operations.

The military helped advance Heartland settlement through construction of forts that provided protection from Indian raids. One installation was Fort Atkinson on the Missouri River near Omaha, Nebraska, built in 1819. This Army garrison remained the largest, westernmost outpost until 1827, when it was replaced by Fort Leavenworth in Kansas. Among the many such forts in the Heartland was Fort Snelling (called Fort St. Anthony until 1825), built in 1819, which served as a garrison for the upper Mississippi River. By 1825 the Indian "solution" no longer involved just the construction of garrisons, but the forcible removal of tribes onto reservations. The Indian Removal Act of 1830 transferred Native Americans from eastern states into Kansas.

The Heartland saw an influx of European immigrants in the 1830s, particularly in Indiana, Illinois, and Michigan, as jobs opened up on the railroads and farms. The Northern Pacific Railroad even printed "help-wanted" ads in Scandinavian languages to attract northern European immigrants to Minnesota.

Most of Minnesota remained in Native American hands, until the federal government signed treaties with the Sioux and Ojibwa in 1837 and acquired large land tracts between the St. Croix and Mississippi Rivers. Lumbering quickly followed, along with settlements at Stillwater and St. Paul. Iowa, too, was sparsely settled until the 1830s. The earliest Iowa community, started on the west bank of the Mississippi in 1828, was dubbed Keokuk in 1834. The state's first public land sale took place in Dubuque in November 1838, and settlers rushed in over the next decade. After spending time first as part of Indiana Territory, then Missouri and Michigan Territories, and finally Wisconsin Territory, Iowa acquired status as a territory in its own right in 1838. Statehood followed in 1846.

Relations were not always friendly among neighboring territories and states during this period. When Ohio held its constitutional convention in 1802, it described its northern border as "an east and west line drawn through the southerly bend or extreme of Lake Michigan." However, no one agreed how far south Lake Michigan extended, and a border dispute followed over the "Toledo Strip." By 1835, troops from Ohio and Michigan Territory squared off on opposite sides of the Maumee River. The "Toledo War" ended when President Andrew Jackson replaced Michigan's territorial governor. Michigan entered the Union in 1837, with its southern border favoring Ohio's claims, but the new state gained the western section of the Upper Peninsula.

Below: *This nineteenth-century Nebraska family's sod house is built into the side of a hill. Prairie sod was cut into bricks that, once in place, were held together by the sod's tough root system.*

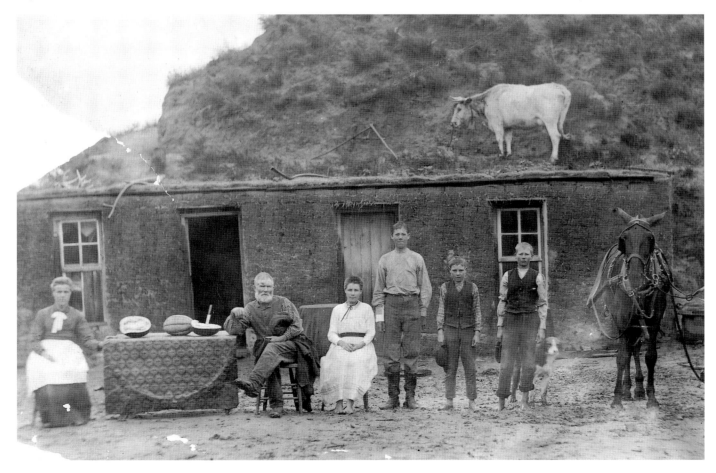

Above: *Iowa farm women and children perch atop a pile of stones created while preparing land for cultivation. While New England is known as the region of rock-bound farms, the Heartland had its own share of rocky soils.*

Opposite: *Situated near Gering, Nebraska, Scott's Bluff was a prominent landmark for settlers traveling in covered wagons along the Oregon Trail in the nineteenth century.*

Settlement of Michigan progressed slowly due to rumors about its swampy and barren soil. After the 1825 opening of the Erie Canal, immigrants came to Detroit. Construction of the Chicago and Territorial Road and arrival of the first railroad in 1836 transformed the area's image, and settlers followed.

Attracted by lead deposits, Wisconsin's first permanent American settlers moved into its nexus with Illinois and Iowa in 1825. By 1829, the population grew to 10,000. In the early part of the century, as territories acquired statehood, the less-settled region of Wisconsin was moved from Indiana Territory into Illinois Territory and then Michigan Territory. It achieved its own territorial status in 1836 and included Iowa, Minnesota, and parts of North and South Dakota. Finally in 1848, it entered the Union as a state, the last of those that had started out under French control.

If new settlement of a region previously inhabited almost exclusively by Native Americans marked the first half of the nineteenth century, politics began stirring up controversy in the Heartland by mid-century. John C. Frémont's expeditions in the 1840s had changed the prevailing view that Kansas land was impossible to farm, and a clamor arose for federal support of settlement. The slave issue heated up to the extent that Kansas went through six appointed governors, four interim governors, and four constitutional conventions in six-and-a-half years of territorial status. Resolution came in the form of the 1854 Kansas-Nebraska Act.

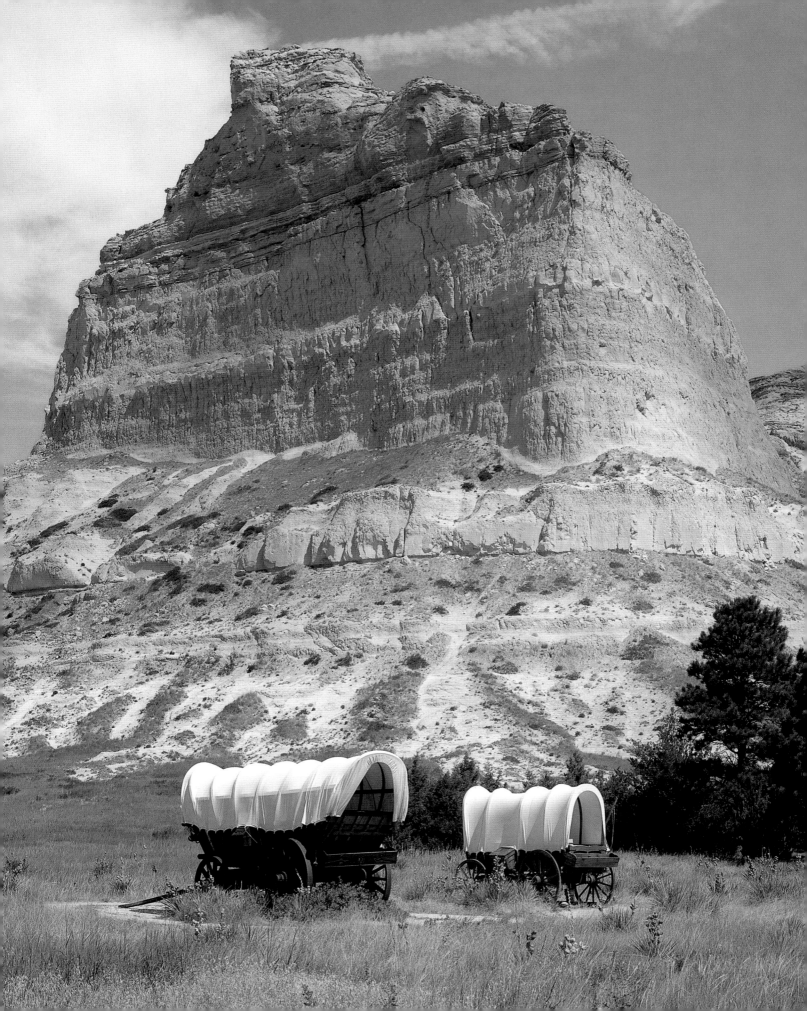

Above: African-American homesteaders John Summer and family pose in front of their Dunlap, Kansas, home. African-American "exodusters," as such homesteaders were called in the post-Civil War era, built an all-black town in Nicodemus, Kansas.

Senator Stephen A. Douglas fashioned a law that left the matter of slavery up to popular sovereignty in the newly created territories of Kansas and Nebraska. Many sectors of the American population were outraged. In Wisconsin and Michigan, the Republican Party was born out of a coalition of abolitionists and Free-Soilers who wanted to keep Southern planters and blacks—free or slave—out of the territories. In retaliation, Southerners supported the 1854 law. Pro-slavery settlers from Missouri headed for Kansas, as did anti-slavery settlers from New England and other parts of the North. Some violence erupted in what became known as "Bleeding Kansas."

The most famous incident involved abolitionist John Brown. Five of Brown's sons settled outside of Lawrence, Kansas, in 1854. When they found themselves harassed by Missouri ruffians, the sons appealed to their father for help. Hearing of plans to turn Kansas into a slave state, the senior Brown left New York, where he was helping resettle slaves and free blacks, for Kansas, carrying a load of weapons. Tensions grew, until Brown joined a paramilitary posse headed by one of his sons. They killed five pro-slavery men along the Potta-watomie River, causing an uproar on both sides of the slave issue. In 1857, Brown returned to Kansas after a stint

in the East to raise money for a slavery-free Kansas. He liberated eleven slaves in Missouri, then moved on to Harper's Ferry, Virginia, to capture its federal arsenal, hoping to start a slave revolt. Instead, he was imprisoned, tried for treason, and hanged.

In the matter of slavery, the spotlight stayed on Kansas rather than less-populated Nebraska during the 1850s. The latter's territory consisted of far more than Nebraska's land area today. Until its current boundaries were set in 1863, it included parts of Montana, North and South Dakota, Wyoming, and Colorado. The controversy over slavery continued to fester, and a Missouri slave took the issue to the Supreme Court. Dred Scott was moved by his owner from Missouri to Illinois and then to

Fort Snelling in Wisconsin Territory. Scott argued that he ceased being a slave once his owner moved him to a free territory. In 1857 the Supreme Court ruled against him, though, thereby making the Missouri Compromise unconstitutional. The slavery issue would soon culminate in the Civil War.

Minnesota, initially included as part of Wisconsin Territory, gained territorial status in 1849. Settlers poured in from the eastern states and Europe, leading in 1858 to statehood, once the slavery dispute was settled in Kansas. The Homestead Act of 1862 offered all comers up to 160 acres each of millions in the upper Mississippi and Missouri valleys. Unfortunately, much of the land went to speculators and railroads. The big push west turned some parts of the

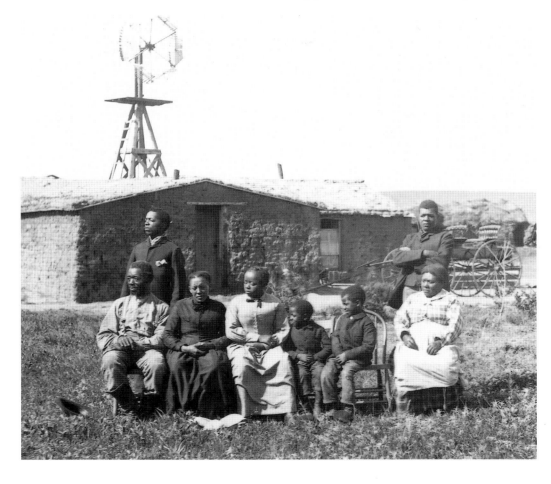

Left: *The Moses Speese family settled in Custer County, Nebraska, in the nineteenth century. Behind their sod house is an early windmill.*

Below: Mrs. Ted Pope, Slope County, North Dakota. Well water was an amenity enjoyed by only the more established nineteenth-century homesteaders.

Heartland into commercial staging areas for pioneers and entrepreneurs. St. Joseph, Missouri, became the easternmost terminal of the Pony Express, which operated from April 3, 1860, until October 21, 1861, when the telegraph ruined its business.

The surge of settlement in the Heartland also led to establishment of a number of institutions of higher education by mid-century. The earliest were the University of Missouri at Columbia, started in 1839; and the State University of Iowa in Iowa City, started in 1847. The University of Minnesota in Minneapolis was founded in 1851. Methodists founded Baker University in Kansas in 1858. Other colleges with religious affiliations followed in Missouri and Iowa. Not to be overlooked was the network of schools, colleges, hospitals, and asylums started by Roman Catholic missionaries.

Although the Civil War was mainly fought along a North-South axis from 1861 to 1865, it affected the Heartland profoundly. The status of the remaining continental territories in regard to slavery, in particular Kansas and Nebraska, could be said to have precipitated the War Between the States. Once Abraham Lincoln came into office, he appointed pro-Union administrators for new territories like Dakota in 1861 and Idaho in 1862.

The Heartland states, some of which were still territories, came down on the Union side, and all sent troops. Missouri was the only exception, its pro-Confederate legislature drawing up an Ordinance of Secession. Yet a second, pro-Union legislature in the hotly contested state also met and elected its own representatives to Congress. Minnesota was the first to respond to Lincoln's call for volunteers, and Indiana was among the earliest. The pride of Ohio was that three of the most prominent Union generals—Ulysses S. Grant, William T. Sherman, and Philip H. Sheridan—were natives of the state.

Missouri was also the one Heartland state that saw significant action during

Left: *Scouts Rest Ranch in North Platte, Nebraska— now a state park— once belonged to William F. Cody. The colorful cowboy and showman acquired the nickname "Buffalo Bill" from his skill at killing buffalo for workers building the transcontinental railroad.*

the Civil War, with twenty-nine battle sites. In the first Heartland engagement, Confederates seized the federal arsenal at Liberty, Missouri, on April 20, 1861. General Franz Sigel was unable to defeat pro-secessionist forces at Carthage on July 5. A month later, Union forces tried again, this time against Confederate forces, in the Battle of Wilson's Creek outside Springfield, and went down to defeat.

On November 1, 1861, General Ulysses S. Grant attacked a rebel force in Belmont, Missouri. The next year, he led forces by water from Cairo, Illinois, into Kentucky and Tennessee, capturing Forts Henry and Donelson. The only battle to take place in Indiana occurred at Corydon, when Confederates crossed the Ohio River and on July 9, 1863, defeated some 400 militia. Kansas paid dearly for its Union support on August 21, 1863, when Confederate forces sacked and burned Lawrence, Kansas. The struggle over Missouri continued, and in 1864, Confederate General Sterling Price attacked Fort Davidson but was driven

off. His campaign was the last action Missouri would see during the war.

If the Civil War was not actually fought in most of the Heartland states and territories, all lost soldiers who had volunteered for action. Twenty-year-old Sarah Seelye joined the Second Michigan Infantry disguised as a man and fought for two years before admitting she was a woman and continuing as a nurse.

In the Reconstruction era following the Civil War, the Heartland continued to attract settlers. Such cow towns as Dodge City and Abilene, Kansas, grew up to serve the cattlemen who drove their herds north from Texas. Some of the most colorful figures of the "cowboy" era lived in the Heartland. Bat Masterson gained fame as a buffalo hunter and sheriff in Dodge City, Kansas. Another Kansas buffalo hunter, Wyatt Earp, worked both sides of the law, getting arrested in Indian Territory for horse theft before becoming a sheriff in Dodge City. James Butler "Wild Bill" Hickok gained a reputation as a gunslinger and became a marshal in Abilene.

Opposite: Martha Jane Cannary, ("Calamity Jane"), above. Below, temperance crusader Carry Nation in a Wichita, Kansas, jail.

Overleaf: Chicago's Schiller building (1892, demolished 1961), also known as the Garrick Theatre, was designed by Louis Sullivan.

Below: Members of the pacifist Anabaptist Mennonites of Russian origin settled in Kansas in 1875.

During the 1870s, Mennonites, a Christian sect started by Dutch reformer Menno Simons, migrated from Russia to Kansas. Excelling as farmers, they developed a winter wheat that became the state's leading crop. By the mid-1880s, railroads carried cattle directly to the East, and the heyday of the cow town was over. Temperance campaigns in the Heartland, like ax-wielding Carry Nation's in Kansas, tried to cap the free-wheeling spirit of such communities, at least as far as their saloons went.

Two natural disasters struck the Heartland in the 1870s. Railroad workers clearing brush in northeastern Wisconsin are believed to have started what became the worst forest fire in American history. The year was 1871,

and 1.2 million acres were razed in the Peshtigo Forest Fire. Named after the town where three quarters of the fire's 1,200 victims died within one hour, it occurred the same day as the Great Chicago Fire and caused as much damage. A grasshopper plague invaded Nebraska's farms for three years starting in 1874, temporarily slowing the arrival of settlers to that state.

Although Dakota Territory was formed in 1861, investors didn't start grabbing up land there until after gold was found in the Black Hills in 1874. The discovery set off a rush into the region and towns like Deadwood, South Dakota, cropped up. "Wild Bill" Hickock and Martha "Calamity" Jane Cannary are both buried there. By 1878,

the "Dakota Boom" brought a new tide of white settlers into the last unsettled region of the Heartland. In the twenty-year period from 1870 to 1890, the population leapt from 12,000 to 350,000. Many were immigrants who came from Germany, Britain, Russia, and Norway. By 1889, North and South Dakota each became states in their own right.

As the population of the Heartland ballooned, its once empty, wide-open reaches changed. Labor unrest emerged in the 1880s. When a group of Chicago anarchists demonstrated in favor of an eight-hour workday on May 4, 1886, the Haymarket Square Riot ensued and eleven died. Farmers began organizing to protest the high shipping rates of railroads. The Patrons of Husbandry or National Grange, founded by Oliver H. Kelley in 1867, became a focal point to

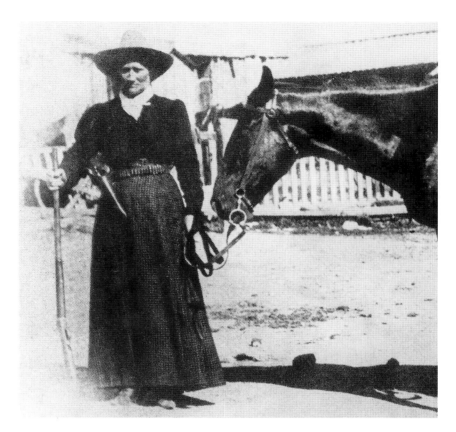

promote government relief for farmers. Missouri, Wisconsin, Minnesota, Iowa, and Illinois soon passed rate laws, and in 1887 Congress passed the Interstate Commerce Act.

What started as agrarian discontent in the Heartland blossomed into a more complex national political movement that worked toward establishment of a third party. The National People's Party came about as the result of conventions held in Cincinnati, Ohio, and Omaha, Nebraska, in 1891. Drafted by Minnesotan Ignatius Donnelly, the Populist platform proposed government ownership of American railroad, telegraph, and telephone systems; graduated income taxes; and return of public lands not needed by railroads. Their credo was government to protect the weak from the strong. "Silver-tongued orator" William Jennings Bryan's defeat in the presidential election of 1896 signaled the decline of the Populist Party, which had supported him in conjunction with the Democratic Party. Historian William Hofstadter called the Populists the first modern political movement in the U.S. to "attack seriously the problems created by industrialism," and many Populist reforms were eventually adopted.

If one event epitomized the position of the Heartland in American culture at the end of the nineteenth century, it was the 1893 World's Columbian Exposition, held in Chicago, Illinois. Marking the 400th anniversary of Christopher Columbus's discovery of America, it featured 150 buildings designed by the leading architects of the day, including a Transportation Building by Louis Sullivan and landscaping by Frederick Law Olmsted.

At Work
in
The Heartland

Previous page: Hay bales dot a field near the tiny town of Freeburg, Missouri. The land here in Osage County originally belonged to the Osage, Shawnee, and Delaware, who used it for hunting. Settlers started arriving in the 1830s and soon began to cultivate the land.

Most settlers who moved into the Heartland around 1800 fulfilled the dream of owning and working their own land. The established population centers of the South and North also provided a ready market for what the Heartland could export, so farming quickly became an important Heartland for-profit business. By the time the century ended, however, the people of the Heartland were working at a vast range of jobs.

The Mississippi and Missouri River systems provided the best means of transportation, and rafts, keelboats, and steamboats laden with agricultural produce—wheat in particular—left the Heartland for points east and south. Two regions in Ohio attracted New England farmers whose soil or patience had given out. The Western Reserve, lands on Lake Erie kept by Connecticut when it ceded claims to the Northwest Territory; and the Ohio Company of Associates, founded in 1786 in Boston, Massachusetts, promoted settlement along the Ohio River. In addition to Ohio, they moved into Michigan, Indiana, Illinois, and Wisconsin. When wheat yields declined, they switched to dairy products. Northern Europeans came to those same areas, bringing new seed varieties and plants with them. In particular, the Mennonites who emigrated from Russia to Oklahoma and Kansas starting in 1873 brought with them the hardy "Turkey Red" wheat that thrived in the new environment. By the last quarter of the century, Wisconsin became "the nation's dairyland" and a cheese-making capital, spurred by Swiss and other European immigrants.

The development of refrigerated rail cars ended the need for cattle drives to towns like Abilene and Dodge City, Kansas. Cattle herds were, however, brought to South Dakota in the 1870s to feed gold miners there, and cattle ranching took hold, as well as in Kansas and Nebraska, in the latter part of the century.

Fur trading provided incomes for many of the earliest Heartland settlers. After Congress banned foreign companies from the American fur trade in 1817, fur magnate John J. Astor made an alliance in St. Louis with the Chouteau family who had helped start the Missouri Fur Company. With their cooperation he was able to establish a monopoly for his American Fur Company that lasted from 1821 to his retirement in 1834. Fur trading, along with railroads, helped turn St. Louis into a major Heartland metropolis.

At the end of the eighteenth century, American fur trading operated under the factory system. It consisted of a series of posts, or "factories," where Native Americans could exchange furs for goods. The goal was to encourage trappers to trade with Americans rather than the British and to allow Native Americans to function free of white interference in their own areas. After the War of 1812, procedures changed, most importantly, by elimination of the one-year credit terms that allowed trappers—Indian or white—to draw against future fur trades. This change severely disadvantaged trappers. In the nineteenth century, annual rendezvous were set up where trappers could meet after a winter of trapping, trade their pelts, and acquire goods brought in from St. Louis. As the terminus for the Santa Fe Trail, Independence, Missouri, also benefited from fur trading.

If farming and furs provided the commercial base of the Heartland at the start of the nineteenth century, other com-

mercial ventures also became important. The earliest explorers learned about lead deposits in Missouri from the Native Americans. Frenchman Philippe Renault had brought 200 French miners and 500 Santo Domingan black slaves north from New Orleans in 1719 to work the Mine LaMotte outside of St. Louis. The old mine's cave system, now underwater, is still there. The Southeast Missouri Lead District in the Flat River region south of St. Louis, Missouri, was opened up in 1800. It became one of the world's biggest lead producers.

Julien Dubuque, who began mining lead outside Dubuque, Iowa, in 1788, also directed mining east of the Mississippi River in Wisconsin. The end of the War of 1812 brought settlers into the region, attracted by the "Spanish mines," so called because of Dubuque's Spanish permits. Galena, Illinois, became the supply center for miners, merchants, and tradesmen in this tri-state mining area. By the mid-1820s, a lead-mining boom

was underway and lasted into the 1840s when the deposits began to run out.

Michigan's Upper Peninsula proved to have rich deposits of iron in the Marquette, Gogebic, and Menominee Iron Ranges in the 1840s. Chippewa Chief Marji-Gesick guided agents of the Jackson Mining Company to the iron deposits at Negaunee, and mining began in 1846. The company's forge on the Carp River, built in 1848, is now the site of the Michigan Iron Industry Museum. Minnesota profited from the discovery of rich iron-ore deposits in the 1880s. Leonidas Merritt and his six brothers, called "The Seven Iron Men," discovered and opened the Mesabi Range in 1890–2; it would prove to be one of the richest iron-ore mining sites in the world.

Copper was another important metal for Michigan miners, once the Chippewa Indians ceded 30,000 acres on the Upper Peninsula. Thousands joined the Copper Rush of 1843. Long after California's Gold Rush subsided, miners discovered the

Below: *El Vaquero, the Achison, Topeka and Santa Fe railroad depot for Dodge City, Kansas, opened in 1896. It featured a Harvey House lunchroom, and also, from 1900 to 1948, a hotel, one of the larger Harvey Houses in Kansas.*

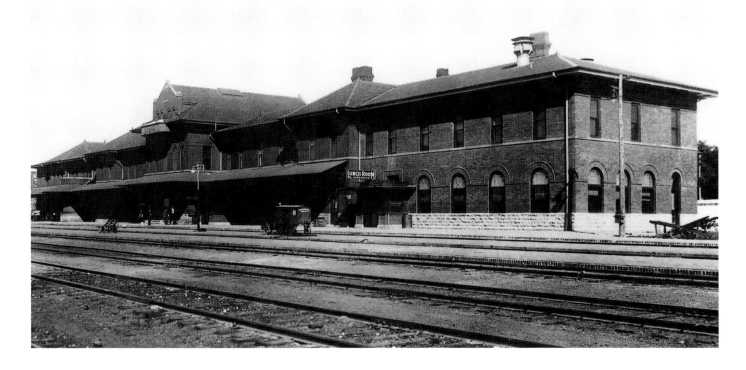

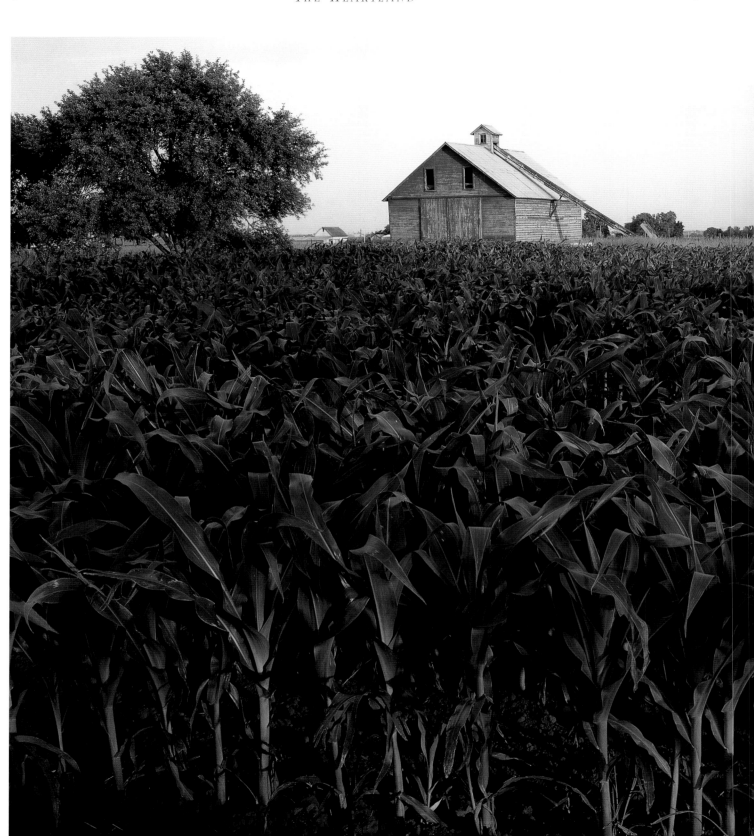

Great Homestake Lode, the largest gold mine in America, in Lead, South Dakota, in 1876. This mine still produces nearly 400,000 ounces of gold a year. Dating from the 1830s, Illinois quarries at Thornton—the second largest in the world—produced limestone. Finally, by the end of the century, oil was discovered in Kansas and Ohio.

In colonial times when trapping was done primarily by Native Americans, trappers transported their pelts by canoe, and white Americans followed the same pattern until the introduction of the keelboat. At the beginning of the nineteenth century, the keelboat, as long as 80 feet and outfitted with a mast and sail, dominated river traffic on the Heartland's main thoroughfare, the Mississippi River, and its tributaries, the Ohio and Missouri. Loaded not only with beaver pelts but products like flour, salt, and iron, the keelboat headed west and south. On the harder, upriver journey it carried sugar, coffee, lead, and more pelts. Where the current was swift, "Mike Fink" and other legendary boat handlers "bushwhacked" by grabbing onto tree branches to pull the boat forward or used tow lines. Otherwise, they poled, earning 80 cents a day.

Once steamboats like the flat-bottomed *Washington* demonstrated in 1817 that steamboats could navigate tributaries as well as the Mississippi, the boatyards of Cincinnati, Ohio, bustled with activity. By the 1850s, St. Louis outpaced Cincinnati in boat building.

After the *Virginia* steamed north on the Mississippi as far as the mouth of the Minnesota River in 1823, the route between St. Louis and Wisconsin's lead mines became heavily traveled. Loggers floated their timber downriver in the

Left: Corn nears maturity in LaSalle County, Illinois. Located south and west of Chicago, LaSalle County was named after French explorer Robert LaSalle.

Below: *The Deadwood stagecoach ran between Deadwood, South Dakota, and Cheyenne, Wyoming. The Wells Fargo Company operating the stagecoach shipped tons of gold from the Black Hills mines out of Deadwood in the late nineteenth century.*

form of rafts until after the Civil War, when steamboats took over the job, pushing acres of floating wood down-river. Native Americans and non-native traders alike stood with mouths agape when the 144-ton *Yellow Stone* arrived at the mouth of the Yellowstone River in Dakota Territory in 1832. By the time the fur trade declined in 1850 from over-trapping and changes in clothing styles, steamboat travel was well established in its own right.

Traveling up and down the Mississippi River with a rich array of freight and passengers, the steamboat enjoyed its heyday from 1850 to 1870. Riverboats carried goods and travelers to towns like Brownsville, which today calls itself the "Oldest Little River Town in Nebraska."

First-class travelers strolled on floral carpeting, ate five-course meals and parked their children in on-board nurseries. Humbler folk, trappers, immigrants, farmers, and other "deckers," slept atop cargo next to livestock and drank river water while traveling as far as 500 miles for a dollar. Showboats brought music, melodrama, and burlesque to riverside communities, often in barter for produce. Towed by a side-wheel steamboat, the Floating Circus Palace could seat an audience of 1,000.

When nature failed to provide needed commercial water routes, canals filled the breach. In the inflationary 1830s, banks offered easy credit and legislatures planned ambitious infrastructure improvements. The Wabash and Lake

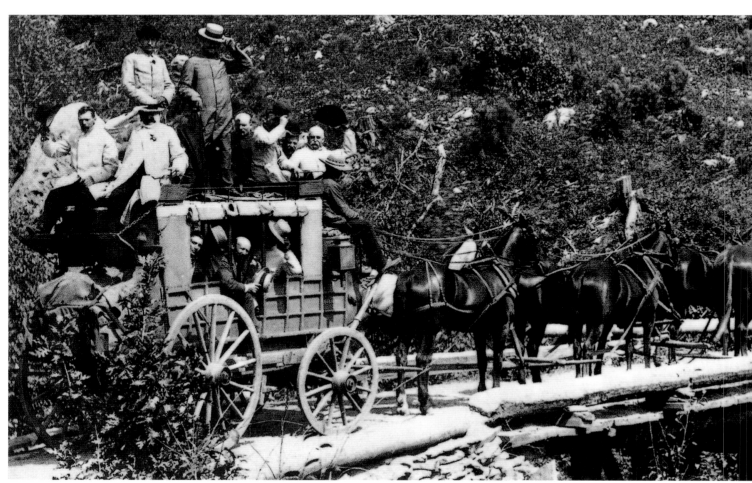

Erie Canal linked Toledo, Ohio, with Evansville, Indiana; the Illinois and Lake Michigan Canal connected Chicago to LaSalle on the Illinois River. Both were completed in 1848. As late as 1852, Congress provided the acreage to build the Sault Ste. Marie Canal between Lake Superior and Lake Huron so that iron ore could be shipped through the Great Lakes. It was completed in 1855.

Called the steamboat of the plains, the prairie schooner carried freight where rivers couldn't. This wagon was smaller than the Conestoga and well adapted to the region. Named after its boatlike shape, it transported everything from mining equipment to tobacco and firearms. When Clement and Henry Studebaker, sons of a Pennsylvania blacksmith, moved to South Bend, Indiana, in 1850, they set up shop to make prairie schooners and became some of the best-known wagon makers. Two other brothers, John and Peter, joined the operation, which incorporated as the Studebaker Brothers Manufacturing Company. Many years later, it became famous for the Studebaker ("Is it Coming or Going?") automobile.

Colorful as steamboats, canals, and prairie schooners were, railroads—still the most efficient and versatile form of inland transportation today—did the most to settle the Heartland. Like the paddlewheels, they were powered by steam and started crisscrossing the region by the 1840s. Michigan's first railroad was opened in 1836 between Toledo and Adrian. The Chicago and

Overleaf: Grand Haven Lighthouse, situated on the western shore of Lake Michigan and operated by the U.S. Coast Guard, was built in 1839. Pictured here under winter conditions, it consists of two lights, a cylindrical one and a second on a massive concrete base, connected by a catwalk.

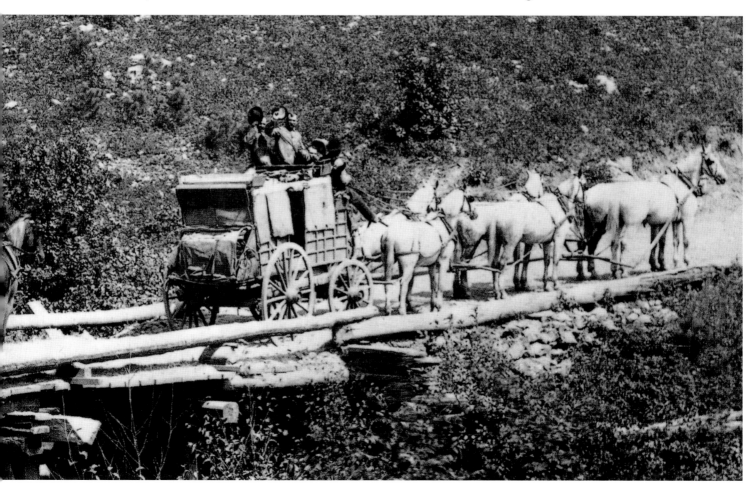

Northwestern Railroad started out as the Galena and Chicago Union, took too long to raise money, and ended up connecting Chicago and Elgin in 1850, adding Rockford in 1852 and Fulton in 1855. The Illinois Central beat them to lead-rich Galena. The Chicago and Rock Island reached the Mississippi in 1854 and continued into Iowa. As soon as the Northern Pacific reached Dakota Territory, railroad towns like Fargo and Bismarck sprang up.

Lumbering, which followed the waves of migration into the Great Lakes region in the 1850s, produced wood for railroads and white pine for housing in the Heartland's cities during the post-war years. By 1880, Michigan led the Heartland states in production. Saginaw alone had more than seventy lumber mills. As trees were cut down, logging moved north, first into the Upper

Peninsula, then on to Wisconsin and Minnesota. In Hinkley, Minnesota, a lethal fire raced through the pines on September 1, 1894, killing 413 people and making history as one of the nation's worst forest fires.

As far south as St. Louis, towns along the Mississippi built their own sawmills to process the stock that was floated downriver. In the era before power saws, most logging was of softwoods like pine, and once the supply was depleted, lumbering moved on.

One of the offshoots of the lumber industry was furniture manufacturing. Furniture making in Grand Rapids, Michigan, which still dubs itself "The Furniture Capital of America," actually dates back to 1837. That year William "Deacon" Haldane arrived and set up business as a cabinetmaker, building furniture by hand. Importing a circu-

Below: The Keystone, Nebraska, depot for the Union Pacific Railroad featured a "Payne Special" car probably in 1906, since the Payne Development Company auctioned off lots for the the town in July of that year.

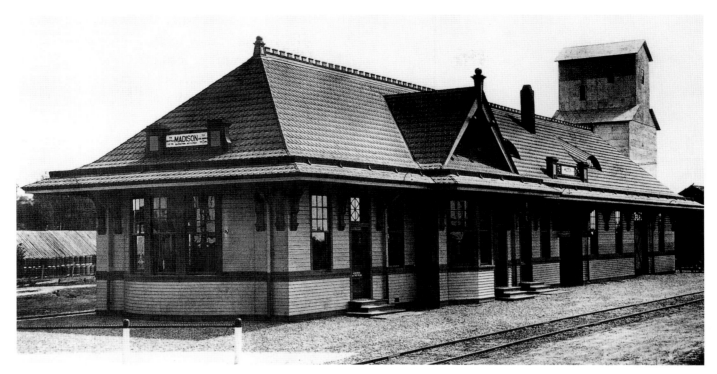

lar saw and lathe from Ohio, Haldane mechanized the process in 1848, and furniture manufacturing got underway. By 1850, Cincinnati, Ohio, along with other Heartland cities, housed their own factories, turning out tables, chairs, bureaus, and bedsteads.

When the Civil War erupted in 1861, commercial and industrial development of the Heartland went on hold, except for companies like Studebaker, which won wartime contracts, in their case to construct military wagons. One form of business that arrived in Missouri after the Civil War was not particularly welcome. Veterans who fought on the losing side of the War Between the States turned to bank robbery or train and stagecoach holdups, bringing a crime wave to that contested state. Jesse Woodson James and his brother, Alexander Franklin "Frank" James, were born into a minister's family in Clay County, Missouri. Both fought with Confederate renegades like William Clarke Quantrill. After the war, the brothers robbed their first bank in Liberty, Missouri, February 13, 1866, killing a bystander. The following years, they were responsible for robberies from Iowa to Alabama. In Kansas City, they held up the box office at a fair attended by 10,000 people, wounding a little girl. In 1881, Missouri put a $5,000 reward on each of their heads. Jesse was shot at home on April 3, 1882, and Frank surrendered a few months later. Such was the legend of the James Brothers that Frank was never convicted and lived quietly until his death in 1915.

Another unpleasant post-Civil War phenomenon was the wholesale slaughter of bison, or buffalo, (the latter a name probably adapted from French explorers). The economic impact of the bison surpassed that of the beaver or the whale. By the 1830s, bison east of the Mississippi had been decimated, but millions still existed on the plains and prairies of the Heartland. Bison meat

Above: *In Madison, Nebraska, the handsome railroad depot for the Achison, Topeka and Santa Fe line was put on the National Register of Historic Sites in 1991. A grain elevator rises behind the station.*

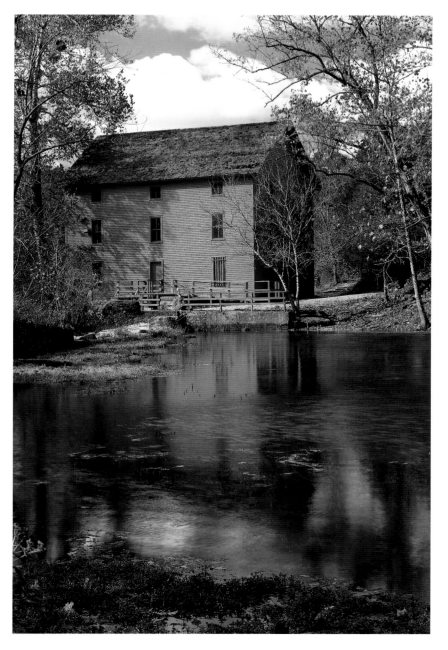

Above: *The Alley Spring Mill, originally known as the Barksdale Spring Mill, was built in 1870 in Eminence, Missouri. Part of the Ozark Scenic Waterways, it is said to be the most frequently visited Ozark spring.*

Territory by rail in 1884. Not all bison were killed for profit. Sport hunting became a popular pastime, and men like "Buffalo Bill" Cody took groups of hunters on bison kills. Waking up to what was in fact a devastating loss to the country, Congress passed protective legislation in 1894.

Mechanization liberated farming from some of its more time-consuming, back-breaking chores. Equipment like the reaper, the thresher, the drill, and new plows made larger operations possible. Before the Civil War, the major wheat producers were Illinois, Indiana, Wisconsin, and Ohio. By 1869 Iowa was the second-highest producer, and ten years later Minnesota was tops. From 1860 to 1870, the wheat crop grew from 2 million to 19 million bushels, and by 1890, it peaked at 95 million bushels. Flour mills developed as a natural extension of wheat farming, and after wheat depleted the soil, Minnesota's farmers expanded dairy production, aided by invention of the cream separator in 1878.

Bonanza farms, each with at least 3,000 and up to 65,000 acres, sprang up in North Dakota after one of the financiers of the Northern Pacific Railroad went bankrupt. A group of East Coast entrepreneurs who wanted to build a railroad from Wisconsin to the Pacific had engineered the largest government railroad grant in history. Strapped for cash after the project bankrupted financier Jay Cooke, they sold off tracts of land for farming. Purchased out of the railroad land grant, these Red River Valley Bonanza farms thrived from the 1870s into the early 1900s, producing "No. 1 Hard" wheat. The high profits of these operations attracted new settlers, with more than 100,000 arriving between 1879 and 1886.

and byproducts were long vital to the Native American way of life. For Indians and Anglos alike, buffalo robes soon became a valuable trading commodity, and by 1880, the Southern Plains were almost devoid of bison. The Northern Plains were next. By 1879, Nebraska lost most of its herds, and bison were annihilated from Dakota Territory by 1883. What may have been the last load of buffalo robes traveled out of Dakota

Americans usually do not talk about higher education in the same breath as commerce and industry, but in fact education is important both to the development of those ventures and as a business in its own right. The 1862 Land-Grant College Act gave funding to all states and led to some of the Heartland's greatest institutions of higher learning. Establishment of a state university was seen as an important governmental role for territories drafting constitutions, more so than in the East, where religious groups tended to

Below: *Hyde's Mill in Iowa County, southern Wisconsin, was built in 1850. At one time, Wisconsin had more than 1,500 flour and grist mills.*

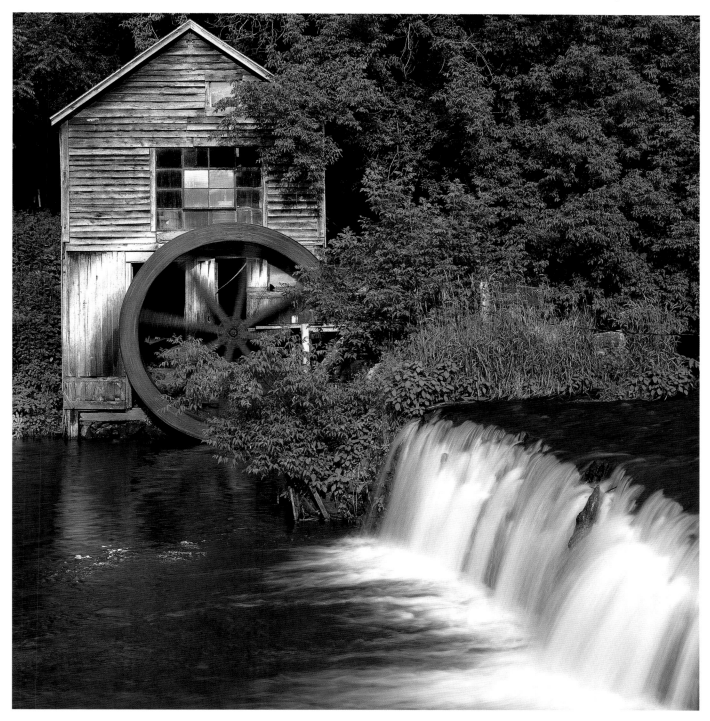

Page 112: Mackinac Island became a popular destination for vacationers in the later nineteenth century. The federal government created Mackinac National Park in 1875.

sponsor colleges and universities early in the nation's history. An endowment early on from the Ohio Company enabled founding of two educational institutions in that state: Ohio University, in Athens in 1802, and Miami University at Oxford in 1809. Since the Morrill, or Land Grant, Act didn't apply to territories, the Land Act of 1881 was drafted, ensuring that Dakota and Idaho Territories, among others, would have land reserved for universities.

Legislation known as two-township grants gave additional land of 30,000 acres for each senator and representative of a state to endow colleges with specialties in agriculture and mechanical arts. These led to support for the University of Kansas, founded at Lawrence in 1863; the University of North Dakota, at Grand Forks in 1883; and the State University of South Dakota, at Vermillion in 1862. The Land Grant and Two-Township grants were not mutually exclusive, and some states combined them: for instance, the University of Minnesota, the University of Missouri, and the University of Nebraska, founded at Lincoln in 1869. Heartland land-grant colleges funded only by the Morrill Act included Iowa State College, founded at Ames in 1858; Kansas State University founded at Manhattan in 1863; and North Dakota Agricultural College, founded at Brookings in 1888. By the 1890s, most Heartland states provided additional support to their state universities through a combination of tax levies and free tuition. Extension services offered information to farmers and towns, thanks to the Hatch Act of 1887.

One of the Heartland's greatest men, by the way, inventor Thomas Edison, had very little formal education. Born in Milan, Ohio, in 1847, he conducted his earliest experiments in Michigan after his family moved to Port Huron.

Some Heartland recreational activities, so important a commercial enterprise for the region in the twentieth and twenty-first centuries, got their start in the post-Civil War years. The Cincinnati Red Stockings, financed by a group of Ohio investors, became the first professional baseball team in 1869. They had a 69-0 win-loss record in their first season and replaced New York as the baseball capital of the country, although most of their players were from New York. Many nineteenth-century sports were not so romantically bucolic. Some involved marksmanship, a strategic survival skill in the Heartland. Others were closely associated with work, such as plowing and team-pulling contests. Women might participate in haying, threshing, husking, or flax-scutching (separating) bees. Logging generated birling (log-spinning) contests, as well as chopping and sawing competitions. Community rabbit drives used clubs to down prey. Competitions between communities might feature foot-racers, wrestlers, and fighters.

Gambling, a favorite nineteenth-century pastime, went hand in hand with the risks necessary to succeed in the frontier-style world of the Heartland. Bunco, or swindling, shell games were popular, as was three-card monte. Card games included faro, five-card draw, and blackjack. Many did not approve, and after five professional gamblers were lynched in Mississippi in 1835, Cincinnati, among other cities, had an anti-gambling campaign. Albert Showers and Bob Potee fleeced cowboys and cattle kings alike in Kansas City in the 1870s, until Missouri passed an anti-gambling law.

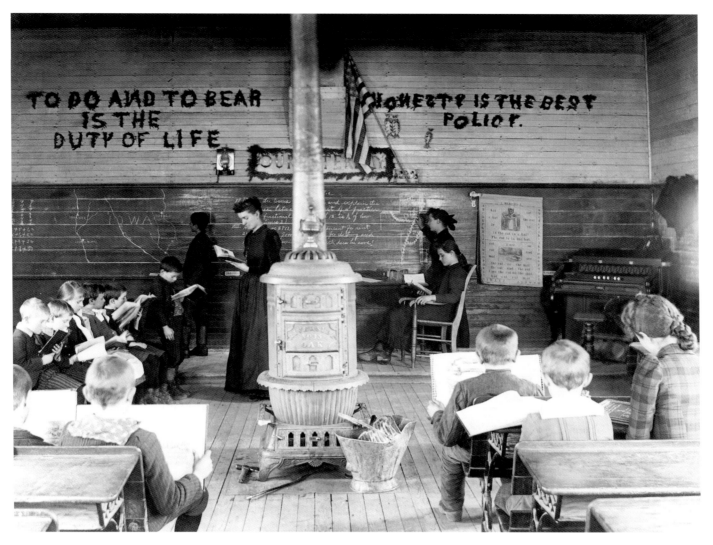

Heartland resorts became popular during the nineteenth century. One example is Mackinac Island, Michigan, which became a national park in 1875, then a state park in 1895. The Mission House, once an Indian school, was converted into a hotel in 1850. The Island House was built in 1852 and the Lake View House, in 1858. By the 1870s, the island grew so popular that existing hotels had to expand, and new facilities, like the Murray, built in 1882, and the elegant Grand Hotel, built in 1887, opened their doors. With its 627-foot veranda overlooking the Straits, the Grand still bills itself as the largest summer hotel in the world.

At the close of the nineteenth century, there were already glimmers of a brave new world in the Heartland. Michigan native Henry Ford completed his first working automobile, the Quadricycle, in Detroit in 1896. Another engineer who had spent time experimenting with gas-powered steam engines, Ransom E. Olds, began driving a horseless carriage the same year. The following year a group of Lansing, Michigan, businessmen financed the Olds Motor Vehicle Company, which built four cars. In this way, the automobile, which was to transform American life in the twentieth century, had its start in the Heartland.

Above: Bear Creek Township in Iowa was one of the first townships established in Poweshiek County. The school pictured here in the late nineteenth century was one of nine originally designated for each township, and it stood next to a Quaker meeting house.

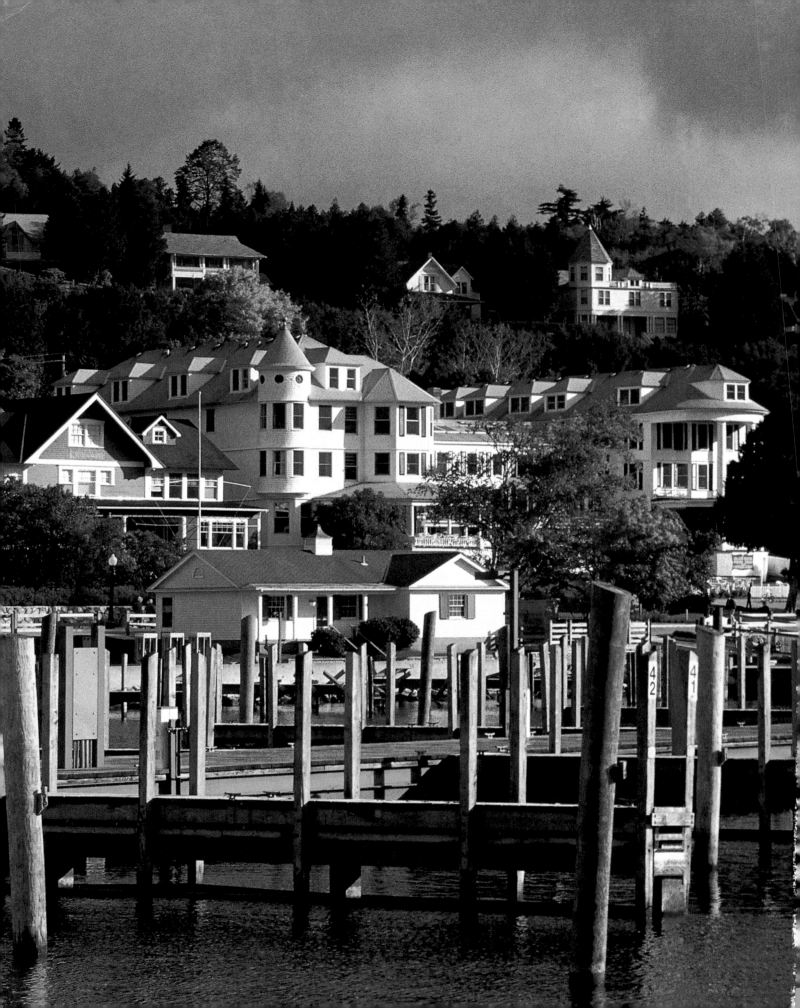

INTO THE
TWENTIETH
CENTURY

Previous page:
Reflecting the level of tourism in the Heartland's St. Croix River valley, this Osceola, Wisconsin, store sells "antiques" or "collectibles." The Fond du Lac County town was settled around 1845 and named after a well-known Seminole chief.

In 1893 a young American historian, Frederick Jackson Turner, read a paper before the American Historical Association's special gathering in honor of the Chicago World's Columbian Exposition. Titled "The Significance of the Frontier in American History," it charted the role that the ever-available territories of North America played in shaping the American experience, and it concluded that the frontier had come to an end. In effect, Turner was claiming that the Heartland had now become a fixed and stable entity. Perhaps in the strict sense of geographical boundaries and available land, this was true, but during the first half of the twentieth century the Heartland would prove that there were many more frontiers to take on and develop.

The turn of the century was a time of turmoil and change for the Heartland, especially its youngest states, North and South Dakota. President Benjamin Harrison shuffled the signing papers so that both sections of Dakota Territory became states in 1889, but no one knew which was the thirty-ninth and which, the fortieth (although North Dakota is now officially recognized as the thirty-ninth).

North Dakota's giant Bonanza farms, which dazzled so many, went bust after wheat prices fell in 1890. Badlands ranchers lost cattle to thirst in summer and freezing temperatures in winter. In South Dakota, 60 percent of the homesteaders couldn't "prove up," or hold onto their land, for the requisite five years. If drought didn't kill crops, then hailstorms, blizzards, or grasshopper plagues did. By 1898, a burst of new settlers arrived in North Dakota, necessitating lotteries to give away land, and homesteading reached its peak by 1906. North Dakota became the leading producer of spring wheat, and cattle and sheep ranching in South Dakota was bounced back after restructuring.

Right: *This early twentieth-century photograph illustrates wheat harvesting in South Dakota during the days before gas-engine farm machinery. The horses are probably wearing sheets to protect them from insects.*

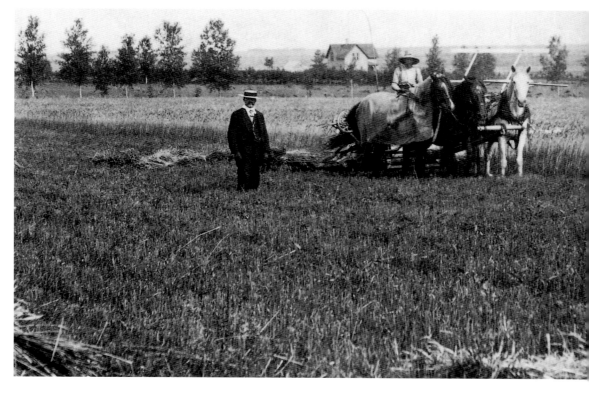

In 1902 the Newlands Reclamation Act brought in federal monies to attack Heartland drought problems with irrigation ventures like the North Platte project in Nebraska. The Keokuk Dam in Iowa, finished in 1910, was at the time the largest hydroelectric dam in the world. Recognizing how difficult it was to make a go of conventional 160-acre homesteads, Nebraska Representative Moses P. Kinkaid sponsored a bill increasing parcels to 640 acres. Wheat was still king in Kansas at the turn of the century, and corn reigned in Iowa. In the spring of 1913, though, flooding of the Ohio and Upper Mississippi River valleys brought devastation to communities like Tiffin, Ohio, and led to new flood-control projects.

In 1904, St. Louis hosted the Louisiana Purchase Centennial Exposition, featuring more than 200 buildings and two square miles of exhibits. Technology was the byword, including the first successful demonstration of wireless telegraphy from ground to air. Initially, the new century's most radical technology, the automobile, was thought of as a toy for the rich. In 1901 the cheapest car, the Oldsmobile, cost $695. Henry Ford's Model T, known as the "Tin Lizzie," put this new-fangled machine in reach of the average working man. Some 15 million Model Ts were sold between 1908 and 1927. Although automobile manufacturers sprang up throughout the Heartland—Indiana's Studebaker Brothers introduced an electric car in 1902—Michigan would soon dominate. It was the home of Ford and Olds, a well-established system of factories and ready ports in the Great Lakes.

Development of the new automobile industry had many ramifications for the Heartland. Dr. Benjamin F. Goodrich, who established a rubber company in Akron, Ohio, in 1870 and started out manufacturing bicycle tires, moved on

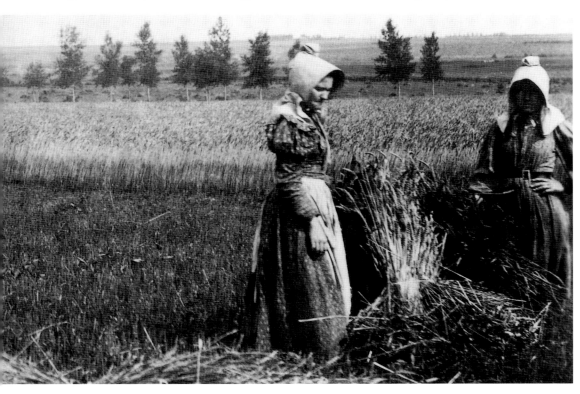

Right: The Henry Ford Museum and Greenfield Village complex in Dearborn, Michigan, features the largest indoor-outdoor museum in the U.S., as well as a replica of a 300-year-old American village. The museum was originally known as "Henry's attic."

Below: A vintage John Deere tractor, probably dating from the 1950s, pulls a modern-day hay rake. The John Deere Company began by making steel plows in Vermont, and after relocating to Moline, Illinois, in 1852, the company began building tractors in 1918.

to automobile tires. Ford's genius was not limited to invention of the Model T. Through product standardization and adaptation of the conveyor belt and assembly line to automobile production, he also revolutionized manufacturing techniques. In addition, his employees received high wages and profit sharing.

The success of the automobile industry also boosted agriculture, as tractors and other farm equipment came into production. Prodded by the automobile manufacturing, both steel mills and oil refineries began to appear in the Heartland. As if in anticipation of the automobile's advent, Standard Oil had

built one of the largest oil refineries in the world in Whiting, Indiana, in 1889. Founding the city of Gary, Indiana, U.S. Steel built a steel mill there in 1906. Construction of the Minnesota Steel Company near Spirit Lake began in 1910. Opening in 1909, the Indianapolis Motor Speedway ran the first Indianapolis 500, the oldest automobile race in America, in 1911. It still remains the testing ground of new technology for most car manufacturers. Once the automobile was introduced, planning, construction, and maintenance of Heartland highways got underway, and in 1916, the Federal Aid Road Act provided matching funds.

The automobile had a profound impact on tourism in the Heartland. Resorts like Michigan's Grand Hotel on Mackinac Island lost business when travelers took to their cars and stayed at motels. Meanwhile, Henry Ford's Greenfield Village, designed in 1928 to house the Henry Ford Museum and the Edison Institute, became an attraction for newly mobile tourists.

Just as Populism gave voice to political discontents in the Heartland during the nineteenth century, Progressivism did in the early twentieth century. After Ohio native and conservative William Howard Taft won the White House in 1908, Theodore Roosevelt helped oust him by running as the candidate of the progressive Bull Moose Party and splitting the Republicans. "Battling Bob" La Follette, elected governor of Wisconsin in 1900 and 1902, brought a variety of progressive reforms to the Badger State, including direct primaries, child labor laws, and big business taxation. Known as the Wisconsin Idea, such reforms provided the model for progressives in other states and the nation as a whole. La Follette ran for president as a Progressive in 1924 but lost by default to Calvin Coolidge. Illinois was also active in the Progressive Movement and became one of many Heartland states where the campaign for women's suffrage began early on. In North Dakota, farmers founded the Nonpartisan

Right: Two of the most celebrated women to come out of the Heartland are Jane Addams (near right) and Carrie Chapman Catt. Born in Ripon, Wisconsin, and raised in Charles City, Iowa, Catt was a major figure in the woman suffrage movement and in 1920 founded the League of Women Voters. Addams, born in Cedarville, Illinois, founded and ran the world-renowned Chicago social settlement, Hull House.

League in 1915 to lobby for state ownership of grain elevators, banks, and flour-mills, and in 1919 the state enacted much of their platform. The same reformist spirit may have inspired Father Edward Joseph Flanagan, the Irish immigrant priest who came to Omaha, Nebraska, and first founded the Workingman's Hotel, a shelter for homeless men; then in 1917, the Home for Homeless Boys, popularly known as Boys Town.

Cereal became another important product of the Heartland, starting in the early twentieth century. Dr. Will Keith Kellogg and his brother John Harvey Kellogg, both Seventh-Day Adventists and therefore vegetarians, accidentally invented cornflakes while searching for a better diet for their Battle Creek, Michigan, sanatorium patients. Will founded the Battle Creek Toasted Corn Flake Company in 1906.

When the "War to End All Wars," as World War I was called, started in 1914, the Heartland, like most of the United States, favored neutrality. U.S. foreign policy promoted isolationism, and

Heartlanders were strong advocates of this, despite or because of the many European immigrants who had settled there. Although he supported Woodrow Wilson's 1912 election, Wisconsin's La Follette was a leader in the peace movement. Once the U.S. entered the war in 1917, La Follette opposed conscription and the Espionage Act. Wisconsin Women's Suffragist Carrie Chapman Catt and Chicago Hull House founder Jane Addams were also both pacifists. Addams attended the International Congress of Women at the Hague in 1915 and worked for the Women's Peace Party after the U.S. entered the war. Another Chicago organization, the Heartland Alliance, founded in 1888, was active in humanitarian causes during World War I.

The Heartland's many industrial and farm products made important contributions to the war effort. Dry farming, a means of tilling fields to conserve soil moisture that originated in the Plains states, helped expand wheat production. Detroit's burgeoning automobile indus-

try converted to production of military vehicles. In Galena, Illinois, the Savanna Army Depot tested ammunition. Illinois also provided an Infantry division, called the Big Red One; and the 8th Illinois National Guard, consisting almost entirely of African-American officers, became the 370th U.S. Infantry regiment. Navy personnel were trained at the Great Lakes Naval Center in Illinois, and Ohio sent a National Guard Unit. Private Merle Hay of Glidden, Iowa, and Corporal James Gresham of Evansville, Indiana, became two of the first three Americans killed overseas, and a monument memorializes them in France.

Factories, which had geared up during World War I, continued to attract workers, turning Michigan into an urban state by the postwar years. Until the end of World War I, more cars were produced in Indiana than anywhere else in America. Made in Indianapolis were the luxurious Lafayette, the Stutz, and the Duesenberg. Columbus manufactured the double-wheeled Reeves Octoauto, and Evansville turned out the Simplicity.

After World War I, wheat and corn prices fell because of overproduction. In 1919, Iowa produced 16 percent of the nation's corn, with Illinois, Indiana, Ohio, and Nebraska following, but foreign demand dropped. In North Dakota, farmers went broke, and banks failed. Wisconsin's dairy farmers, who had expanded production with government-set livestock and milk prices, were squeezed by postwar inflation as well as lower prices.

World War I also had a social impact. In both Wisconsin and Illinois, some German-Americans felt the aftermath of the wartime hostilities. African-Americans migrated north to Michigan and Illinois, attracted by factory jobs, and competed with poor whites for jobs and housing. Race riots shattered East St. Louis in 1917 and Chicago in 1919.

Overleaf: Mount Rushmore National Memorial, with its Avenue of Flags from fifty-six states and territories, was built by sculptor Gutzon Borglum with the help of 400 stoneworkers between 1927 and 1941. It features Presidents George Washington, Thomas Jefferson, Abraham Lincoln, and Theodore Roosevelt.

Below: Group Bible-study meetings were popular at the beginning of the twentieth century. This Friday Bible Class was photographed at the home of J. H. Leavitt in Waterloo, Iowa, ca. 1910.

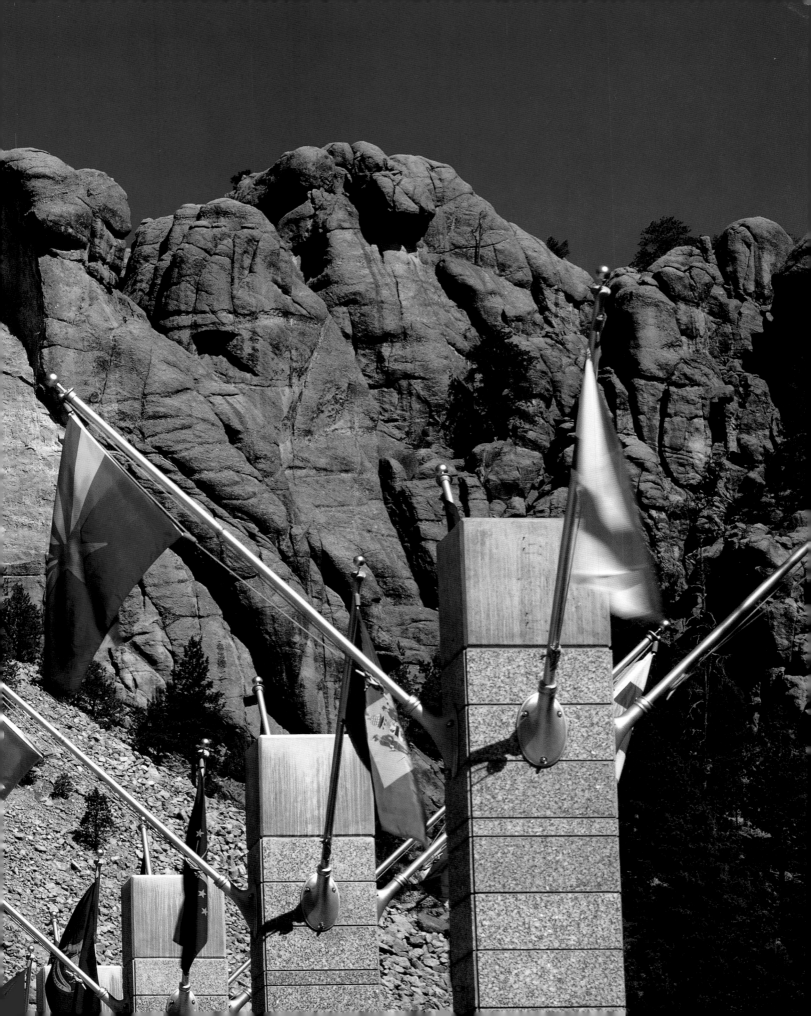

Ohio's Anti-Saloon League was a primary force behind the movement for Prohibition in the early part of the century, and the Eighteenth Amendment, passed by Congress in 1917, went into effect in 1920. After an initial decrease, alcohol consumption actually increased under Prohibition. So did crime. Illegal speakeasies operated in every Chicago neighborhood, and Al Capone, who monopolized alcohol sales there, made Chicago synonymous with crime after the St. Valentine's Day Massacre in 1929.

The hard times of Heartland farmers presaged the Dirty Thirties Depression era. The grim aspect of agricultural expansion had been that the region's native, drought-resistant plants fell before the plow and took with them the soil's anchors. South Dakota, still reeling from earlier droughts, underwent

one that lasted most of the decade. Grasshoppers devoured any crops that weren't withered by drought, and "black blizzards," as dust storms were called, carried off the topsoil. North Dakota's dry-weather problem peaked in 1936, exacerbated by dry farming techniques adopted during the war years, and farmers left the land in droves. After winds darkened the skies in Kansas and the rest of the Great Plains on April 14, 1935, the term "dust bowl" was coined by an Associated Press journalist. Bankruptcy was common.

In Missouri, droves of workers arrived in hopes of landing one of the 10,000 jobs available for construction of the Bagnell Dam and the Lake of the Ozarks outside of St. Louis. At the time, it was the largest construction project in the nation. A bright spot in Michigan was establishment of Cranbrook Foundation in 1927 by George and Ellen Booth in Bloomfield Hills, near Detroit. Many of its buildings were designed by architect Eliel Saarinen, who in 1932 became president of Cranbrook Academy, a magnet for art and furniture design.

The federal government stepped in with many new programs to help the Heartland during the Depression era. Franklin Delano Roosevelt's New Deal set up the Civilian Conservation Corps (CCC), which planted trees in the Great Plains. The CCC museum in Grayling, Michigan, pays tribute today to fire fighting, bridge- and road-building and many other projects completed in Michigan. The Works Progress Administration (WPA) constructed flood-control locks along the Mississippi in Muscatine, Iowa, and Salverton, Missouri. WPA-funded murals completed in 1937 grace the walls of the

Below: The Cincinnati, Ohio, Union Terminal (1933). This and the Omaha, Nebraska, 1931 Union Station were among several notable Art Deco landmarks constructed by American railroad companies during the 1930s.

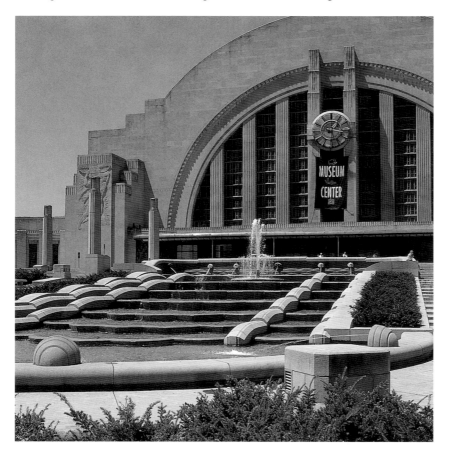

Granville, Ohio, post office, and Omaha Union Station, built in 1931 by the WPA, was one of the nation's finest Art Deco buildings. Yet another WPA project was construction of the amphitheater at the Toledo, Ohio, public zoo.

Already active in the first quarter of the new century, unions entered a new era of success during the Depression. Discontented automobile workers in Michigan founded the United Auto Workers of America in 1935 and organized a sit-down strike at General Motors' Flint plant. Born in Iowa, John L. Lewis, starting work in a coal mine at fifteen, eventually became President of the United Mine Workers of America and was an important union leader for forty years.

In 1933, Chicago commemorated its one-hundredth year with a fair called "A Century of Progress." The event was so popular that the organizers extended it through 1934. While its architecture did not have the impact of the 1893 Columbian Exposition, it starred the nation's first diesel-powered train, the Burlington Zephyr, which traveled up to 112 mph to arrive in Chicago from Denver. That same year, the Illinois Waterway linked Chicago to the Mississippi River. The discovery of oil in Patoka, Illinois, in 1937 and Boice, Nebraska, in 1939 brought economic relief to those sections of the Heartland.

When the nation entered World War II in 1942, the Heartland's industries and farms revived. Companies like International Harvester and Caterpillar Tractor, which began building a special engine for the M-4 tank, converted to production of military equipment. In Ohio, Lima Locomotive Works produced Sherman tanks for the war effort. Many of Detroit's automobile factories also switched to production of military

vehicles. In Wichita, Kansas, Boeing Aircraft employed 40,000 workers and turned out B-29 Superfortresses. The world changed profoundly at a volleyball field underneath a University of Chicago stadium in 1942, when physicist Enrico Fermi conducted experiments leading to the first controlled nuclear chain reaction.

Despite national preoccupation with the war, irrigation and flood control continued to be important issues for the Heartland. The 1944 Pick-Sloan Missouri Basin Project brought a series of dams, hydroelectric plants, and reservoirs to Nebraska and other states along the Missouri River. In North Dakota, construction began on the enormous earth-fill Garrison Dam in 1947.

After the war ended, the Army underwent reorganization, forming the Strategic Air Command in November 1946. Two years later, Columbus, Ohio, native General Curtis LeMay took over as commander, and SAC headquarters moved to Offutt Air Force Base, located just south of Omaha, Nebraska.

Above: *An Akron, Ohio, Firestone Tire and Rubber Company employee checks 1,000-pound bomb cases before they are filled with explosives in 1944. Heartland women joined the American workforce in droves during World War II.*

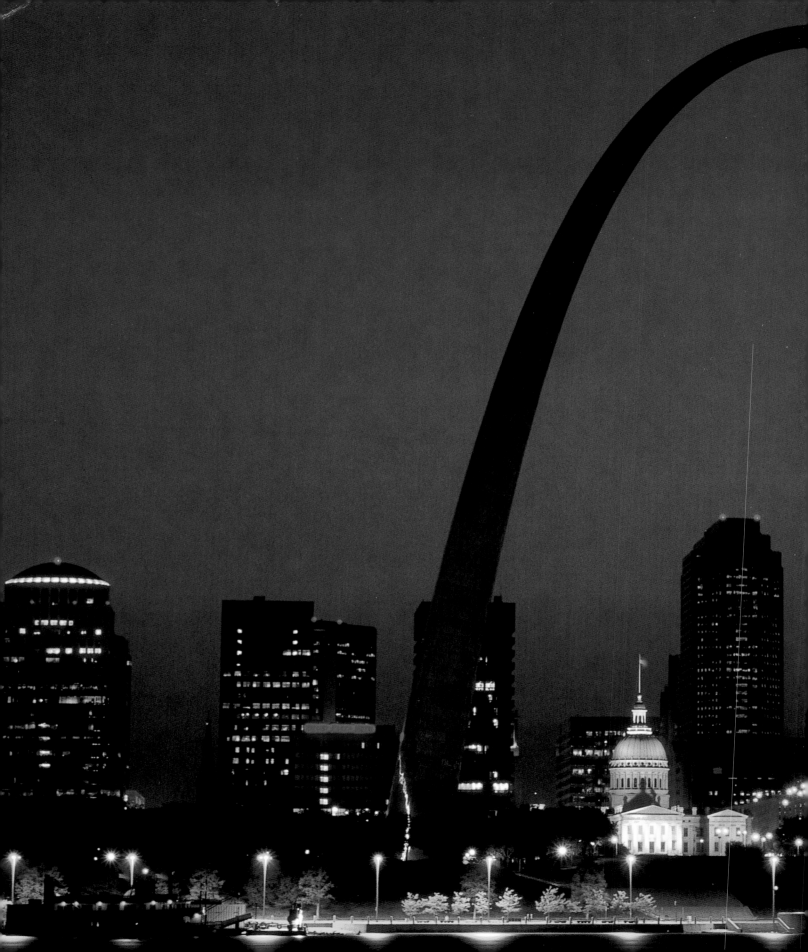

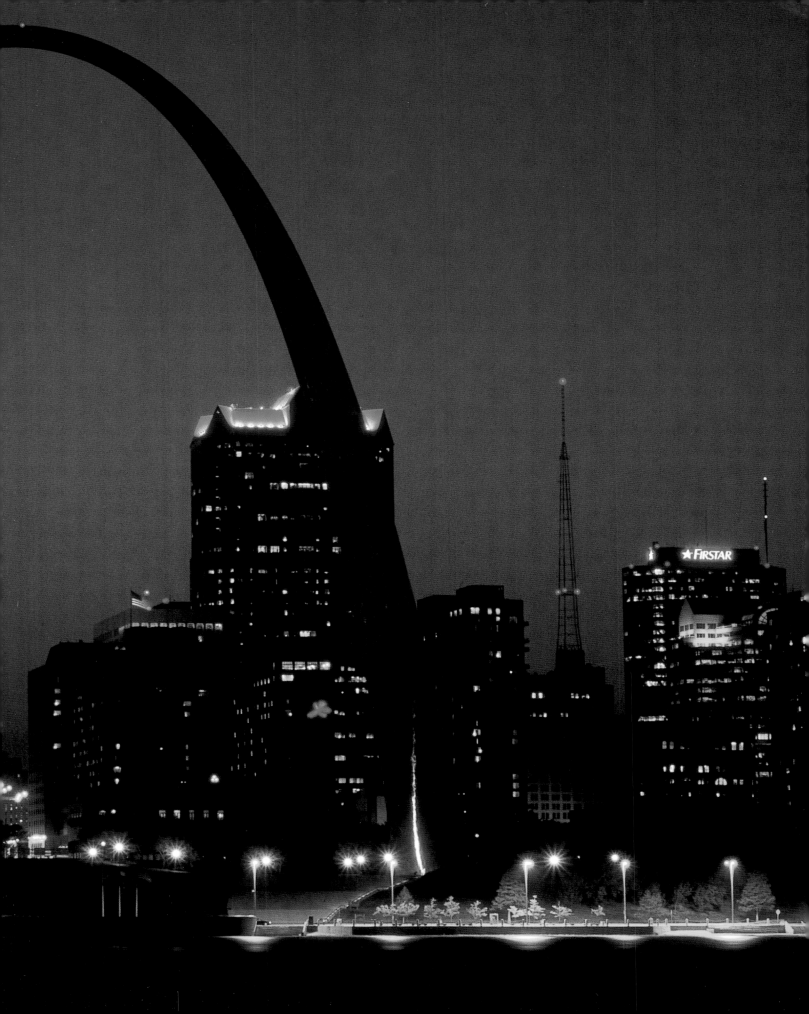

Previous pages: St. Louis's Gateway Arch— officially known as the Jefferson National Expansion Memorial in recognition of the Lewis and Clark Expedition that set out from St. Louis—looms over the city's night-time skyline in this view from the Mississippi River. At 630 feet, the arch is the tallest monument in the U.S. National Park system.

In the postwar world, new industries replaced old Heartland manufacturers and farming practices. The richest iron ore in Minnesota, Michigan, and Wisconsin was exhausted, and the mines began shutting down. Then University of Minnesota researchers discovered a way to process taconite, a lower grade of iron, and the mining industry adapted. Although the economy in general was thriving, new farm machinery eliminated many jobs in states like Wisconsin, and the shift from agriculture to industry speeded up in parts of the Heartland. In others, like Iowa, corn and soybeans continued to be big crops. Severe drought conditions invaded Kansas, Nebraska, and Oklahoma in 1953, devastating agriculture.

Tourism developed into a major new economic factor. Mount Rushmore National Monument in South Dakota's Black Hills opened in 1929, attracting tourists to Gutzon Borglum's colossal busts of Presidents George Washington, Thomas Jefferson, Abraham Lincoln, and Theodore Roosevelt, visible for up to sixty miles. In western Wisconsin, Little Norway, also known as the Valley of the Elves, attracted travelers with its replicas of Norwegian architecture and culture. Conner Prairie Museum in Noblesville, Indiana, opened in 1935 by pharmaceutical scion J. K. Lilly, Jr., gave visitors the opportunity to explore a typical nineteenth-century Indiana village. The Lincoln Pioneer Village in Rockport, Indiana, is run by nearby Earlham College. Composer Antonin Dvorak spent a summer in Spillville, Iowa, whose population is predominantly Bohemian and Czech, and travelers can drive the Dvorak Memorial Highway and see the Bily Clocks Museum with its Dvorak exhibit.

In Urbandale, Iowa, a cluster of eighteenth- and nineteenth-century farms and a museum draw visitors to the Living History Farms, and the nineteenth-century Little Brown Church, near Nashua, offers another Iowa attraction. Starting in 1912, Father Paul Dobberstein built West Bend, Iowa's, Grotto of the Redemption from his collection of minerals, gems, fossils, corals, and shells. By the time of his death in 1954 he had created the largest grotto and concentration of minerals and petrifications in the world.

Minnesota, Michigan, and Wisconsin all feature statues of the legendary Paul Bunyan that tourists love to visit. A 25-foot statue in Akeley, Minnesota, bends down with a hand outstretched for tourists to sit in. Brainerd, Minnesota, has a Paul Bunyan Center, and Ossineke, a companion statue of Babe the Blue Ox. Alpena, Michigan's, 30-foot statue of Bunyan is made out of Kaiser auto parts. The Soo Locks in Sault Ste. Marie, Michigan, also attract tourists, as does the Bavarian village of Frankenmuth, Michigan. Many Amish—Swiss and German Protestants who emigrated to Pennsylvania in the early 1700s—moved on to settle in Indiana, Illinois, Iowa, and Ohio, and the 90-mile Heritage Trail near Elkhart, Indiana, guides tourists through Amish country.

The Great American Music Festival draws tourists to Silver Dollar City in Branson, Kansas. In central Ohio, the Olentangy Indian Caves offer Indian lore and artifacts. Although North Dakota today is perhaps the least visited of the fifty states, it has the most wildlife refuges of any state. Bison and elk are the attraction in Sullys Hill National Game Preserve near Devils

Lake. The 630-foot St. Louis Gateway Arch designed by Eero Saarinen (Eliel's son), was planned in 1947 and completed in 1966. The tallest memorial in the United States, it was built to honor the pioneers' expansion into the West.

What originally brought settlers into the Heartland was its abundance of land; the outdoors, state for state, remains one of its biggest draws. Ohio's Indian Lake, a recreational area since the turn of the century, was formed by glacial action that created a series of kettle lakes. It is a major resting stop for migrating birds like eagles, herons, and egrets. Twenty species of fish entice anglers to South Dakota's Great Lakes. Iron Mountain's rivers, streams, lakes, and forests span Michigan and Wisconsin. Unusual rock formations to the south of Utica, Illinois, account for the name of Starved Rock State Park, which has spectacular overlooks of the Illinois River.

Minnesota bills itself the "Ultimate Outdoors State," and has almost 12,000 lakes, adding up to more miles of shoreline than California, Hawaii, and Florida put together. Effigy Mounds National Monument near Harper's Ferry, Iowa, is unusual because many of its prehistoric mounds are shaped like animals. The area features a combination of forests, tall-grass prairies, wetlands, and rivers. The Lake of the Ozarks, created by construction of Bagnell Dam, has four of Missouri's many show caves, which are wild caves outfitted with walkways, bridges, and handrails.

In South Dakota, the eerie moonscape of Badlands National Park has been chiseled by wind and water erosion, leaving exposed fossil-laden bands of sedimentary and volcanic rock. Kanopolis Lake in Kansas is the site of the state's first state park and features ancient Native American carvings on Inscription Rock, Horse Thief Canyon. Near Phillipsburg, Kansas, the rolling grasslands of Kirwin National Wildlife Refuge and its wooded creek habitats attract 197 types of migratory birds, including bobwhite, prairie chicken, turkeys, and pheasants. Milford

Below: Chicago's Children's Fountain is situated on a Wacker Drive traffic island. The great city's skyscrapers fill the background, including the 1924 Wrigley Building, commissioned by the chewing-gum magnate.

Lake, west of Topeka, is Kansas's largest lake. In Nebraska, Wildcat Hills Recreation Area, overlooking the North Platte River Valley, dates back to 1929. During the Depression, both the CCC and WPA helped develop this state park, adding a picnic area and a game reserve. Devils Lake was described as "enchanted waters" by the Frémont Expedition in 1837. It consists of four separate recreational spots:

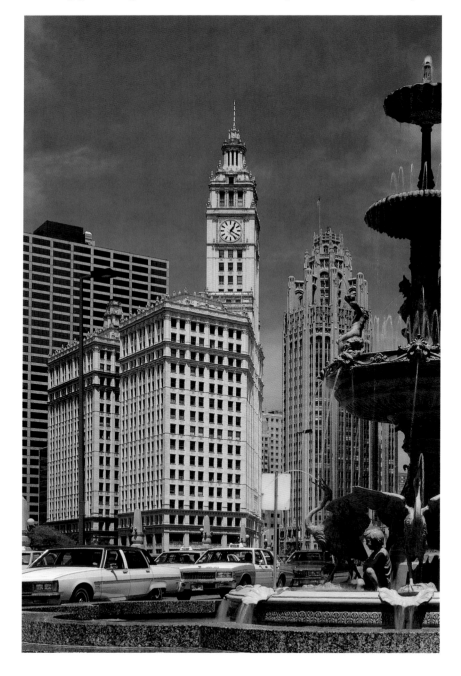

Black Tiger Bay, Grahams Island State Park, Shelvers Grove State Recreation Area, and the Narrows.

By mid-century, the Heartland could no longer be considered a lonely frontier with nothing but wide-open spaces. Suspension bridges like the Mackinac, built in 1957 across the Mackinac Straits in Michigan, began to crisscross the Heartland. Such Heartland museums as the Art Institute of Chicago and the Cleveland Museum of Art achieved world-class status, and the region featured some of the nation's most memorable architecture, including Louis Sullivan's Owatonna Bank in Minnesota and Frank Lloyd Wright's home Taliesin in Spring Green, Wisconsin. Heartlanders could attend concerts on a par with Europeans by the Chicago Symphony Orchestra, the Cleveland Symphony, and the St. Louis Symphony Orchestra. The region's public colleges and universities continued a tradition of greatness, and the Heartland's private institutions attracted students from across the world. These included Wisconsin's Marquette University; Minnesota's Carlton and Macalester Colleges; Michigan's Albion College; Indiana's DePauw University; Illinois's Loyola, Northwestern, and Chicago Universities and Wheaton College; Missouri's Washington University; Iowa's Grinnell College; Ohio's Antioch, Kenyon, and Oberlin Colleges and Case Western Reserve University. One of the greatest health institutions in the world, the Mayo Clinic, made its home in Rochester, Minnesota.

Not just America's geographic center, the Heartland could rightfully lay claim to being the pulse of American life as the twentieth century moved forward into ever more new frontiers.

NORTH DAKOTA, SOUTH DAKOTA, AND MINNESOTA

WESTERN NORTH DAKOTA

Williston

Fort Union Trading Post National Historic Site: originally built by the American Fur Company in 1828; reconstructed fort grounds include the Indian Trade House, whitewashed stockade, manager's house, kitchen, and Bourgeois House (now a visitor center exhibiting life at the trading post, from 1828 to 1867)

Fort Buford State Historic Site: established in 1866 to protect settlers; Sitting Bull and 200 Sioux surrendered here in 1881; extant structures include the powder magazine and frame officer's quarters

Theodore Roosevelt National Park

Encompasses 70,000 acres of varied landscape and wildlife; attractions include *Painted Canyon,* with multicolored rock formations; *Scenic Loop Drive;* the *Maltese Cross Cabin,* Roosevelt's ranch headquarters 1883–4; Roosevelt's 1884 *Elkhorn Ranch Site* with museum of Roosevelt's time in the area; and a *visitor center* which runs tours, nature walks, and campfire programs

Medora

Museum of the Badlands: displays the area's natural and pioneer history, and Roosevelt memorabilia

De Mores Interpretive Center: displays of the town's history and its founder, the wealthy Marquis de Mores

Little Missouri National Grassland: offers a 58-mile wildlife and scenic tour

Little Missouri State Park

Offers 5,700 acres of scenic trails through striking landscape formations

New Town

Three Affiliated Tribes Museum: preserved historical information and cultural artifacts of the Mandan, Hidatsa, and Arikara

CENTRAL NORTH DAKOTA

Minot

Scandinavian Heritage Park: a 225-year-old Norwegian house

Ward County Historical Society Pioneer Village and Museum: 14 turn-of-the-century buildings including a three-story farmhouse

Stanton

Knife River Indian Villages National Historic Site: preserves more than 50 historic and archaeological remains of the Northern Plains Indians, spanning 8,000 years; includes a reconstructed Hidatsa earth lodge, two Hidatsa village sites, visitor center, and 11 miles of walking trails

Washburn

North Dakota Lewis and Clark Interpretive Center: gives an overview of the expedition; exhibits Native American artifacts

Fort Mandan State Historic Site: fort of the Lewis and Clark expedition

Fort Clark

Fort Clark State Historic Site: built 1831, a major fur trading post

Mandan

Fort Lincoln State Park: includes *Custer House,* a reconstruction of the 1874 original, designed by the general himself; a guided tour of the household; a historical museum; and five Mandan earth lodge reconstructions

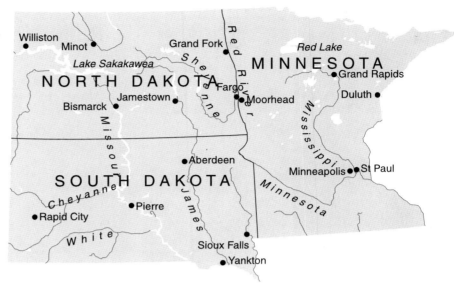

Bismarck

State Capitol: a mid-1930s structure with marbled Art Deco interiors

North Dakota Heritage Center: examines the history of the state, from prehistoric times; displays Sitting Bull's painted robe

Cape Hancock State Historic Site: an 1872 military installation

Lewis and Clark Riverboat Cruises: tours on a paddle wheeler

Double Ditch Indian Village State Historic Site: remains of earth lodges of a Mandan village that thrived from 1675–1780

Lewis & Clark National Historic Trail

A trail running closely to that of the expedition of the Corps of Discovery, for approximately 3,700 miles; visitor centers highlight local history

Lake Sakakawea

North Country National Scenic Trail: connects areas of scenic, natural, recreational, historic, and cultural significance throughout New York, Pennsylvania, Ohio, Michigan, Wisconsin, Minnesota, and North Dakota

Rugby

Pioneer Village and Museum: features 30 frontier buildings restored and reconstructed to house a vast assortment of memorabilia, pioneer artifacts, and machinery

Belcourt

Turtle Mountain Chippewa Heritage Center: displays beadwork, quills, and clothing belonging to the Turtle Mountain peoples

EASTERN NORTH DAKOTA

Pembina

Pembina State Museum: interprets the region's ancient history to modern times; a 72-foot-high observation platform gives views of the Red River Valley

Walhalla

Gingras Trading Post State Historic Site: preserves the hand-hewn log home and trading post of the successful Metis fur trader Antoine Gingras, who died in 1877, reputedly the richest man in the region

Cavalier

Icelandic State Park: looks at history of the Icelandic farmers, who came here in the 1870s; includes Gunslogson Homestead, an 1882–90 farmhouse; a nature trail; and visitor center with displays on regional culture

Fort Totten Indian Reservation
Fort Totten State Historic Site: preserves a military post built in 1867

St. Michael
Bell Isle Store & Museum: Native American tools, clothing, and beadwork

Grand Forks
Center for Aerospace Science: large civilian pilot-training school
Myra Museum: interesting collection of nineteenth-century pioneer artifacts

Jamestown
Frontier Village: a small-town, nineteenth-century street lined with mostly original buildings, including a saloon, fire department, and barber shop
National Buffalo Museum: pays tribute to the American bison and the Plains peoples of all cultures who depended upon them

Fargo
Bonanzaville: a historical village of 40 buildings; includes a town hall, schoolhouse and several farmhouses, all with period fixtures and furnishings
Red River and Northern Plains Regional Museum: displays pioneer artifacts and a large Native American collection

SOUTH DAKOTA: BLACK HILLS

Spearfish Canyon
Spearfish Canyon National Scenic Byway: 19-mile route
Devils Tower National Monument: a spectacular rock formation and sacred Native American site

Sturgis
National Motorcycle Museum and Hall of Fame: includes a 1902 Harley
Old Fort Meade Museum: fort established in 1878 after the Battle of Little Bighorn; displays the possessions of Chief Dewey Beard

Spearfish
D. C. Booth Historic National Fish Hatchery: built 1899

Deadwood
Infamous "Wild West" Gold Rush town, and a National Historic Landmark; past residents include James "Wild Bill Hickock" Butler and Martha "Calamity Jane" Cannary, both buried here in *Mount Moriah Cemetery*
Broken Boot Gold Mine: offers gold panning and tours around the small mine
Adams Museum: exhibits memorabilia of the town's most famous past residents, rare fossils, and Native American and Chinese artifacts
Historic Franklin Hotel: constructed in 1903 and in continuous operation
Saloon No.10: where Wild Bill Hickock was shot and killed by Jack McCall

Lead
Black Hills Mining Museum: displays the history and technology of Black Hills gold mining with a simulated shaft of the Homestake Mine
Homestake Mine Visitor Center and Open Cut Overlook

Rapid City
Journey Museum: prehistoric and historic collections of the western Plains; includes the *Museum of Geology*, the *Archeological Research Center*, the *Sioux Indian Museum* and the *Minnilusa Pioneer Museum*
Edward Nielsen Settler's Cabin: with Norwegian antiques and artifacts

Mount Rushmore National Memorial
World famous mountain sculpture; 60-foot busts of Presidents George Washington, Thomas Jefferson, Abraham Lincoln, and Theodore Roosevelt; *Sculptor's Studio*, built in 1939, displays original plaster scale models and tools of the sculpting process; site contains a *Visitor Center*, *Museum*, and the *Presidential Trail*, a boardwalk providing spectacular close-up views

Keystone
Borglum Historical Center: displays Borglum's life and accomplishments
1880 Train: a steam engine of the Black Hills Central Railroad takes two-hour narrated rides between Keystone and Hill City

Crazy Horse Mountain Monument
Project begun in 1939 by Sioux leader Henry Standing Bear; a vast sculpture of revered warrior Crazy Horse on horseback; the artist Korczak Ziolkowski set out to make the biggest statue in the world; work began on Thunderhead Mountain in 1948 and the 90-foot-high face was completed in 1998; the site also exhibits many Native American artifacts and crafts, and a Native American Education and Cultural Center

Jewel Cave National Monument
The third-longest cave in the world, with more than 127 miles of passages

Custer State Park
Encompasses 73,000 acres of the southern central Black Hills

Wind Cave National Park
Preserves one of the nation's longest cave systems, discovered in 1881, along with 28,295 acres of mixed-grass prairie, forest, and varied wildlife

Hot Springs
Mammoth Site: a seven-foot tusk was unearthed here in 1974, in what turned out to be a 26,000-year-old grave of at least 40 Columbian and woolly mammoths; the fossils are housed in a shelter over the site

WESTERN SOUTH DAKOTA

Badlands
Badlands National Park: 244,000 acres of eroded landscape—bluffs, pinnacles, and the largest, protected mixed grass prairie in the nation; the *Fossil Exhibit Trail* displays various fossils dug from the sandstone dating back 23–35 million years; *Ben Reifel visitor center* is operated by the Oglala Sioux, who take tours into the Pine Ridge Reservation and to sites of the 1890s Ghost Dances
Pine Ridge Indian Reservation: the second largest Indian reservation in the United States; encompasses *Wounded Knee*, where on December 29, 1890, the U.S. Army killed several hundred unarmed Sioux men, women, and children, most of whom were Ghost Dancers; also includes *Red Cloud Indian School* with traditional Sioux star quilts and paintings

Wall
Wall Drug: world famous emporium, begun in 1931; serves up to 20,000 visitors per day and has an enormous collection of photos and memorabilia

CENTRAL SOUTH DAKOTA

Mobridge
Sitting Bull Burial Site: resting place of the legendary Sioux chief who won victory over Custer at Little Bighorn, and also Sacagawea
Sherr-Howe Arena: contains 10 murals of the Sioux artist Oscar Howe

Pierre
Cultural Heritage Center: structure modeled on traditional Plains Indian dwellings, housing pioneer implements and prehistoric artifacts

Aberdeen
Dacotah Prairie Museum: hands-on exhibits of prairie life and history
Centennial Village: more than 30 buildings dating from the 1880s and 90s

Huron
Pyle House Museum: built in 1894, still with original fixtures; former residence of Gladys Pyle, the first Republican woman elected to the U.S. senate

EASTERN SOUTH DAKOTA

Lewis & Clark National Historic Trail: *see* Central North Dakota

Missouri National Recreational River: preserved to commemorate the river's role in the settlement of the Great Plains

Mitchell
Corn Palace: Moorish structure, originally built in 1892 to encourage settlement and to display local agricultural products; decorated annually with large murals made of native corn, grains, and grasses
Friends of the Middle Border Museum of American Indian and Pioneer Life: frontier history and artifacts dating from 8,000 B.C. to the 1890s
Mitchell Prehistoric Indian Village: active archaeological site
Akta Lakota Museum: Native American Museum of art and artifacts

De Smet
Little Town on the Prairie: made famous by author Laura Ingalls Wilder

Madison
Prairie Village: over 40 buildings represent early 1900s life

Sisseton
Joseph N. Nicollet Tower and Interpretive Center: 75-foot tower offering spectacular views; interpretive center commemorates Joseph Nicollet, sent west in 1836 to map the area between the Missouri and Mississippi Rivers
Fort Sisseton State Historic Park: military buildings dating from 1864–89

Brookings
South Dakota Art Museum: regional art and a Native American collection
State Agricultural Heritage Museum: displays huge array of farming equipment with exhibits focusing on the Homestead Act and early settlers

Garretson
Devil's Gulch: 60-foot chasm over which, in 1876, Jesse James supposedly leapt on horseback to escape the pursuing posse; hiking trails lead to the bottom

Sioux Falls
Falls Park: Big Sioux River rushes over magnificent rock formations
Old Courthouse Museum: interactive exhibits of the region's history
Historic District: walking tour of the city's oldest, grandest mansions including the Queen Anne style ***Pettigrew Home and Museum***
Battleship South Dakota Memorial: exhibits artifacts and memorabilia from one of the most decorated battleships in U.S. history

Yankton
Dakota Territorial Museum: includes original 1892 Great Northern Railroad passenger depot and 1920s period rooms
W. H. Over Museum: excellent displays of life and settlement on the plains

NORTHERN MINNESOTA

Lake Itasca
Itasca State Park: Minnesota's oldest state park (1891) and wildlife sanctuary

Voyageurs National Park
A beautiful landscape named for the French-Canadians who traveled these waterways of the Minnesota/Canada border in birch-bark canoes

Superior National Forest
Boundary Waters Canoe Area Wilderness: a vast area of about 1 million acres, comprising hundreds of lakes and over a thousand canoe passages; also excellent for backpacking, fishing, skiing, and cross-country dogsled trips; bisected by the ***Gunflint Trail***, an unpaved 60-mile wilderness trail

Chisholm
Ironworld Discovery Center: living history interpreters show visitors Old World traditions, interactive mining exhibits, and trolley rides

Hibbing
Greyhound Bus Origin Center: home of America's biggest bus company
The Hull-Rust Mahoning Mine: was the world's largest open-pit iron ore mine

Duluth
Canal Park Marine Museum: displays commercial shipping history
SS William A. Irvin: flagship of U.S. Steel's Great Lakes Fleet
St. Louis County Heritage and Arts Center: constructed in 1892 in the French-Norman style; served as the depot for seven different rail lines in 1910; now a national historic landmark that houses the Lake Superior Railroad Museum, a children's museum, cultural heritage center, and art museum
Lake Superior and Mississippi Railroad: 90-minute journey by the St. Louis River, along the first railroad linking Duluth with the Twin Cities
Tom's Logging Camp: authentic duplicate of a typical logging camp

MINNESOTA: LAKE SUPERIOR SHORELINE

Grand Portage
Grand Portage National Monument: commemorates the heritage of the Ojibwa people and preserves a major site and route of the eighteenth-century fur trade; contains archaeological remains of the trade route into western Canada interior, and several fur trading posts

Isle Royale National Park
A wilderness archipelago, encompassing a total area of 850 square miles, including many ancient lava formations; contains historic lighthouses, shipwrecks, and ancient copper mining sites

Scenic Highway 61
Dramatic route along high, steep cliffs; made famous by Minnesota native Bob Dylan, it follows Lake Superior from Duluth to the border

SOUTHERN MINNESOTA

Minneapolis-St. Paul
Alexander Ramsey House: home of the first territorial governor
Historic Fort Snelling: 1820s military outpost that demonstrates the frontier life with staff acting out scenes from the era
James J. Hill House: majestic, red sandstone home of the builder of the Great Northern Railway; tours demonstrate servant life in the Gilded Age
Minnesota History Center: an architectural masterpiece that offers amazing views of downtown and the State Capitol; historical exhibits
Minnesota Transportation Museum: features streetcars, trains, and steamboats, and displays documenting the railroading industry
American Swedish Institute: museum and cultural center housed in a turn-of-the-century mansion; collections include Swedish glass, decorative and fine arts, textiles, photographs, diaries, and vintage recordings
St. Anthony Falls: the only falls on the Mississippi River; tours around the industrial ruins of the flour-milling district, once the largest in the world; a two-mile Heritage Trail along the Minneapolis riverfront
Sibley House Historic Site: one of the state's oldest settlements with four fully furnished limestone buildings dated 1820s–50s

Pipestone
Pipestone National Monument: trails lead past preserved Plains Indian quarries of the soft red rock, used for centuries to make peace pipes
Upper Midwest Indian Cultural Center: offers cultural demonstrations, and provides access to the short Circle Trail, which runs through native prairie to the pipestone quarries and Winnewissa Falls; the visitor center museum contains pipes and pipestone artifacts

NEBRASKA, KANSAS, MISSOURI, AND IOWA

WESTERN NEBRASKA

Oglala National Grassland
Includes *Toadstool Geological Park*, spectacular undeveloped badlands with trails through weird rock formations

Chadron
Museum of the Fur Trade: extensive collection of Native American artifacts, rifles, and frontier weapons; stands on the site of the Bordeaux Trading Post (1830s–1876), which is reconstructed on the grounds

Fort Robinson State Park
Preserved 1874 fort site where the U.S. Army campaigned against the native Sioux; includes restored fort buildings, a living history village, a museum of the geology and paleontology of the state, and the Fort Robinson Museum of its military history; a marker points out where Crazy Horse was killed in 1877

Agate Fossil Beds National Monument
One of the most important collections of mammal fossils dating from 13–20 million years ago; a visitor center explains the area's paleontology and displays over 500 Native American artifacts; many outdoor activities include hiking trails to observe the prairie flowers and wildlife

North Platte Valley
Courthouse and Jail Rocks: two towering bluffs, standing 400 feet above the North Platte Valley, with steep trails leading to their base; served as markers for pioneers on the Oregon, Mormon, and Pony Express Trails

Gering
Scotts Bluff National Monument: natural towers that rise 800 feet above the valley floor, also a marker for those on the Oregon Trail, of which there are some remnants here; known to the Sioux as *Me-a-pa-te* "hill that's hard to get around," subsequently named for fur trader Hiram Scott in 1828 after he was found dead at its base; a museum exhibits the human and natural history of the area; many outdoor activities and hiking trails to the summit
North Platte Valley Museum: demonstrates the lives of settlers with a reconstructed sod house and log cabin

Bayard
Chimney Rock National Historic Site: a unique rock formation that projects nearly 500 feet from an eroded hill; a visitor center explains the geology and history of the rock and the Oregon Trail; one- and four-day wagon train trips to the rock are available

Sidney
Fort Sidney: established in 1867; remains include an 1874 officer's quarters, now the county museum of local military and civilian history; and the Post Commander's Home, restored to 1867–94 era

Ash Hollow State Historical Park
Once a popular stop along the Oregon Trail, now has a visitor center containing exhibits on geology, Native American culture, and local pioneer history

Ogallala
Boot Hill Cemetery: contains grave of "Rattlesnake" Ed Whorley, and displays news stories of the cattle-drive era
Petrified Wood Gallery: music boxes, pictures, western scenes, and sculptures crafted entirely out of petrified wood

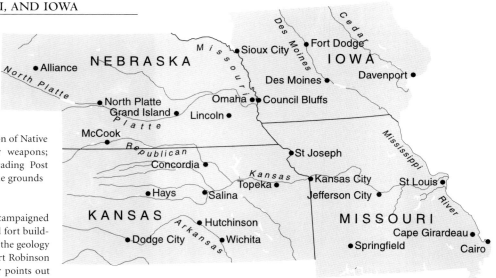

Alliance
Carhenge: car sculpture modeled on Stonehenge, constructed in 1987

CENTRAL NEBRASKA

Oregon National Historic Trail: historic 2,170-mile-long route to the Pacific for fur traders, gold seekers, and missionaries, 1840s–60s; passes 235 historic sites through Missouri, Kansas, Nebraska, Wyoming, Idaho, and Oregon

Niobrara National Scenic River: a 76-mile stretch of the Niobrara River with at least 90 waterfalls, some more than 75 feet high

North Platte
Buffalo Bill Ranch Historical Park: a property of William "Buffalo Bill" Cody; the mansion and various barns are open for viewing
Lincoln County Historical Society Western Heritage Museum: memorabilia and artifacts of the Sioux and early settlers

Lexington
Dawson County Historical Museum: exhibits on history of central Platte River Valley, including the preserved bones of a 15,000-year-old mammoth

Kearney
Fort Kearney State Historic Park: established in 1847, the first military post along the Oregon Trail; contains museum and outdoor exhibits

Minden
Harold Warp Pioneer Village: more than 25 pioneer buildings filled with exhibits dedicated to American progress, 1830–1960

Red Cloud
Willa Cather State Historic Site: offers tours of five buildings mentioned in Cather's novels, including the restored author's home from 1884–90

Grand Island
Stuhr Museum of the Prairie Pioneer: dedicated to the arts and settlers of the Great Plains; includes a Pawnee earth lodge, a railroad town, a settlement of pioneer cabins, and the house where Henry Fonda was born in 1905

Aurora
Plainsman Museum: extensive collection of Western memorabilia; an 1881 homestead, a blacksmith shop, a Victorian house, and a log cabin

EASTERN NEBRASKA

Lewis & Clark National Historic Trail: see Central North Dakota

Mormon Pioneer National Historic Trail: 1,300-mile-long trail from Nauvoo, Illinois, to Salt Lake City, Utah, running through five states; the mid-nineteenth-century route of the Mormons, traveling west after Brigham Young; connects 83 historic sites and museums

Fort Calhoun
Fort Atkinson State Historical Park: site of the first formal meetings between Lewis & Clark and Native Americans, in 1804; also the first U.S. military post west of the Missouri River, in 1820

Omaha
Fort Omaha: includes the *General Crook House Museum*, once home of General George Crook, who spent nearly 40 years on the frontier

Great Plains Black History Museum: the history of African-Americans on the prairies, focusing on the "buffalo soldiers" of the frontier army

Western Heritage Museum: displays a re-created pre-WWII railroad station and other exhibits relating to Omaha 1880–1954

Mormon Trail Center: site of the winter quarters of the Mormon pioneers of 1846–8; exhibits and guided tours detail their history

Lincoln
Nebraska state capitol: 1932 building with 400-foot central tower, topped by a 20-foot statue of a sower on a pedestal of wheat and corn; contains excellent murals and an observation deck on the 14th floor

Museum of Nebraska History: anthropological displays span 12,000 years

University of Nebraska State Museum: dedicated to natural history; its highlight, the Elephant Hall, is a gallery of enormous mammoth, mastodon, and four-tusker skeletons

Nebraska City
John Brown's Cave and Historical Village: shows hiding places and escape routes of slaves on the Underground Railroad from Missouri to Canada

Mayhew Cabin: was owned by the sister of John Henri Kagi, who lived and ran many of the Underground Railroad operations here

Beatrice
Homestead National Monument of America: built on the site of one of the first homesteads in America, to commemorate the Homestead Act of 1862; has living history presentations, short films, and exhibits on the life and tools of the homesteaders; also has a pioneer cabin, an old schoolhouse, restored tallgrass prairie, several trails, and outdoor activities

Shubert
Indian Cave State Park: preserves petroglyph-etched cave walls and St. Deroin, a reconstructed nineteenth-century town

WESTERN KANSAS

Nicodemus
Nicodemus National Historic Site: preserves, protects, and interprets the only remaining African-American–established western town following the Civil War

Dodge City
Boot Hill Museum and Historic Front Street: located on the original site of Boot Hill Cemetery; exhibits life in the nineteenth century with a reconstruction of Dodge City in 1876, and history demonstrations; offers stagecoach rides through downtown and gunfight reenactments

Dodge City Trolley: narrated streetcar tour of the city's history and folklore, including the original locations of the Longbranch Saloon, Gospel Hill, the "deadline," and Front Street

Coronado Cross: marks the place where Francisco Vasques de Coronado is said to have crossed the Arkansas River in search of the fabled "Cities of Gold" in 1541; a center details the history of Coronado's expedition

Historic Fort Dodge: served as base of operation against Native Americans from 1865–82; offers tours of the 1860s buildings, and a museum of the fort's history since 1890

CENTRAL KANSAS

Hays
Ellis County Historical Society: displays early pioneer life; also maintains the *Volga-German House*, a reconstruction of an early German immigrant home

Fort Hays State Historic Site: built 1867 and abandoned 1889; preserves several original structures including a blockhouse, officer's quarters, and guardhouse containing exhibits of the fort's history

Larned
Santa Fe Trail Center: regional museum telling the story of the Santa Fe Trail from prehistoric times to the end of WWI; displays Native American artifacts; a sod house, and a 1902 one-room school house

Fort Larned National Historic Site: military base established in 1859 to protect Santa Fe Trail travelers; maintains nine restored buildings furnished to original appearance, and a museum of its history; offers living history programs and nature trails

Abilene
University of Kansas Museum of Anthropology: excellent examples of Native American artifacts from various groups, and African cultural materials

Old Abilene Town: a replica of the town during its cattle boom, complete with a reconstructed school, saloon, jail, log church, and stagecoach rides; has weekly gunfights

Eisenhower Center: the former president's boyhood home, with its original furnishings; and a museum of his presidential artifacts

North Newton
Kaufmann Museum: tells story of the 1870s Mennonite settlers with a historical homestead and re-created prairie

Wichita
Old Cowtown Museum: a living history museum that re-creates the town of 1865–80, following Jesse Chisholm's arrival in 1864

Indian Center Museum: exclusively Native American art, culture, technology; traditional artifacts, contemporary art, and history

First National Black Historical Society of Kansas Museum: examines the African-American role in the region

Wichita-Sedgewick County Historical Museum: local history from Native American to modern times; includes a re-created cottage from c. 1890

EASTERN KANSAS

Lewis & Clark National Historic Trail: see Central North Dakota

Oregon National Historic Trail: see Central Nebraska

The Pony Express National Historic Trail: in operation from 1860–61, the trail took mail from St. Joseph, Missouri, to Sacramento, California, in only ten days; approximately 120 historic sites remain, including 50 Pony Express stations or station remnants

California National Historic Trail: mid-eighteenth-century route of goldseekers and farmers to California; originally of more than 5,500 miles; now holds more than 240 historic sites and passes through Missouri, Kansas, Nebraska, Colorado, Wyoming, Utah, Nevada, Oregon, and California; activities include auto touring, backpacking, and horseback riding

Fort Riley Military Reservation

U.S. Cavalry Museum: shows the First Infantry Division's history from 1777 onwards; old fort includes the 1855 officer's quarters of Custer House

Manhattan

Riley County Historical Museum: displays artifacts of the settlement period, and the prefabricated Hartford House, brought here by steamboat in 1855

Konza Prairie Research Natural Area: 8,616 acres of tallgrass prairie preserved for ecological research; has several hiking and nature trails

Council Grove

Kaw Mission State Historic Site and Museum: completed in 1851 as a boarding school for Kaw (Kansa) children; examines Native American and settler interaction and the history of the Santa Fe Trail

Topeka

Brown v. Board of Education National Historic Site: commemorates the 1954 Supreme Court decision to end segregation in public schools; consists of the Monroe Elementary School (early-twentieth-century segregated school for African-Americans) and visitor center displaying the history of the decision

Historic Ward-Meade Park: an 1870s mansion, botanical gardens, and reconstructed turn-of-the-century town square, set in land bought in 1854 from a Kaw-Potawatomi

Kansas History Center and Museum of History: detailed account of state history and settlement with pioneer and Native American artifacts

Bonner Springs

Wyandotte County Historical Museum: interprets regional Native American History; includes a 200-year-old canoe and Hopewell culture exhibits

Leavenworth

Fort Leavenworth: established 1827; includes the Frontier Army Museum, with extensive exhibits on frontier military life and campaigns; and self-guided driving tours of the base

Atchison

Atchison County Historical Museum: exhibits describe the town's history and the beginning of the famous Atchison, Topeka & Santa Fe Railroad (also displayed in the **Atchison Rail Museum**)

Amelia Earhart Birthplace Museum: preserved birthplace and childhood home of the first woman to attempt an around-the-world flight; she disappeared over the Pacific in 1937

Fort Scott

Fort Scott National Historic Site: consists of 20 French Colonial structures with exteriors restored to 1840s appearance and several historically furnished rooms, a parade ground, and five acres of restored tallgrass prairie; interpretive and audio-visual programs, nature walks, and guided tours are offered

Independence

Little House on the Prairie: a reconstruction of the house of Laura Ingalls Wilder, built on the original site

NORTHERN MISSOURI

Lewis & Clark National Historic Trail: see Central North Dakota

St. Joseph

Pony Express National Historic Trail: see Eastern Kansas

Pony Express National Memorial: dioramas set in the original stables of the legendary Pony Express tell the story of the company and its riders, such as Buffalo Bill Cody

St. Joseph Museum: exhibits on local resident Jesse James, the city's role in history, and the region's Native American and natural history

Jesse James Home Museum: the cottage where the notorious outlaw was living when shot by Robert Ford on April 3, 1882; visitors can see where blood-stained splinters were chiseled from the floor to be sold as souvenirs

Lewis and Clark State Historic Site

A pavilion with 11 concrete columns representing the number of present-day states the explorers passed through; set on the site where they are thought to have spent the winter of 1803–4

Liberty

Jesse James Bank Museum: where Jesse James staged the first ever daylight bank robbery in 1866; contains the vault and the safe that he raided, memorabilia, and relics of early banking

Historic Liberty Jail: excavated and reconstructed site of imprisonment for many notorious men, such as Joseph Smith, in December 1838

Kearney

Jesse James Farm and Museum: his birthplace and home for 15 years until he became a Confederate guerilla in the Civil War; exhibits James family belongings and furnishings

Kansas City

Kelly's Westport Inn: built 1837, the city's oldest structure

Missouri Town 1855: living history interpreters explain technology and history of pre–Civil War Missouri, in and around 27 original mid-1800s buildings

Arabia Steamboat Museum: displays the cargo, from perfume to pickles, of a vessel that sank in Missouri in 1856 with 200 tons of goods, and was recovered in 1988

Independence

National Frontier Trails Center: interprets city's era as a center of frontier expansion with histories of the various trails

Truman Library and Museum: includes a reconstruction of the 33rd president's White House office and documents pertaining to the development of the atomic bomb

Harry S. Truman Office & Courtroom: his courtroom preserved from his days as a county judge

Harry S. Truman National Historic Site: includes home where he lived from 1919 until his death; and the **Truman Farm Home**, in Grandview, built in 1894 by his maternal grandmother, where he worked from 1906–17; a visitor center has interpretive exhibits, and offers guided tours of both homes, historic Independence, and the Truman neighborhood

Hannibal

Mark Twain Museum and Boyhood Home: holds local memorabilia including the author's first editions, letters, and photos

Mark Twain State Park: preserves his childhood home; includes a museum

MISSOURI: ST. LOUIS AND AROUND

St. Louis

Grants Farm: offers tram rides through a 160-acre wildlife preserve on farmland once owned by General and Mrs. Ulysses S. Grant

Jefferson National Expansion Memorial: consists of Eero Saarinen's 630-foot stainless steel **Gateway Arch**, completed on October 28, 1965 at a total cost of $13 million, with tram rides to the viewing gallery at the top; the **Museum of Westward Expansion**, with its extensive collection of pioneer artifacts, including a detailed look at the Lewis and Clark expedition; and the **Old Courthouse,** one of the oldest standing buildings in St. Louis, begun in 1839, site of the first two trials of the Dred Scott case; now houses a museum of the case with restored courtrooms and displays on the city's history

Union Station: beautiful Romanesque structure with a 230-foot clock tower; first opened in 1894

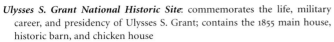

Ulysses S. Grant National Historic Site: commemorates the life, military career, and presidency of Ulysses S. Grant; contains the 1855 main house, historic barn, and chicken house

Anheuser-Busch plant: the only brewery, out of many that German settlers opened in the late eighteenth century, that still stands; now the largest in the world; with free guided tours and tasting

Forest Park: contains the Beaux Arts *St. Louis Art Museum* (the only surviving structure from the 1904 World's Fair), which houses one of the world's most extensive collections of German Expressionism; *St. Louis Zoo*; a *History Museum*, with old pictures of St Louis; and the *St. Louis Science Center*

St. Charles
The KATY Trail: follows the Mississippi for 50 miles along the route of an old railroad; the *Spirit of St. Louis Riverboat* operates cruises

First Missouri State Capitol State Historic Site: the Federal-style brick building that served as meeting place of 1820s frontier legislation, restored to this era

Defiance
Daniel Boone Home: the frontiersman's Georgian mansion built between 1805 and 1810; contains many original furnishings and the only portrait Boone sat for, at the age of 85

Mastodon State Park
North America's largest Pleistocene fossil beds, which contain the bones of prehistoric creatures perfectly preserved by mud from springs and a museum with exhibits on Ice Age Clovis Culture

CENTRAL MISSOURI

Columbia
Museum of Anthropology: the largest collection of prehistoric Missouri Native American artifacts in the world

Jefferson City
State Capitol: includes the Missouri state museum with exhibits on the natural resources and history of the state

Jefferson Landing State Historic Site: three nineteenth-century riverside buildings, comprising the Lohman Building, formerly a store, now a visitor center; the Union Hotel; and the Christopher Maus House, which demonstrates a typical dwelling in the early days of statehood

Cole County Historical Society: housed in an 1871 row house with beautifully preserved period furniture and a Spanish sword from the 1500s that was discovered nearby in the mud of the Missouri River

Rolla
Museum of Missouri Geology: exhibits include huge fossils, mastodon and musk ox bones, and curious rock formations

St. James
Maramec Spring Park: contains the Maramec Museum, which shows the impact of iron production on the people and lands of the area; an agricultural museum; and the remains of Maramec Village (c. 1871)

SOUTHERN MISSOURI

Oregon National Historic Trail: see Central Nebraska

Lamar
Harry S. Truman Birthplace State Historic Site: the six-room house is preserved and refurbished to the time of his birth (1884)

Springfield
Wilson's Creek National Battlefield: the 1861 battlefield is preserved in almost pristine condition to commemorate the battle between approx. 5,400

Union troops and 12,000 Confederates; a self-guided auto tour stops at eight significant points of the battle; includes an 1850s field hospital, living history programs depicting Civil War soldier life, cavalry drills, and historic weapons firing demonstrations

National Cemetery: established 1867; the first cemetery where Union and Confederate soldiers were buried together

Mansfield
Laura Ingalls Wilder–Rose Wilder Lane Museum and Home: Rocky Ridge Farm, established in 1894, where all the *Little House* books were written; has a museum of memorabilia

Diamond
George Washington Carver National Monument: 210-acre park with nature trail, museum, and the 1881 Historic Moses Carver house (the scientist's boyhood home)

Branson
Shepherd of the Hills Homestead: working homestead with a spectacular 360-degree panorama from the top of Inspiration Tower

Branson Scenic Railway: offers a local history tour through the Ozark Hills, across scenic trestles, and along Lake Taneycomo

Ozark National Scenic Riverways
Preserves 134 miles of the Current and Jacks Fork Rivers, with forests, fields, caves, springs, and the Ozark Mountains; includes the *Alley Mill*, built in 1894, still housing much of the original milling equipment; *Storeys Creek One Room Schoolhouse*, with exhibits on its past; and a visitor center, with exhibits on the life and culture of the Ozarks

WESTERN IOWA

Lewis & Clark National Historic Trail: see Central North Dakota

Arnolds Park
Abbie Gardner Cabin Historic Site: restored home of settlers killed in 1857 in the Spirit Lake Massacre involving the Dakota Sioux, led by Inkpaduta

Iowa Great Lakes Maritime Museum: offers cruises on West Okoboji Lake aboard the reconstructed 1884 steamship *Queen II*

Council Bluffs
One of three major starting points for pioneers on the Oregon Trail and starting point for the Mormon trail; includes the *Historic General Dodge House*, the 1869 home of railroader and Civil War General Grenville M. Dodge; and *Historic Pottawattamie County Jail*, built in 1888 and used continuously as a jail until 1969

CENTRAL IOWA

Boone
Boone & Scenic Valley Railroad: scenic journey traveling 15 miles across Des Moines River Valley, over a 150-foot-high trestle; the depot includes the Iowa Railroad Museum

Ames
Farm House Museum: decorated in Victorian style, the first building on campus of the Iowa State University, with an experimental farm from the 1860s

Urbandale
Living History Farms: trace the evolution of agriculture on the Plains; tours lead from the oval bark homes of a 1700 Iowa native settlement, through an 1850s homestead, to a 1900 horse-powered farm; also features the 1875 town of Walnut Hill—14 buildings with costumed demonstrations of period trade and industry

Des Moines
Iowa State Capitol: completed 1886, topped with a gold-leaf dome, boasts marbled corridors and Venetian glass mosaics

Iowa Historical Building: holds exhibits on Iowa's agriculture, geology, wildlife, and history

Des Moines Art Center: world-class art museum, renowned for its contemporary collections

Winterset
The setting for best-selling novel and 1995 movie *The Bridges of Madison County*, holds six (out of an original 19) nineteenth-century covered bridges

John Wayne Museum: former home of the famous actor's father, now run as a museum of his photos, personal belongings, and mementos

EASTERN IOWA

Mormon Pioneer National Historic Trail: see Eastern Nebraska

Waterloo
Grout Museum District: includes the *Grout Museum of History and Science*, exhibiting regional and national history; and the *Rensselaer Russell House Museum*, one of the oldest houses in the county (1861)

Decorah
Vesterheim Norwegian-American Museum: documents the history of early 1800s settlers to the area, with collections of clothes, tools, and folk crafts

McGregor
Effigy Mounds National Monument: 2,526 acres of forests, tallgrass prairies, wetlands, and rivers, containing 195 prehistoric mounds of which 31 are effigies of mammals, birds, and reptiles; includes a visitor center/museum of archaeological and natural exhibits; offers hiking trails, guided walks, and prehistoric tool demonstrations; *Fire Point Trail* provides scenic overlooks from 300-foot bluffs and passes 19 ceremonial and burial mounds

Pikes Peak State Park
Extensive hiking trails to a scenic overlook give sweeping panoramas across the Mississippi at the mouth of the Wisconsin River; explorers Marquette and Joliet stopped here in 1673

Dubuque
Mississippi River Museum: exhibits explore over 200 years of river history

Fred W. Woodward Riverboat Museum: displays the navigational history of upper Mississippi, including a collection of model vessels

Mathias Ham House Historic Site: stately mansion of one of the town's earliest settlers contains mid-nineteenth-century furnishings and exhibits on local history; also incorporates an 1833 log cabin—one of Iowa's oldest buildings

Fenelon Place Elevator: built in 1882; said to be the world's shortest and steepest, it runs from downtown up a sheer bluff to residential Fenelon Place; gives excellent views across the Mississippi to Illinois and Wisconsin

Crystal Lake Cave: discovered by lead miners in 1868; a guided walking tour shows rare mineral and rock patterns, formed centuries ago

Cedar Rapids
Czech Village: traditional houses and a small museum of national costumes and pioneer artifacts of Czech immigrants in the late 1840s

Museum of Art: the world's largest collection of paintings by Grant Wood, best known for depictions of farm life, as seen in *American Gothic*

Amana Colonies
Seven communal religious villages founded in 1855 by pacifist German refugees called the Community of True Inspiration; the largest village, *Amana*, has a small museum of its history; *Homestead* offers a walking trail around a dam on a scenic bend of the Iowa River, built centuries ago by Native Americans to concentrate fish into one area; the *Amana Colonies Trail* links the smaller towns, each with their own museum

Coralville
Coralville Dam: a flood here in 1993 exposed the Devonian Fossil Gorge, its collection of fossils dating back 310–350 million years; a visitor center illustrates the phenomenon

Iowa City
Old Capitol: grand, gold-domed building that served as state capitol 1842–57, before government was transferred to Des Moines; restored to the period

University of Iowa Museum of Natural History: displays geology, archaeology, agriculture, and the history of the corn industry

University of Iowa Museum of Art: internationally important collection, including a fine collection of sub-Saharan African objects

West Branch
Herbert Hoover National Historic Site: a re-created 1870s Quaker farming village, including the 1874 cottage where Hoover was born; his father's blacksmith shop; a schoolhouse; a Quaker Meetinghouse; and the Presidential Library-Museum which presents his life and public career

Le Claire
Buffalo Bill Museum: pays tribute to William F. Cody, the Wild West horseman, scout, buffalo hunter, and showman, born near here in 1846; contains Cody memorabilia, and Native American and pioneer relics

Buffalo Bill Cody Homestead: Cody's boyhood home, a restored 1847 farmhouse

Davenport
Putnam Museum of History & Natural Science: explores ancient and regional history featuring a 3,000-year-old Egyptian mummy and artifacts belonging to the Sauk chief Black Hawk, who fought under Tecumseh in 1812

Muscatine
Muscatine Art Center: housed in a 1908 mansion, displays Mississippi River History, including the pearl industry

Toolesboro Indian Mounds National Historic Landmark
Consists of seven burial mounds, constructed by Hopewell between 100 B.C. and A.D. 200, on a bluff overlooking the Iowa River; decorative materials from the Hopewell's trading network are on display

Mount Pleasant
Midwest Old Threshers Heritage Museums: exhibits on farm women, past and present

Harlan-Lincoln House: built in the 1870s by U.S. Senator James Harlan, whose daughter married Abraham Lincoln's son in 1868; beautifully restored

Salem
Lewelling Quaker House: built in 1840 as a refuge for runaway slaves on the Underground Railroad; displays tell their story

Fort Madison
Old Fort Madison: re-created fort, built in 1808 as exchange post with local tribes; the Midwest's oldest American military garrison on the upper Mississippi River; displays frontier military life

Keokuk
Miller House Museum: Federal-style house that belonged to antislavery lawyer Samuel Miller, appointed to the U.S. Supreme Court in 1862 by Abraham Lincoln

Keokuk River Museum: displays the *Geo M. Verity* paddle wheeler with tours of the main deck, boiler deck, and pilothouse

WISCONSIN, MICHIGAN, AND ILLINOIS

NORTHERN WISCONSIN

Apostle Islands National Lakeshore
Encompasses 21 islands and 12 miles of mainland Lake Superior shoreline; features pristine stretches of sand beach, spectacular sea caves, old-growth forests, resident bald eagles and black bears, and the largest collection of lighthouses anywhere in the National Park System; contains a restored historic fish camp which shows how commercial fishermen lived and worked

Saint Croix National Scenic River
Consists of 252 miles of the Namekagon and St. Croix Rivers; diverse habitats for wildlife viewing; other recreational activities include canoeing, hiking, fishing, camping, and cross-country skiing; various visitor centers display the area's early settlement, trade, geology, and nature

WISCONSIN: LAKE MICHIGAN SHORE

Green Bay
National Railroad Museum: displays freight trade locomotives and artifacts
Oneida Nation Museum: shows local Native American and gambling history

Milwaukee
Pabst Mansion: completed in 1892; lavish, Flemish-Renaissance home of a nineteenth-century brewing baron; beautifully restored interiors
Annunciation Greek Orthodox Church: architecturally stunning, designed in 1956, by Frank Lloyd Wright
Milwaukee Art Museum: excellent collection of Postimpressionist paintings; stunning views of Lake Michigan
Villa Terrace Decorative Arts Museum: Italian Renaissance mansion and formal garden; decorative arts from the sixteenth–eighteenth centuries
Schlitz Audubon Nature Center: offers walking trails among the wildlife of forests and the lakeshore; has a 60-foot observation tower

SOUTHERN WISCONSIN

Oshkosh
Paine Art Center and Gardens: decorative and fine arts, period rooms, and furnishings in a Tudor Revival mansion with botanical gardens
Oshkosh Public Museum: exhibits more than 250,000 documents and artifacts on the history of local exploration, settlement, and development

Madison
State Capitol: sumptuous white granite structure, built 1906–17 at a cost of $7.25 million; tours of the grand period staterooms
State Historical Museum: displays artifacts, photographs, and dioramas of Wisconsin history
Unitarian Meeting House: dramatic Frank Lloyd Wright structure, designed in the late 1940s
Monona Terrace Community and Convention Center: a Frank Lloyd Wright design, full of architectural detail and motifs that mirror the capitol

Spring Green
Home to Frank Lloyd Wright's *Taliesin* and *Hillside Home School*; offers extensive tours of the house, studio, and grounds; the *Frank Lloyd Wright Visitor Center*, designed by Wright in 1953 as a restaurant, now features displays of his work
House on the Rock: built by Alex Jordan from 1944 onward, on and out of a natural, 60-foot chimneylike rock; never lived in, it houses Jordan's immense collection of memorabilia and is a labyrinth of low ceilings, indoor pools, waterfalls, and trees; a major highlight is the *Infinity Room*, made of 3,000 small glass panels tapering to a point and cantilevered several hundred feet above the Wyoming Valley

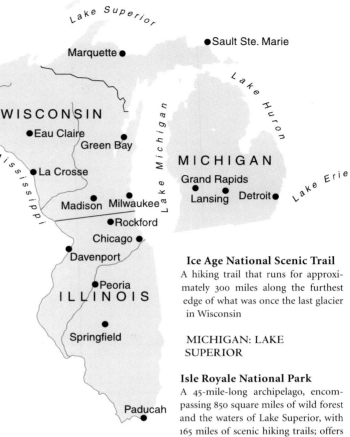

Ice Age National Scenic Trail
A hiking trail that runs for approximately 300 miles along the furthest edge of what was once the last glacier in Wisconsin

MICHIGAN: LAKE SUPERIOR

Isle Royale National Park
A 45-mile-long archipelago, encompassing 850 square miles of wild forest and the waters of Lake Superior, with 165 miles of scenic hiking trails; offers outdoor activities, historic lighthouses, shipwrecks, ancient copper mining sites, and a historic commercial fishery; 3 visitor centers

Keewanaw Peninsula
Good for short driving tours along the dramatic shoreline, with roads winding through forests and past old copper workings

Calumet
Keweenaw National Historical Park: wilderness area commemorating the local history of copper mining, and the site of America's first large-scale hard-rock industrial mining operations

MICHIGAN: UPPER PENINSULA

St. Ignace
Father Marquette National Memorial: commemorates Father Jacques Marquette, who established Michigan's earliest European settlements 1668–71; offers an interpretive trail, hiking trails, and panoramic views

Whitefish Point
Great Lakes Shipwreck Museum: artifacts and exhibits of shipwreck legends of the Great Lakes; guided tours of restored 1861 lightkeepers' quarters

Pictured Rocks National Lakeshore
Encompasses 42 miles of preserved shoreline between Grand Marais and Munising; renowned for its multicolored sandstone cliffs; includes old farmsteads and U.S. coastguard stations, and former logging trails; offers hiking trails along the clifftops and boat trips to view the shoreline and shipwrecks; includes the *Grand Marais Maritime Museum* and the *Munising Falls Interpretive Center*, which displays natural and cultural history, early iron smelting, geology, forest history, and endangered species

Marquette

Marquette Maritime Museum: exhibits on the fishing and freighting industries, and fabled Lake Superior shipwrecks

NORTH MICHIGAN

Mackinac Island

Site of a French mission to the Huron, 1670–71; a French fort in 1715; a base for the American Fur Company; a fishing port; and a jail for Confederate officers during the Civil War; hiking and biking trails lead to the restored Fort Mackinac, which was a U.S. Army outpost until 1890

Charlevoix

An idyllic town, fronting onto Lakes Michigan, Charlevoix, and Round; has a picturesque harbor offering boat trips and lake cruises

Traverse City

Picturesque town, encircled by thousands of acres of cherry orchards and vineyards, with beautiful bay views, sandy beaches, and excellent cycleways

Sleeping Bear Dunes National Lakeshore

An area of natural beauty encompassing 35 miles of Lake Michigan coastline and North and South Manitou Islands; includes forests, beaches, dunes, and ancient glacial phenomena; also features a maritime museum, an 1871 lighthouse, former Coast Guard stations, and a historic farm district

LAKE MICHIGAN SHORE

Ludington

Ludington State Park: beautiful, sweeping sand dunes and virgin pine forests

Grand Haven

Boasts one of the largest and best sandy beaches on the Great Lakes

Holland

Settled in 1847 by Dutch religious dissidents; offers a Netherlands museum, a Dutch village, a clog factory, and windmill

St. Joseph

Picturesque small town that sits on a high bluff with steep steps down to a sandy beach; two parallel piers each have their own lighthouse

SOUTH MICHIGAN

Ann Arbor

Museum of Natural History: exhibits include palaeontology, zoology, anthropology, and astronomy; huge dinosaur skeletons, rare Native American artifacts, and a planetarium

Detroit

Detroit Institute of Arts: the sixth-largest museum in the United States; the internationally renowned collection includes such masterpieces as a Van Gogh self-portrait, Joos Van Cleeve's *Adoration of the Magi*, and Diego Rivera's enormous 1932 mural *Detroit Industry*

Museum of African-American History: the largest African-American museum in the world, with a massive core exhibit covering 600 years of history

Detroit Historical Museum: has over 300 years of history of the Detroit area, with exhibits on its early factories and the automobile industry

Renaissance Center: six gleaming towers with an observation deck offering views of the city

Fox Theater: a huge, spectacularly restored, old Siamese-Byzantine movie palace

Greenfield Village: contains the relocated houses of famous Americans from around the country; includes Henry Ford's birthplace, the Wright Brothers' cycle shop, and Edison's laboratory; costumed staff demonstrate crafts and trade; *Henry Ford Museum:* enormous Museum of Americana with exhibits of automobiles, planes, trains, domestic inventions, children's collectibles, Lincoln's chair, and Kennedy's car

Automotive Hall of Fame: pays homage to innovators of the auto industry

Motown Museum: housed in the small clapboard house that served as Motown's recording studio 1959–72; includes Studio A, which remains just as it was left, and the former living quarters of label founder Berry Gordy

NORTHERN ILLINOIS

Mormon Pioneer National Historic Trail: see Eastern Nebraska

Galena

Ulysses Simpson Grant House: 1865–8 home of the 18th president, restored to 1868 appearance with original Grant family objects and furnishings

Galena Historical Society and Museum: 1858 mansion, displays town and county artifacts; offers guided walking tours of the town, a cemetery walk with costumed actors portraying historical figures, and historic home tours

Rockford

Midway Village & Museum Center: 24 historic structures including stores, a blacksmith shop, one-room schoolhouse, and fire station; museum center displays Rockford's major industries and early Northern Illinois history

ILLINOIS: CHICAGO AREA

Lyons

Chicago Portage National Historic Site: preserved part of the historic portage between the Great Lakes and the Mississippi; guided history walks

Chicago River

Burnham's Promenade: incomplete but elegant promenade leading over 20 drawbridges, designed by Daniel Burnham in 1909

Wacker Drive: holds many diverse structures such as the elegant Beaux Arts *Jewelers Building*, built in 1926, and topped on the 17th floor by a large rotunda that once contained the favorite speakeasy of Al Capone; and *333 W. Wacker Drive*, a 36-story, curved tower block of stunning design

IBM Building: Ludwig Mies van der Rohe's huge 1971 masterpiece with a beautiful facade of bronze and glass

Merchandise Mart: the world's largest building on its opening in 1931

Downtown Chicago

Chicago Board of Trade: contained in a stunning Art Deco tower, topped by a 30-foot stainless steel statue of Ceres, Roman goddess of grain; contains a visitors' gallery tracing the evolution of the trade signaling system

Chicago Mercantile Exchange: the largest stock options exchange in the U.S.

The Rookery: one of the city's most celebrated constructions; built in 1886 with a Moorish Gothic exterior and a lobby of Italian marble and gold leaf

Reliance Building: a Daniel Burnham design, built in 1895, a precedent for the modern skyscraper; his other Chicago structures include the 1890 *Manhattan Building*, the world's first tall all-steel-frame building

Carson Pirie Scott store: one of Chicago's grandest turn-of-the-century department stores, built in 1889 with a magnificent ironwork facade

Sears Tower: the tallest building in the world until 1997, containing over 100 different elevators, two of which ascend in little over a minute from the ground to the 103rd floor; also contains the *Skydeck Observatory* for breathtaking views as far as Michigan, Wisconsin, and Indiana

Swedish American Museum: heritage of the Swedish people who came to the Chicago area two centuries ago; art, artifacts, and history exhibits

Gold Coast and Old Town

Old Town: originally a German immigrant community; centered around the 1873 *St. Michael's Church*, with many century-old rowhouses and workers' cottages, notably the *House of Glunz*, a wine shop dating to 1888

Grant Park

A 200-acre park full of sculptures and such famed monuments as *Buckingham Fountain*, with its spectacular light-and-water shows; includes the *Field Museum of Natural History*, a huge Burnham-designed Greek temple, with such exhibits as the entire burial chamber of the son of a Fifth Dynasty pharaoh; the enormous 1930s *Shedd Aquarium*; the *Oceanarium*; and the *Adler Planetarium*, which offers excellent views of the city skyline

Lincoln Park and Wrigleyville

Chicago Historical Society Museum: exhibits local history and artifacts

Biograph Theater: movie house originally opened in 1914; where infamous bank robber John Dillinger was killed by the FBI in 1934, following a tip-off from the "lady in red"

North Side

Michigan Avenue: part of what's known as the *Magnificent Mile*; developed in the 1920s with such landmarks as the 1920 *Drake Hotel*, the *Wrigley Building*, built in 1920 by the chewing-gum magnate; the *Tribune Tower*, completed in 1925, which still houses the editorial offices of Chicago's morning newspaper; also holds the 1970 *John Hancock Center*, 1,127 feet high, with a 360-degree panorama from its 94th floor

Historic Water Tower: stone castle, topped by a 100-foot tower, built in 1869

Arlington Heights Historical Museum: displays 150 years of neighborhood history with a coach house, log cabin, the 1906 Soda Pop Factory Building, the 1882 F. W. Muller Home, and the 1908 N. M. Banta House

South Side

Art Institute of Chicago: excellent collections of American, Asian, and European paintings, prints, and photography

Fine Arts Building: built for the Studebaker Carriage Company in 1885, it once held the offices of *Wizard of Oz* author L. Frank Baum and the drafting studio of the young Frank Lloyd Wright

Glessner House: Chicago's only surviving H. H. Richardson-designed house, built in 1886 in a Romanesque style; filled with Arts and Crafts furniture and swathed in William Morris fabrics and wall coverings

Clarke House: Chicago's oldest building, a plain, white 1836 Greek Revival pioneer home, now a minor museum of interior decor

Presbyterian Church: a lavish, Gothic structure, with Burne-Jones and Tiffany stained-glass windows.

University of Chicago: endowed by Rockefeller in 1892, the campus holds the huge, Gothic *Rockefeller Memorial Chapel*, and Frank Lloyd Wright's 1909 Prairie-style *Robie House*

Du Sable Museum of African-American History: looks at the experience of Americans of African origin, from slavery to the present day

West Side and Oak Park

Oak Park: c. 1900 suburb, preserved as a national historic district; visitor center offers excellent architectural walking tours; birthplace and boyhood home of Ernest Hemingway; the *Oak Park and River Forest Historical Society* holds a collection of Hemingway memorabilia; Frank Lloyd Wright erected 25 buildings here, some of which are open to the public

Unity Temple: Frank Lloyd Wright's impressive 1906 structure; one of the earliest public buildings constructed of concrete

Frank Lloyd Wright Home and Studio: designed by him, built in 1889; offers guided tours of the house and walking tours of the district

The Illinois & Michigan Canal National Heritage Corridor

A 97-mile long 1848 canal route that connected the Great Lakes to the Mississippi River, rapidly transforming Chicago from a small settlement to a critical transportation center; the towpath runs through farmlands, forests, and a number of towns; offers many outdoor, nature, and winter activities; encompasses the *Isle a la Cache Museum*, with exhibits on the Voyageur–Native American contact period of the mid-1700s; and the *Little Red Schoolhouse Nature Center*, with exhibits on local animal and plant life

CENTRAL ILLINOIS

Lewis & Clark National Historic Trail: see Central North Dakota

Lewiston

Dickson Mounds Museum: an on-site archaeological museum, exploring 12,000 years of human existence in the Illinois River Valley; includes the excavated remains of *Eveland Village*, three early Native American structures

Petersburg

Lincoln's New Salem State Historic Site: reconstruction of the village where Abraham Lincoln spent his early adulthood; includes log houses, the Rutledge Tavern, workshops, stores, mills, and a school, restored and furnished to its appearance in the 1830s

Springfield

Lincoln Home National Historic Site: two-story home of Abraham and Mary Lincoln from 1844 until 1861, restored to its 1860s appearance; visitor center offers tours of the house

Old State Capitol: center of state government 1839–76, where Lincoln served as state legislator; offers 1850s-costume guided tours

Oak Ridge Cemetery: contains Lincoln's tomb, with busts and statuettes

Illinois State Capitol: grand structure, built 1868–88; tour highlights include the chambers of the state Senate and House of Representatives

Illinois State Museum: displays natural and Native American history, and Illinois family life from 1700 to 1970

Dana-Thomas House: completed in 1904; the best-preserved of Frank Lloyd Wright's early Prairie houses; more than 400 original fixtures

Arcola

Illinois Amish Interpretive Center: museum of the Old Order Amish in central Illinois; offers guided tours of Amish homes and farms

SOUTHERN ILLINOIS

Collinsville

Cahokia Mounds State Historic Site: one of the largest prehistoric Indian cities north of Mexico in c. A.D. 1100, subsequently abandoned c. 1400; 109 mounds remain, one of which is said to be the largest prehistoric earthen structure in the Americas; features a museum of artifacts and a model reproduction of the original city

Belleville

Victorian House Museum: built in 1866 by a prosperous German immigrant; contains nineteenth-century furnishings made by local craftsmen, vintage clothing, quilts, and other artifacts

Emma Kunz House Museum: an ethnic German rowhouse, built 1830; the oldest surviving Greek Revival house in the state, with original interiors completely furnished to represent the lives of early settlers

Prairie du Rocher

Fort de Chartres State Historic Site: massive stronghold built by the French in the early 1700s, the center of French control in the state; abandoned in 1772 and gradually dismantled; now the walls and sentry boxes are reconstructed and a museum contains artifacts excavated from the site

Chester

Fort Kaskaskia State Historic Site: situated on a bluff overlooking the Mississippi River; the remnants of an earthwork and timber fort, constructed by the French during the mid-1700s; offers seasonal re-creations of the Revolutionary War and a French Colonial encampment

The Pierre Menard Home: built in the early 1800s for the state's first lieutenant governor; furnished with period pieces to demonstrate the upper class French-American lifestyle of the early nineteenth century

INDIANA, OHIO

NORTHERN INDIANA

Elkhart
Elkhart County Museum: offers an audio driving tour through small towns, cities, and back roads, looking at Amish life and area history

South Bend
Northern Indiana Center for History: exhibits the history of the St. Joseph Valley; includes the 1895, 38-room Copshaholm mansion and an 1870s factory worker's cottage

Porter
Indiana Dunes National Lakeshore: 25 miles of the southern Lake Michigan shore; a beach landscape with wetlands and forests; displays an 1830s French-Canadian homestead and a working turn-of-the-century farm

Michigan City
Barker Mansion: an opulent 38-room Victorian home, built by a founding father of the rail car industry, John H. Barker; offers tours
Great Lakes Museum of Military History: displays military memorabilia from Revolutionary War to the present

Crown Point
"Grand Old Lady": beautifully designed Lake County Courthouse, built 1878; houses a museum of local memorabilia

Nappanee
Amish Acres Historic Farmstead: farming, crafts, and chores as practiced by the first Amish settlers (1839); demonstrations of quilting, lye soap and broom making, rug weaving, apple butter boiling, and candle dipping

Fort Wayne
The Lincoln Museum: proclaimed as the world's largest museum dedicated to Abraham Lincoln's life and his contribution to American society

CENTRAL INDIANA

Fountain City
Levi Coffin State Historic Site: restored Federal-style house built in 1839, once the home of Levi and Catharine Coffin, who helped runaway slaves on the Underground Railroad

Lafayette
Tippecanoe Battlefield and Museum: site of 1812 battle between Tecumseh and his followers and western settlers under William Henry Harrison; displays battle history and local Native American heritage

Indianapolis
Monument Circle: a series of memorials and plazas dedicated to veterans; includes the 284-foot Soldiers and Sailors Monument
Lockerbie Square Historic District: cobblestone streets of multicolored wood-frame cottages, once home to nineteenth-century craftsmen
Eiteljorg Museum of American Indians and Western Art: displays Native American artifacts and crafts, a Haida totem pole, and modern art
The Congressional Medal of Honor Memorial: one-time training field and Civil War encampment, dedicated to medal winners
Crown Hill Cemetery: contains graves of former president Benjamin Harrison, Hoosier poet James Whitcomb Riley, and John Dillinger
Indianapolis Speedway: home to the legendary Indianapolis 500, America's most watched car race, where drivers rocket around the track at 225 mph; contains the **Hall of Fame Museum** of the Speedway's history

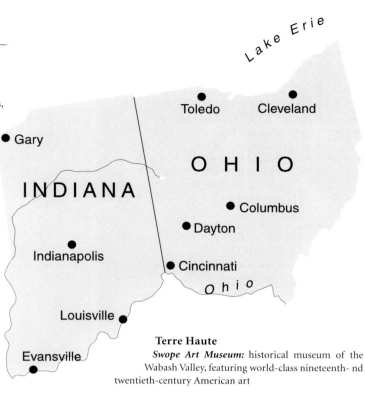

Terre Haute
Swope Art Museum: historical museum of the Wabash Valley, featuring world-class nineteenth- nd twentieth-century American art

Bloomington
Indiana University Art Museum: designed by I. M. Pei & partners; displays Byzantine to modern Western art, Asian and Ancient art, and collections from Africa, the Pacific, and Pre-Columbian America

SOUTHERN INDIANA

Madison
Lanier Mansion State Historic Site: 1844 Greek Revival house and gardens of local hero James Franklin Doughty Lanier, restored to the style of his time
Eleutherian College: constructed 1854–6; first college in Indiana to admit students without regard to race or gender

Marengo
Marengo Cave National Landmark: tours around huge colorful caves with elaborate formations

Wyandotte
Squire Boone Caverns: discovered in 1790 by Daniel Boone and his brother Squire; stalactites, massive underground waterfalls, and mineral formations

Vincennes
George Rogers Clark National Historical Park: site of Fort Sackville, captured from the British by George Rogers Clark and his frontiersmen in 1779; interpretive programs; costumed living history programs

Lincoln City
Lincoln Boyhood National Memorial: boyhood home of Abraham Lincoln; a living history farm re-creates the pioneer homestead with buildings, gardens, and crop fields; museum of the Lincoln family era

Evansville
Angel Mounds State Historic Site: inhabited from A.D. 1100 to 1450; the settlement's history and culture is shown in a reconstructed village
Reitz Home Museum: a restored French Second Empire mansion that was once the home of John Augustus Reitz, known as the Lumber Baron

Rockport

Lincoln Pioneer Village & Museum: restored log-cabin village with hundreds of artifacts collected from the area

OHIO: LAKE ERIE ISLANDS AND SHORE

Kelleys Island

The whole island is a National Historic District, containing over 70 archaeological sites such as **Inscription Rock**, a limestone slab carved with 400-year-old pictographs; the **Glacial Grooves State Memorial**, on the west shore, is a 400-foot trough of solid limestone, marked by the glacier that carved the Great Lakes; a haven for swimming, bird watching, and hiking

South Bass Island

Perry's Victory and International Peace Memorial: commemorates the Battle of Lake Erie, September 10, 1813; a 25-acre park with a 352-foot stone Doric column and observation deck from which to view the battle site; Rangers offer living history demonstrations and firing demonstrations of the weapons of 1812
Heineman Winery: the only one of 26 vineyards that survived Prohibition here; gives tours and tastings

Milan

Thomas Edison Birthplace: childhood home of the inventor of the lightbulb; restored to its 1847 condition, with guided tours and an adjacent museum displaying his early inventions, documents, and family mementos

Mentor

James A. Garfield National Historic Site: preserves the 1876 home of the 20th president and his family; offers tours

NORTHERN OHIO

Cleveland

Avenue at Tower City: a glamorous shopping mall with an observation deck on the 42nd floor, giving excellent views of the skyline
Cleveland Museum of Art: from Renaissance armor to African art
Cleveland Museum of Natural History: exhibits on dinosaurs, Native American culture, over 1,500 gems and minerals, and Earth and planetary exploration
Rockefeller Park: 24 small landscaped cultural gardens, dedicated to and tended by the city's diverse ethnic groups, including Croatians, Estonians, and Finns

Cuyahoga Valley National Park

Recreation area for hiking, biking, horseback riding, winter sports, fishing, scenic train rides, and ranger-guided programs; includes historical sites and museums such as **The Boston Store** (c. 1836), which housed the Boston Land and Manufacturing Company Store, now a canal boatbuilding museum; the **Frazee House**, (1825–6) an early Federal-style Western Reserve home with exhibits on architectural styles and construction techniques; the **Hunt Farm**, typical of the small farms that dotted the area in the late nineteenth century, with agricultural exhibits; and visitor centers illustrating 12,000 years of valley history and the history of the Ohio & Erie Canal

Vermilion

Inland Seas Maritime Museum: looks at shipping on the Great Lakes with models, pictures, and artifacts from the late seventeenth century to recent times

Oberlin

Oberlin College: America's first coed university and one of the first to enroll black students; played an important role in the Underground Railroad, a commemorative sculpture of which stands on campus

Youngstown

The Butler Institute of American Art: works from the Colonial period to the present, featuring Mary Cassatt, Thomas Eakins, and Charles Sheeler

CENTRAL OHIO

Scio

Custer Monument: a bronze statue on the site of George Armstrong Custer's birthplace, the foundations of which are on display; an exhibit hall

New Philadelphia

Schoenbrunn Village State Memorial: reconstructed village founded in 1772 as a Moravian mission; 17 log buildings, and the original cemetery

Piqua

Piqua Historical Area State Memorial: contains the home and farm of John Johnston, restored to its 1829 appearance; costumed interpreters and craft demonstrators provide tours and display activities; a ring-shaped mound earthwork, discovered and preserved by Johnston, was constructed here by the Adena more than 2,000 years ago

Columbus

Ohio Statehouse: renovated 1839 Greek Revival structure with tours of the ornate Senate and House chambers
Columbus Museum of Art: collections of Western and modernist art, and a renowned photography gallery
Topiary Garden: Georges Seurat's famous Postimpressionist work, *Sunday Afternoon on the Island of La Grande Jatte*, re-created in topiary
German Village and Brewery District: mid-nineteenth century settlement of thousands of German immigrants; the **German Village Meeting Haus**, offers walking tours of the area and **Columbus Brewing Co.** still produces beer by traditional methods, and offers tours

SOUTHERN OHIO

Dayton

Dayton Aviation Heritage National Historical Park: commemorates the work of Wilbur Wright, Orville Wright, and Paul Laurence Dunbar; preserves buildings relating to the men, and the 1905 *Wright Flyer III*
Carillon Historical Park: outdoor museum featuring 20 exhibit buildings that display the transportation and settlement history of the area; includes the oldest building still standing in Dayton (a 1796 tavern)

Cincinnati

MainStrasse Village: nineteenth-century neighborhood of Germanic origin; contains **Carroll Chimes Bell Tower**, a German Gothic tower where 21 mechanical figures and glockenspiel music toll the hour
Oldenberg Brewery: microbrewery and museum of brewing memorabilia
The William Howard Taft National Historic Site: commemorates the only man to serve as both president and chief justice; features Taft's restored birthplace
Carew Tower: 48-story Art Deco building with viewing gallery on its top floor, giving a panorama of the city and surrounding hillsides
Taft Museum: an 1820 Federal-style mansion; collection of works by Rembrandt, Goya, Turner, Gainsborough, Ming porcelain, and French enamels
Cincinnati Art Museum: 100 galleries spanning 5,000 years of international art
Museum Center at Union Terminal: stunning Art Deco structure with restored lobby of intricate mosaic murals
Museum of Natural History: features dioramas of Ice Age Cincinnati and "The Cavern," which houses a living bat colony
Riverside Walk: a cobbled wharf on the original site of the city, with painted showboats and other river craft

Chillicothe

Hopewell Culture National Historical Park: remnants of a large earthwork and mound complex, originally of a monumental scale, of the Hopewell culture, here from c.200 BC to AD 500; the visitor center displays artifacts recovered from the Mound City Unit during various excavations

INDEX

Numbers in **bold** type refer to illustrations

Aco, Michel 54
Addams, Jane 118, **118**
Adena Indians 42–43, **45** see also Woodland Indians
Agriculture **8**, **9**, **18**, 26, 27, **26–27**, **32**, 38, 39, **39**, 42, 44, 47, 82, **82**, 86, 88, **88**, 94, 96, **97**, 98, **100–101**, 102, 108, 110, 114–115, **114–115**, **116–117**, 117–118, 119, 122, 123, 126: Cattle ranching 27, 93, 98, 110, 114; Dairy production 98, 108, 119
Allouez, Jean Claude 51
American Revolution, the 14, 54, 59–60, 63, 68–69, 70, 72
Amherst, Lord Jeffrey 68
Archaic Period Indians 38–39, 47
Arkansas River 34, 54
Ashley, Lieutenant Governor William Henry 73
Astor, John Jacob 86, 98
Bad Axe River 74
Bad River 83
Baptism River **36–37**, 82
Battle of Wilson's Creek 93
Becknell, William 83
Beuro, Pierre de 31
Bienville, Col. Celeron de 66–67
Big Foot 78
Bimeler, Joseph Michael 84–85
Bison 17, 20, 34–35, 38, 39, **80**, 93, 107–108, 126
Black Hawk 73–74, **74**
Black Wolf 71
Blue Jacket 71
Boone, Daniel 11, 63
Booth, George and Ellen 122
Bonaparte, Napoleon 64
Borglum, Gutzon 126
Boston Tea Party, the 59
Bourgmont, Etienne Veniard 55
Bradstreet, Colonel John 68
Brock, General Sir Isaac 72
Brown, John 90–91
Brulé, Etienne 50
Bryan, William Jennings 96
Buffalo see Bison
Buffalo Bill see Cody, William F.
Bunyan, Paul 126
Burnham, Daniel **29**
Caldwell, Captain William 69
Canals 84, 88, 102–103
Cannary, Martha Jane 94, **95**
Capone, Al 122
Carp River **19**, 99
Cather, Willa 14
Catlin, George 84, **84**
Catt, Carrie Chapman 118, **118**
Cavalier, Robert 51, 54
Céleron de Blainville, Pierre Joseph de 58
Champlain, Samuel de 50

Chicago River 20
Chouart, Médard 50
Cincinnati Red Stockings, the 110
Civil War 54, 75, 91–93, 102, 107, 108
Clark, General George Rogers **60**, 68–69, 70
Clark, Captain Meriwether see Lewis and Clark
Clemens, Samuel Langhorne see Twain, Mark
Climate 15, 17, 18, 30, 34, 38, 39
Cody, William F. **93**, 108
Colonial powers 50, **62**: Britain 14, 50, 51, **54**, 55, 58–59, 60, 63, 64, 66–69, **68**, **70**, 71–73, **72**, 74, 84, 98; France 14, 50–51, 55, 58–59, 63, 64, **64**, 66–67, 88; Spain 50, 55, 58, 60, 63, 64, 66–67, 99 see also Colonists
Colonists 14, 66: English 55, 58–59, 67, 83; French 14, 31, 50–51, 54–55, 58–59, **59**, 60, 63, **67**, 98 see also Missionaries; Spanish 14 see also Colonial powers and Immigrants
Columbus, Christopher 96
Connolly, Dr. John 68
Coolidge, Calvin 117
Cornstalk, Chief 69
Coronado, Francisco Vasquez de 20, 50
Cowboys 93–94, 110
Crazy Horse **77**
Crime 11, 107, 122
Crook, General George 77
Cutler, Manasseh 90
Currier, Nathaniel **74**
Curtis, Edward S. **78**
Custer, General George Armstrong 15, 75, 77
Dakota Territory, the 75, 77, 92, 94, 102, 106, 108, 110, 114
Declaration of Independence 59
Deere, John **116–117**
Depression, the 122, 128
Dobberstein, Father Paul 126
Donnelly, Ignatius 96
Dorion, Pierre 63
Douglas, Stephen A. 90
Dubuque, Julien 63, 99
DuLhut, Sieur 54
Dunmore, Lord (Governor John Murray) 68–69
Dvorak, Antonin 126
Earp, Wyatt 93
Edison, Thomas Alvah 11, 110
Education 92, 109–110, **111**, 128
Erie Canal, the 84, 88, 102–103
Explorers 15, 20, 29, 46, 47, **47**, 99: American 26, 30–31, 47, 73, 82, 83; British 58; French 11, 14, 30, 34, 45, 50–51, 54–55, 58, 59, 63, 66; Spanish 20, 50 see also individual names
Fermi, Enrico 123
Flanagan, Father Edward Joseph 118
Flat River 99

Floyd, Sergeant Charles 83
Ford, Henry 11, 111, 115–117, **116**
Forsyth, Colonel James 79
Forts: Fort Abraham Lincoln 77; Fort Atkinson 86; Fort Buford 77; Fort Davidson 93; Fort de Chartre 58, **64**; Fort Daer 84; Fort Dearborn 72; Fort Detroit 59, 60, 67, 68, 69, 72, 84; Fort Greenville 71; Fort Kaskaskia 60; Fort Knox 70; Fort Larned 75; Fort Leavenworth 17, 86; Fort Lisa 83; Fort Mackinac **54**, 63, 84; Fort Madison 82; Fort Mandan 82; Fort Michilimackinac 63, 68, 69; Fort Patrick Henry see Fort Sackville; Fort Pierre 83; Fort Pontchartrain 55; Fort Recovery 63, 70–71; Fort Ridgely 74; Fort Robinson 77; Fort Sackville 60, **70**; Fort Snelling 91; Fort St. Joseph 60; Fort Tecumseh 84; Fort Washington 70; Fort Wayne 70
Frémont, John C. 88, 128
French and Indian Wars, the 14, 55, 58–59, **64**, 66–67
Fugina, Martin **28**
Fur trade 20, 50, 51, 54–55, 59, 63, **67**, 73, 83, 86, 98, 102
Gaine, General Edward 73–74
Galbraith, Thomas 74
Gambling 110
Garland, Hamlin 9
Gateway Arch, the St. Louis **124–125**
George III, king of England 59
Ghost Dance, the 77–78, **79**
Gist, Christopher 58
Gladwin, Major Henry 68
Gold rush, the see Mining: Gold
Goodrich, Dr. Benjamin 115
Government 59, 60, 62–63, 69–70, 82, 87, 88, 89–90, 95–96, 108
Grant, Ulysses S. 92–93
Great Lakes, the 9, 20, 30, 34, **39**, 50, 51, 54, 55, **62**, 67, 71, 103, 106, 115, 127 see also individual lakes
Greenville Treaty, the 63
Greysolon, Daniel 54
Haldane, William "Deacon" 106–107
Hamilton, Lieutenant Governor Henry 59–60
Hamtramck, Major John 70
Hancock, Gen. Winfield Scott 75
Harmar, Brigadier Gen. Josiah 70
Harrison, Benjamin 114
Harrison, William Henry 71, 72, 84
Helms, Leonard 60
Hemingway, Ernest 14
Hennepin, Louis 54
Henry IV, king of France 55
Hickok, James Butler "Wild Bill" 93, 94
Homestead Act, the 91

Hopewell Indians, the 34, 43–45 see also Woodland Indians, the
Hudson Bay Territories, the 55
Hughes, Langston 14
Hull, General William 72, 84
Hunting 26, 27, 34–35, 38, 39, 42, 47, 80, 93, 107, 108
Ice Age, the 17, 18, 34, 60
Idaho Territory 110
Illinois **9**, 17, 18, **32**, 34, 43, 44, 46, 51, 54, 58, 60, 63, 66–67, 73, 82, 83, 84, 86, 88, 91, 96, 98, 101, **100–101**, 108, 117, 119, 123, 126, 128: Bishop Hill 85; Cahokia 39, **42**, 45, 55, 60, 69, 74; Cairo 93; Carrier Mills 39; Cave in Rock State Park **12–13**; Cedarville 118; Chicago 11, 20, **29**, 54, 72, 95, **96**, 103, 106, 114, 118, 119, 122, 123, 128, **128**; Elgin 106; Fort de Chartres 58, **64**; Fort Dearborn 72; Fort Patrick Henry see Fort Sackville; Fort Sackville 60, 70; Fulton 106; Galena 99, 119; Harmony **85**; Horseshoe State Park **40–41**; Kaskaskia 55, 59, 60, 69; Koster 38–39; LaSalle 103; Matthiessen State Park **33**; Modoc Rockshelter 39; Moline 116; Monks Mound 42; Nauvoo 86, 86; New Harmony 85, **85**; Oak Park 14; Patoka 123; Prairie de Rocher 58; Rockford 106; Rock Island 106; Springfield 11, 69; Starved Rock State Park 127; Utica 54, 127
Illinois River 31, 51, 54, 103, 127
Illinois Territory 58, 59–60, 88
Immigration 11, 14, 29–30, 84, 85, 86, 88, 91, 94, 95, 98, 102, 118
Indiana 17, **18**, 34, 43, 46, 54, 58, 59, 60, 64, 66–67, 69, 70, 82, 83, 84, 86, 92, 98, 108, 119, 126, 128: Columbus 119; Corydon 93; Elkhart 126; Evansville 103, 119; Fort Knox (Vincennes) 70; Fort Wayne 70; Gary 20, 117; Indianapolis 119; Lafayette 55; McGregor 42; Noblesville 126; Ouiatanon 55; Prophetstown 71; Rockport 126; South Bend 103; Vincennes 55, 60, 69, **70**; Whiting 117; Wyandotte Caves 27
Indiana Territory 64, 71, 83, 87, 88
Indian Removal Act, the 86
Industry 107, 109, 118–119, 123, 126: Automobiles 11, 103, 111, 116–119, 123; Lumbering 20, 87, 101–102, 106, 110; Oil 116–117, 123; Steel mills 116–117 see also Mining
Iowa 18, 34, 47, 54, 58, 60, 63, 74, 82, 83, 84, 87, 88, **88**, 92, 96, 106, 107, 108, 115, 119, 123, 126, 128: Ames 110; Bear Creek Township **111**; Charles City 118; Dubuque 63, 87, 99; Effigy Mounds National Monument **44**, 45, 127; Fort

Madison 83; Harper's Ferry 127; Iowa City 92; Keokuk 87; Marquette 44, 45; Muscatine 122; Nashua 126; Pike's Peak State Park 61; Sioux City 82–83; Spillville 126; Urbandale 126; Waterloo 119
Iowa River 74
Iowa Territory 45, 74, 87
Jackson, Andrew 87
James, Alexander Franklin 107
James, Jesse Woodson 107
Jefferson, Thomas 59, 82, 120–121, 126
Johnson, Sir William 68
Jolliet, Louis 34, 54
Kansas 15, 17, 20, 29, 34, 47, 54, 58, 63, 75, 82, 83, 86, 88, 91, 92, 93, 94, 98, 101, 115, 122, 126: Abilene 93, 98; Branson 126; Dodge City 93, 98, 99; Dunlap 90; Flint Hills 17, 81; Fort Larned 75; Fort Leavenworth 17, 86; Kanopoly Lake 127; Konza Prairie Research Natural Area 27; Lawrence 90, 93, 110; Manhattan 110; Milford Lake 128; Nicodemus 90; Philipsburg 127; Strong City 81; Tallgrass Prairie Natural Reserve 81; Topeka 128; Wichita 95, 123
Kansas-Nebraska Act, the 74, 88
Kelley, Oliver H. 95–96
Kellogg, John Harvey 118
Kellogg, Dr. Will Keith 118
Kicking Bear 78
Kinkaid, Moses P. 115
Knox, Henry 70
Laclede Liguest, Pierre de 59
La Follette, Robert M. "Battling Bob" 117–118
LaFramboise, Joseph 83
Lake Erie 20, 66, 72, 73, 84, 98, 102–103
Lake Huron 50, 103
Lake Itasca 83
Lake Michigan 20, 28, 50–51, 52–53, 60, 72, 87, 103, 104–105
Lake Ontario 51
Lake Superior 11, 20, 21, 28, 38, 42, 46, 49, 50, 51, 56–57, 103
Lake Superior Highlands, the 20
La Salle, Sieur de 51, 54
Law, John 58
Leavenworth, Colonel Henry 73
LeMay, General Curtis 123
Lery, M. de 11
Lewis and Clark 26, 30–31, 73, 82
Lewis, John L. 123
Lewis, Captain William see Lewis and Clark
Lincoln, Abraham 11, 74, 92, 120–121, 126
Lisa, Manuel 83
Literature 9, 14, 17, 84 see also individual authors
Little Bighorn 77

Little Crow 74–75
Little Turtle 70–71
Logan, John 69
Long, Major Stephen 83
Louisiana Purchase, the see Louisiana Territory
Louisiana Territory 14, 50–51, 58, 63, 64, 66–67, 73, 82
Lumbering see Industry: Lumbering
Ma-ka-tai-me-she-kia-kiak see Black Hawk
Mallet, Paul 63
Mallet, Pierre 63
Maps: Great Lake region, the 62; Louisiana Territory 50–51; Peace of Paris Agreement, the 72
Marji-Gesick 99
Marquette, Father Jacques 34, 51, 54
Masterson, William Barclay "Bat" 93
Maumee River 70, 71, 87
Menard, René 50
Merritt, Leonidas 99
Miami River 69, 70
Michigan 11, 17, 34, 35, 38, 46, 55, 58, 59, 60, 64, 66, 68, 72, 82, 83, 86, 87, 88, 90, 98, 99, 106, 119, 122, 123, 126, 127, 128: Adrian 103; Alpena 126; Battle Creek 118; Belle Isle 67; Big Spring 28; Bloomfield Hills 122; Dearborn 14, 116; Detroit 30, 55, 63, 69, 88, 111, 118, 123; Ecorse 67; Empire 28; Fort Detroit 59, 60, 67, 68, 69, 72, 84; Fort Mackinac 54, 63, 84; Fort Pontchartrain 55; Fort St. Joseph 60; Frankenmuth 126; Gainey 35; Gogebic 99; Grand Haven 104–105; Grand Rapids 106; Grayling 122; Greenfield Village 117; Isle au Cochon 67; Keweenaw Bay 50; Kitch-iti-kipi 28; Lansing 111; Mackinac Island 54, 86, 111, 112, 117; Mackinac Strait 50, 128; Manistique 28; Marquette 99; Menominee 99; Michilimackinac 63, 68, 69; Negaunee 99; Newberry 28; Niles 60; Ontonagon 19; Pictured Rocks National Lakeshore 28, 48; Porcupine Mountains Wilderness State Park 19; Port Huron 110; Saginaw 106; Sault Sainte Marie 51, 126; Sleeping Bear Dunes National Lakeshore 24–25, 28; Tahquamenon Falls 28; Upper Peninsula, the 87, 99, 106
Michigan Territory 87, 88
Migration 9, 11, 29–30, 69, 86, 86, 89, 90–92, 106, 119
Miles, Colonel Nelson 77
Mining: Copper 99; Lead 55, 63, 88, 99, 101, 106; Gold 75, 75, 77, 94, 98, 101, 102; Iron 99, 126; Limestone 28, 101
Minnesota 17, 18, 20, 34, 44, 47, 47, 54, 58, 60, 63, 74, 75, 82, 83, 86–87,

88, 91, 92, 96, 99, 106, 108, 110, 126, 127, 128: Akeley 126; Birch Coulee 74; Brainerd 126; Duluth 20, 54; Falls of St. Anthony, the 54; Fort Ridgely 74; Fort Snelling 86; Fort St. Anthony 86; Grand Portage National Monument 56–57; High Falls 29; Hinkley 106; Lake Itasca 18; Lake of the Woods 58; Little Falls 83; Mesabi Range, the 99; Minneapolis 18, 54, 92; New Ulm 74; Northwest Angle 29; Ossineke 126; Red Wing 45; Rochester 128; Spirit Lake 117; St. Charles 58; Stillwater 87; St. Paul 14, 87; St. Pierre 58; Superior National Forest 36–37; Wood Lake 74
Minnesota River 54, 101
Missionaries 50–51, 54–55, 55, 59, 63, 69, 92
Mississippian Indians, the 34, 39, 42, 44–45 see also Woodland Indians
Mississippi River 9, 15, 18, 20, 29, 30, 34, 40–41, 43, 45, 46, 47, 50, 51, 54, 55, 58, 60, 61, 63, 73, 74, 83, 86, 87, 98, 99, 101, 102, 106, 122, 123, 124–125
Mississippi River Valley 54, 55, 58, 59, 91, 115
Missouri 11, 15, 17, 18, 29, 34, 47, 51, 58, 59, 60, 63, 82, 86, 90, 91, 92–93, 96, 99, 107, 110, 122, 128: Belmont 93; Carthage 93; Columbia 93; Eminence 108; Femme Osage Valley 63; Fort Davidson 93; Fort Tecumseh 84; Freeburg 97; Graham Cave 39; Hannibal 84; Independence 86, 98; Jefferson National Expansion Memorial 124–125; Joplin 14; Kansas City 107, 110; Lake of the Ozarks 122, 127; Liberty 93, 107; Portage des Sioux 73; Rodgers Shelter 39; Salverton 93; Springfield 93; St. Francis Xavier 55; St. Genevieve 58, 59, 63; St. Joseph 92; St. Louis 54, 55, 59, 83, 98, 99, 101, 106, 115, 119, 122, 124–125, 127, 127, 128; St. Philippe 58
Missouri River 30–31, 34, 54, 55, 58, 63, 67, 82, 83, 84, 86, 98, 101, 123
Missouri River Valley 91
Missouri Territory 73, 84, 87
Monks Mound, the 42, 45
Morrison, Toni 14
Mothe Cadillac, Antoine de la 55
Mound-building Indians, the 42, 42–45, 44
Mount Rushmore National Memorial 120–121, 126
Murray, Governor John see Dunmore, Lord
Namekegon River 14
National Parks and Monuments:

Apostle Islands National Lakeshore 11, 49; Badlands National Park 76, 127; Chequamegon National Forest 65; Effigy Mounds National Monument 44, 45; Fort Mackinac National Historic Landmark 54; Grand Portage National Monument 56–57; Jefferson National Expansion Memorial 124–125; Mount Rushmore National Memorial 120–121, 126; Pictured Rocks National Lakeshore 28, 48; Sleeping Bear Dunes National Lakeshore 24–25, 28; Superior National Forest 36–37; Tallgrass Prairie Natural Reserve 81; Theodore Roosevelt National Park 6, 16
Nation, Carry 94, 95
Native American conflicts 11, 14, 55, 58–59, 60, 64, 66–75, 67, 69–71, 72, 77–78, 86: Battle of Fallen Timbers, the 71; Battle of Little Bighorn, the 77; Battle of Olentangy, the 69; Battle of Piqua, the 69; Battle of Raisin River, the 72; Battle of Rosebud Creek, the 77; Battle of the Thames River, the 72, 74; Battle of Tippecanoe, the 71; Black Hills War, the 75, 77, 77; Chief Pontiac's War, the 58, 67–68, 68; French and Indian Wars, the 14, 55, 58–59, 64, 66–67; Ghost Dance Campaign, the 77–78, 79; Hancock's War 75; Lord Dunmore's War 68–69; Pontiac's War 58, 67–68, 68; Red Cloud's War 75; Sioux Uprising, the (1862) 74–75; War of 1812, the 72, 73, 74, 84, 98, 99; Wounded Knee Massacre, the 78, 79
Native Americans 11, 14, 20, 29, 39, 45–47, 50, 54, 55, 58, 59–60, 63, 79, 79, 82, 84, 86, 87, 88, 98, 99, 101, 102, 108, 126, 127: Adena Culture 42–43, 45; Algonquian 45; Arapaho 47; Arikara 47, 67, 73; Assiniboine 46; Cahokia 46; Cheyenne 47, 75, 77; Chippewa 28, 71, 99; Dakota Sioux 47; Delaware 98; Fox 35, 46, 63, 66, 73, 74; Hidatsa 47; Hopewell Culture, the 34; Huron 50, 73; Illinois 46, 59; Ioway 47; Iroquois 30, 45; Kanota Sioux 47; Kaskaskia 46; Kickapoo 46; Lakota Sioux 47; Mandan 47, 82; Mascouten 46; Menominee 47; Meshkwahkihaki see Fox; Mesquakie see Fox; Miami 46, 50, 70; Michigamea 46; Mingo 69; Miniconjou Sioux 79; Mississippian Culture the 34, 39, 42, 44–45; Missouri 47, 50; Moingwena 46; Mound-building

Indians, the 42, 42–45, 44; Oglala Sioux 75, 77; Ohio 50; Ojibwa 46, 46–47, 66, 87; Omaha 46; Osage 46, 50; Oto 47; Ottawa 46, 51, 58, 67–68, 68, 71, 73; Paiute 77; Pawnee 15, 47, 82; Peoria 46; Ponka 46; Potawatomi 46, 51, 71; Santee Sioux 74–75; Sauk 35, 46, 66, 73–74, 74; Seminole 114; Shawnee 20, 60, 68–72, 71, 98; Sioux 20, 43, 45, 47, 54, 58, 63, 73, 74–75, 77–78, 77, 78, 79, 87; Tamaroa 46; Teton Sioux 75; Wacochachi 35; Wapekutah Sioux 74; Wichita 47; Winnebago 47; Woodland Culture, the 34; Yankton Sioux 63

Nebraska 7, 14, 15, 17, 29, 31, 34, 47, 54, 55, 58, 63, 82, 82, 83, 86, 87, 91, 91, 92, 94, 98, 108, 119, 123, 126: Boice 123; Brownsville 102; Fort Atkinson 86; Fort Lisa 83; Fort Robinson 77; Gering 89; Keystone 106; Lincoln 110; Madison 107; North Platte 93, 115; Omaha 86, 96, 118, 122, 123; Scott's Bluff 89; Wildcat Hills Recreation Area 128; Woods Park 15

Nebraska Territory 90, 91

Neolin 67

Nicolet, Jean 50, 51

North Dakota 17, 20, 47, 54, 55, 58, 63, 67, 82, 84, 88, 91, 92, 95, 108, 114, 117, 119, 122, 123, 126: Amidon 27; Bismarck 58; Brookings 110; Devil's Lake 126–127, 128; Fort Abraham Lincoln 77; Fort Buford 77; Fort Daer 84; Fort Mandan 82; Grand Forks 110; Theodore Roosevelt National Park 6, 16; Spirit Lake 74

Northwest Ordinance, the 62–63

Northwest Territory, the 14, 50, 60, 62–63, 64, 69, 71–72, 82, 98

Ohio 11, 17, 18, 29, 34, 43, 46, 51, 58, 59, 60, 64, 66–67, 68, 69, 71, 82, 84, 85, 86, 87, 92, 98, 101, 107, 108, 115, 117, 119, 122, 126, 128: Akron 115, 123; Athens 110; Blue Hole, the 29; Castalia 29; Chillicothe 42, 64, 69; Cincinnati 70, 96, 101, 107, 110, 122; Cleveland 128; Columbus 42; Dominion 42; Flint Ridge 44; Fort Greenville; Fort Recovery 63, 70–71; Fort Washington 70; Granville 123; Great Serpent Mound 42–43; Hillsboro 43; Indian Lake 127; Lima 123; Lorain 14; Marietta 63; Miami Valley 69; Milan 110; Newark 44; Olentangy Indian Caves 126; Oxford 110; Portsmouth 84; South Bass Island 73; Springfield 71, 71; Sullys Hill National Game Reserve 126; Tiffin 115; Toledo 26–27, 71, 103, 123; Zoar 85

Ohio Company, the 58

Ohio Company of Associates, the 63

Ohio River 20, 30, 34, 50, 51, 59, 60, 63, 69, 70, 71, 93, 98, 101

Ohio River Valley 12–13, 58, 59, 67, 69, 70, 71

Ohio Territory 87

Oil see Industry: Oil

Olds, Ransom E. 111

Oregon Trail, the 83, 86, 89

Ozarks, the 55

Ozark Scenic Waterways, the 108

Paleo-Indians, the 34–35, 38

Parkman, Francis 17–18

Peshtigo Forest Fire (1871), the 94

Perrot, Nicholas 55

Perry, Captain Oliver 84

Pike, Zebulon 83

Pioneers see Migration and Settlers

Plains, the 7, 17, 34, 38, 43, 50, 75, 77, 86, 107, 108, 118, 122 see also Prairie

Platte River 18, 31, 34, 55, 86, 128

Pontiac, Chief 58, 67–68, 68

Pony Express, the 92

Pottawatomie River 90

Prairie 17, 18, 20, 27, 27, 39, 81, 87, 107, 127 see also Plains, the

Price, General Sterling 93

Procter, General Henry 72

Prophet, the see Neolin

Putnam, Rufus 63

Quebec Act (1774), the 59

Quebec Province, the 59

Quebec Territory, the 58

Queen Anne's War 55 see also French and Indian Wars, the

Radisson, Pierre 50

Railroads 14–15, 86, 88, 91, 93, 94, 95, 96, 98, 99, 103, 106, 106, 107, 108, 122, 123

Rainy River 58

Red Cloud 75

Red River 84

Religion 59, 119: Amana Society 85; Amish 85, 126; Anabaptist Mennonites 94, 94, 98; Evangelists 59, 69; Lutheran Seperatists (Rappites) 85; Methodists 92; Mormons 86, 86; Roman Catholics 92; Quakers 111

Renault, Philippe 99

Reno, Major Marcus A. 77

Roosevelt, Franklin Delano 122

Roosevelt, Theodore 117, 120–121, 126

Saarinen, Eero 127

Sandburg, Carl 17

Schoolcraft, Henry 47

Scott, Dred 91

Seelye, Sarah 93

Settlers 9, 20, 26, 59, 60, 62, 63, 69–75, 72, 77–78, 79, 82–84, 87, 88, 90–95, 98, 99, 108, 114, 127 see also Immigration and Migration

Shawnee Prophet see Tenskwatawa

Sheridan, Philip H. 92

Sherman, William T. 92

Short Bull 78

Sibley, Colonel Henry Hastings 74

Sigel, General Franz 93

Simons, Menno 94

Slavery 84, 88, 90–91, 92, 99

Slow Bull 43

Smith, Joseph 86

South Dakota 17, 20, 34, 47, 54, 58, 63, 73, 77, 82, 83, 84, 88, 91, 95, 98, 114, 114–115, 122, 127: Badlands National Park 76, 127; Black Hills, the 17, 22–23, 75, 75, 76, 94, 102, 126; Deadwood 94, 102–103; Elk Point 82; Fort Pierre 83; Lead 101; Mount Rushmore National Memorial 120–121, 126; Pine Ridge Reservation 75, 77–78; Rosebud 77; Standing Rock Reservation 78; Vermillion 110; White River 75; Wounded Knee Creek 78

Spanish Raid, the 60

Sport 110, 117

St. Clair, Governor Arthur 60, 70

St. Clair River 30

St. Croix River 87, 113

Steamboats 30, 74, 83–84, 83, 98, 101–103

Studebaker Brothers Manufacturing Company, the 103, 107, 115

St. Valentine's Day Massacre 122

Taft, William Howard 117

Taoyateduta see Little Crow

Tashunca-uitco see Crazy Horse

Tecumseh 71, 71–72, 74

Tenskwatawa 71

Territorial boundaries 14, 29, 45, 46, 50, 50–51, 55, 58, 59–60, 62–64, 66–67, 69, 71–75, 77–78, 82–84, 87–88, 90–92, 94, 98, 114

Terry, General Alfred H. 77

Tippecanoe River 71

Toledo War, the 87

Trade 14, 20, 31, 38, 42, 43, 50, 51, 54–55, 56–57, 58, 59, 63, 66, 67, 68, 73, 83, 84, 86, 96, 98, 99, 102, 108, 109

Trapping 55, 58, 98, 101–102, 107 see also Fur trade

Treaty of Fort Greenville, the 71

Treaty of Fort Wayne, the 71

Treaty of Paris, the 58, 60, 63, 72

Treaty of Utrecht, the 55

Truman, Harry S. 11

Turner, Frederick Jackson 78, 114

Twain, Mark 84

Universities 109–110, 128: Baker University 92; Iowa State College 110; Kansas State University 110; Miami University, Ohio 110; North Dakota Agricultural College 110; Northwestern University, Illinois 128; Ohio University 110; State University of Iowa 92; State University of South Dakota 110; University of Chicago, Illinois 123, 128; University of Kansas 110; Loyola University Chicago, Illinois 128; University of Minnesota 92, 110, 126; University of Missouri 92, 110; University of Nebraska 110; University of North Dakota 110

Vegetation 17, 20, 27, 34, 38, 39, 127

Verendrye, Francois 58

Verendrye, Louis Joseph 58

Verendrye, Pierre 58

Wabash River 20, 55, 63, 69, 70, 85

Wacochachi 35

War of 1812, the 72, 73, 74, 84, 98, 99

Washington, George 58, 69, 120–121, 126

Wayne, Anthony 63, 70–71

Wildlife 17, 20, 26–27, 34–35, 38, 126, 127

Wilson, Woodrow 118

Winchester, Gen. Brigadier James 72

Wisconsin 8, 10, 17, 18, 20, 34, 35, 44, 46, 47, 51, 58, 59, 60, 73, 74, 82, 88, 90, 96, 98, 99, 101, 106, 108, 109, 117, 118, 119, 126, 127, 128: Apostle Islands National Lakeshore 11, 49; Ashland 50; Big Eddy Falls 35; Cave of the Mounds, the 28; Chequamegon Bay 51; Chequamegon National Forest 65; Cornucopia Harbor 20; De Pere 51; Fort Snelling 91; Fountain City 28; Green Bay 50, 51, 66; Horeb 28; LaCrosse 45; Little Norway 126; Madison 34; Osceola 113; Peninsula State Park 52–53; Peshtigo 94; Prairie du Chien 61; Richland Center 34; Ripon 118; Spooner 14; Springbrook 14; Spring Green 128; Wisconsin Dells 29; Wyalusing State Park 45

Wisconsin River 29, 54, 61

Wisconsin Territory, the 87, 91

Wolf River 35

Woodland Indians, the 34, 39, 42–45, 47

Works Progress Administration (WPA), the 122–123, 128

World's Columbian Exposition, the 96, 114, 123

World War I 118–119

World War II 123, 123

Wounded Knee 78, 79

Wovoka 77

Yellowstone River 102

Zeisberger, David 59, 69

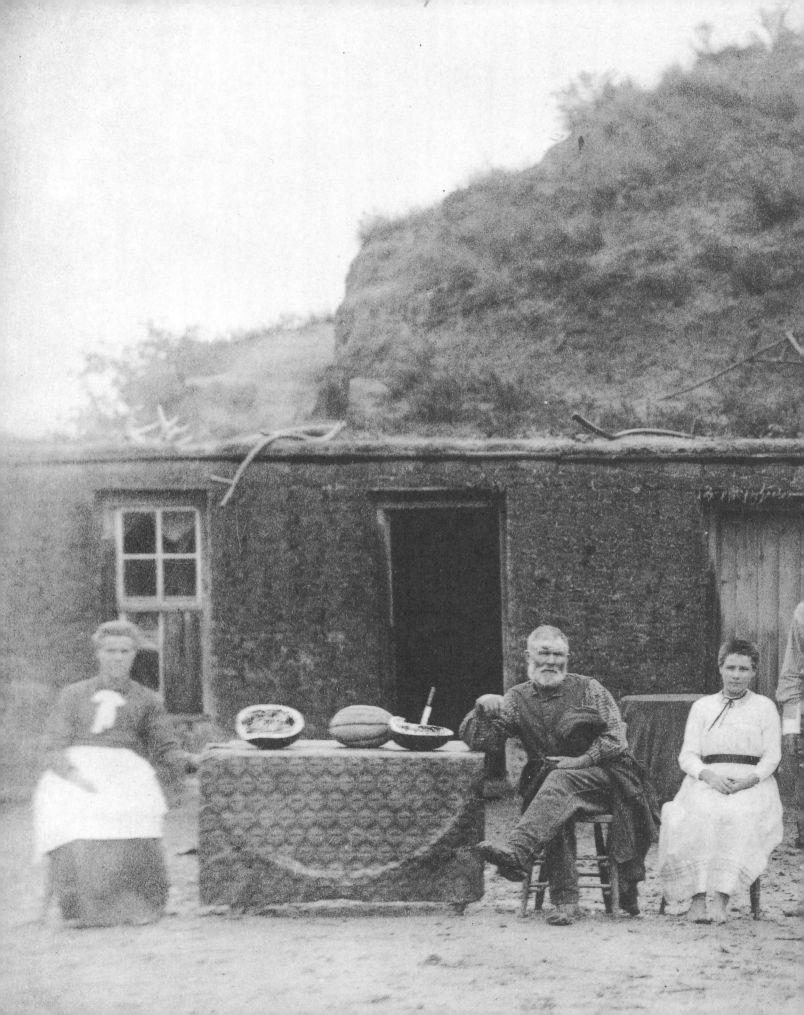